NATIVE AMERICAN VOICES ON IDENTITY, ART, AND CULTURE

OBJECTS OF EVERLASTING ESTEEM

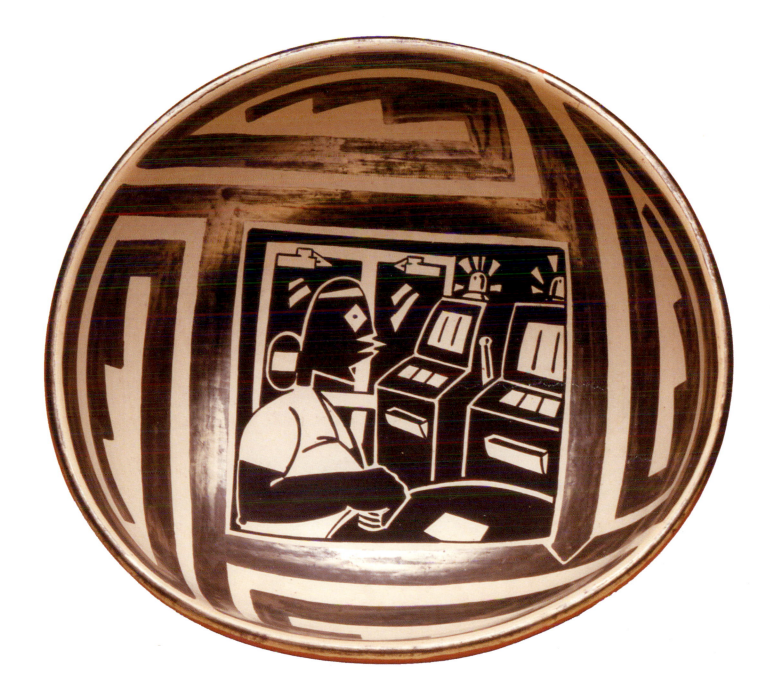

NATIVE AMERICAN VOICES

ON IDENTITY, ART, AND CULTURE
Objects of Everlasting Esteem

edited by LUCY FOWLER WILLIAMS, WILLIAM WIERZBOWSKI,

AND ROBERT W. PREUCEL

UNIVERSITY OF PENNSYLVANIA

MUSEUM OF ARCHAEOLOGY AND

ANTHROPOLOGY Philadelphia

Copyright © 2005
by the University of Pennsylvania
Museum of Archaeology and Anthropology
3260 South Street
Philadelphia, PA 19104

First Edition.
All color plates photographed by Karen Mauch.

Library of Congress Cataloging-in-Publication Data
Native American voices on identity, art, and culture : objects of
everlasting esteem / edited by Lucy Fowler Williams, William
Wierzbowski, and Robert W. Preucel.—1st ed.
 p. cm.
Includes bibliographical references and index.
ISBN 1-931707-80-4 (hardcover : alk. paper)
1. Indians of North America—Material culture. 2. Indians
of North America—Antiquities—Collectors and collecting.
3. Indian philosophy—North America. 4. Indian cosmology—
North America. 5. Cultural property—Philosophy. I. Williams,
Lucy Fowler. II. Wierzbowski, William S., 1951– III. Preucel,
Robert W. IV. University of Pennsylvania. Museum of Archaeology
and Anthropology.
E98.M34N38 2005
704.03'97'007474811—dc22 2005000385

Printed in the United Kingdom on acid-free paper.

Published with the generous support

of GREGORY ANNENBERG WEINGARTEN

and the ANNENBERG FOUNDATION

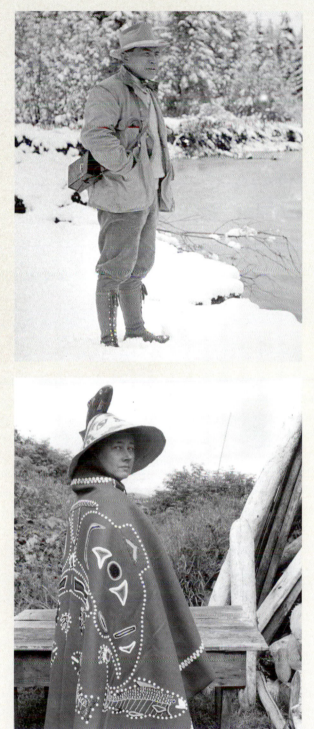

*This book is
dedicated to the
memory of
Louis Shotridge
(1886–1937)
and
Frederica de Laguna
(1906–2004),
whose lives and work
continue to inspire
and teach us.*

*"After the first snow, and no snowshoes."
Self-portrait by Louis Shotridge, ca. 1918.
UPM Archives, neg. 14848.*

*Frederica de Laguna in Angoon, AK,
1949. Photograph by Edward Malin.
UPM Archives.*

Perceptions of an Ethnographic Object

You o'piece were created
as a living, functioning
serving object
in a culture
predicted to be extinct.
Yet today you still exist
as a remembrance of a time past,
through cultural genocide
your creators survived
your purpose changed
your role shifted
from a functional to a
symbolic
representation of a once strong
healthy community.

Through time your context,
significance and meaning
changed.
Now embodied within your existence
your time has come again
to teach, to promote, to share, to ensure
your creators
their role, their history
is not gone, but alive through you.

SVEN HAAKANSON, JR.

Contents

Eyes—Looking Forward for Future Generations

Foreword

This book helps define the role of the University of Pennsylvania Museum of Archaeology and Anthropology within the realms of a large research university and the general public. It presents and clarifies some of the connections between the Museum and the Native American communities.

Let me begin by stating what the Penn Museum is not. It is not just a repository of artifacts and things. It is not a place of dead objects from the past. And it is not a collection of cultures and cultural knowledge of both the past and the present.

The Museum, instead, is a place of people and ideas about human societies and cultures, a place of living, active objects. It is a place where the living present can connect to the living past.

These concepts about our Museum are embodied in this book, where Native American artists and scholars come face-to-face with and respond to the vital and vibrant materials of their past, thus demonstrating how these objects enrich and enliven important issues today.

Some important concepts include the nature of Native American identity in the past and in the present, indigenous sovereignty, the active destruction of Native American culture and language over the past half-millennium along with the perseverance and strength of the Native American community to survive, and finally the power of ancestors in today's world.

The essay by Robert W. Preucel, Lucy Fowler Williams, and William Wierzbowski sets forth many issues about the connections between the Native American community and the Penn Museum. They discuss Louis Shotridge, the Tlingit Indian who was responsible for our Museum's acquisition of a very large and extensive collection of material from the Northwest Coast. It is clear from his writings that Shotridge understood the role of museums as post-colonial entities that positioned Native American cultures on a low rung of cultural evolutionary structures. But Shotridge purchased and collected on behalf of the Museum apparently with great ambivalence. He knew that with the changes within the indigenous communities, Native Americans were losing their identity and culture. As I understand it, he was purchasing these materials for two reasons. First, he wanted to preserve the objects and materials from the past. And second, he wanted to raise the perception of American culture and make it equal to that of the Near East, of the Mediterranean, and of China.

It is interesting to note that Shotridge's ambivalence is no different than the contrast of comments, both from within and from outside, of the new National Museum of the American Indian in Washington, DC. Is that museum intended for the Native American community to understand better its past and present? Or does it exist to inform the non-Native community about the importance of the indigenous community in the Americas?

The many Native American scholars and artists who participated in this book project will assist the Penn Museum as we attempt to become a more integral part of today's world. I

personally know many of these participants. And to these and to the individuals I have not yet had the pleasure to meet I want to extend my thanks for their time and, most importantly, for their ideas about our collection of living culture.

Space limitations of this Foreword prevent me from discussing all the commentaries. I think the volume editors' essay does a wonderful job of identifying some interesting and important overarching themes of the book's structure and organization. But I would like to highlight a few thoughts that I think emphasize the importance of this project. Several commentators discuss the physical emptiness of the objects they examine while at the same time mentioning the incredible cultural spirits that similarly inhabit these objects. This contrast is emphasized in Buddy Gwin's commentary about the Dog Soldier Leggin's, in Kevin Noble Maillard's discussion of a Seminole bag, and Roger C. Echo-Hawk's statement about a Pawnee shirt: "This shirt may look empty, but it is filled with the world that gave rise to 20th century America."

Michael Wilcox identifies a similar but slightly altered historical construct for museums. For him, this contrast is physically embodied in the 19th century on the Washington, DC, mall where one entity, the Department of War, was attempting to destroy the living Native American people while just down the mall the Smithsonian Institution was charged with the preservation of the objects of these indigenous peoples. This contrast of destruction and preservation is also highlighted in Bernard Perley's choice and discussion of the Massachusetts Bible. On the one hand, this bible is an attempt to convert and then to save the soul of the Indians while, at the same time, indigenous peoples were being destroyed through disease, genocide, and cultural annihilation.

The last, but I think the most important idea emphasized in these commentaries relates to the ongoing attempt to preserve and maintain cultural identity and sovereignty for the indigenous peoples of the Americas. It is the preservation of ideas embodied within objects from the past and present that allows for the representation and strength of Native American identity in the modern world. This book clearly shows how a museum like our University of Pennsylvania Museum of Archaeology and Anthropology is not just a collection of objects of the past but of ideas of the present and for the future.

RICHARD M. LEVENTHAL
The Williams Director
University of Pennsylvania Museum
of Archaeology and Anthropology

NATIVE AMERICAN VOICES ON IDENTITY, ART, AND CULTURE

OBJECTS OF EVERLASTING ESTEEM

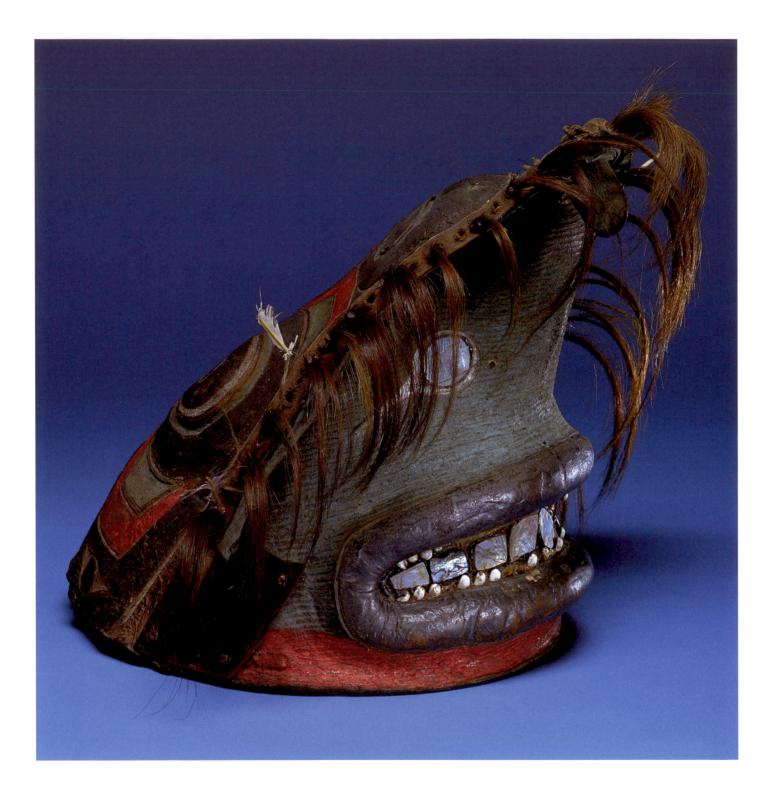

1. *Kaagwaantaan* shark
helmet (29-1-1), collected
by Louis Shotridge in 1929.
Photograph by Francine
Sarin.

The Social Lives of Native American Objects

ROBERT W. PREUCEL, LUCY FOWLER WILLIAMS, and WILLIAM WIERZBOWSKI

On March 29, 1929, Louis Shotridge, of the University of Pennsylvania Museum, sent a telegram to Miss Jane M. McHugh, the acting director of the Museum, to notify her of the opportunity to purchase the famous *Kaagwaantaan* "shark helmet" (Figure 1). Museum collectors across the East Coast widely regarded this Tlingit Indian object as having particular historical interest. The shark was the original crest of the powerful *Kaagwaantaan* clan. It was subsequently replaced by the wolf, the current crest, at a council meeting at Grouse Fort, Alaska, in the late 1800s. At the meeting, *Stoowukáa*, one of Shotridge's ancestors, gave a powerful speech urging his clan members to "cast out from your minds, Kaguanton, this cowardly fish which, with its rows of sharp teeth, would only slink in the presence of danger, and only take advantage of a helpless being. Think of the 'Wolf' now; he is bold and will fight when necessary" (Shotridge 1929:341).

Shotridge was able to purchase the helmet because of the death of the *Kaagwaantaan* housemaster, the keeper of the clan valuables. He paid the two women heirs the sum of $350. Shotridge described the transaction in an article in the *Museum Journal*: "When I carried the object out of its place no one interfered, but if only one of the true warriors of that clan had been alive the removal of it would never have been possible. I took it in the presence of aged women, the only survivors in the house where the old object was kept, and they could do nothing more than weep when the once highly esteemed object was being taken away to its last resting place" (Shotridge 1929:339-40). He then confessed to a profound feeling of ambivalence. As a Museum employee, he rejoiced in the acquisition of this important specimen, but as a Tlingit Indian and member of the *Kaagwaantaan* clan, he felt himself a traitor who had betrayed his people.

This event poignantly captures some key issues surrounding museum collecting practices in the first half of the 20th century. Shotridge and other museum curators were able to amass large collections because Native cultures were undergoing profound economic, political and cultural changes. Many elders willingly sold their ceremonial objects because they perceived the younger generation as rejecting traditional ways and embracing new, Western values and behaviors.

Shotridge himself was a product of this "modernization process" (Figure 2). As a high-ranking member of the Kaagwaantaan clan from the village of Klukwan, Alaska, he enjoyed certain traditional privileges and rights. His maternal grandfather, Chief Tschartritsch, was widely considered the most prominent chief in the mid-19th century. As someone interested in modernity and cultural preservation, Shotridge eagerly accepted an offer of employment with the University Museum. While in Philadelphia, he even took classes at the University of Pennsylvania's Wharton School of Business so he might, according to one reporter, "equip his mind with the things of modern civilization that he may carry wisdom and developed ability back to Chilkat Land and govern his people well" (Wanneh 1914:280). Shotridge thus

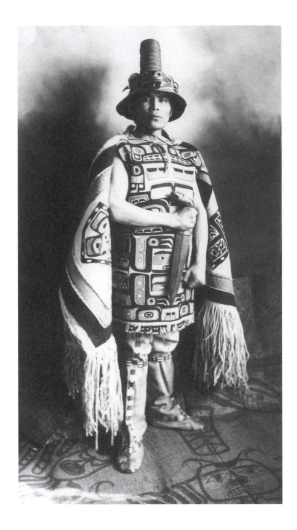

bridged two worlds—that of the Tlingit people of Alaska and that of the museum-going public in Philadelphia.

Today, some Tlingit people regard Shotridge in a negative light. They feel that he "sold out" his culture for his own profit, and some clans are actively seeking the repatriation of these objects under the Native American Graves Protection and Repatriation Act (NAGPRA). Yet Shotridge's motives clearly extended beyond his own family's material comforts. He had a vision for his people's future during a time of cultural reorganization. He was committed to preserving Tlingit history and wanted to raise it up as the equal of the ancient Near East, the Mediterranean, and China. He felt that the University Museum, because of its worldwide holdings, offered this possibility. It seems likely that were Shotridge alive today he would be actively involved in the processes of cultural revitalization currently taking place all across Native America.

In the past twenty years, anthropology museums have come to realize that our collecting and exhibition practices are not neutral acts (Karp and Lavine 1991). They exist within a one-sided power relationship between tribes and the U.S. Government, a relationship that inhibits true sovereignty for Native peoples. Recent historical studies reveal that the origins of museums during the Victorian era are intimately associated with colonialism and the placement of indigenous peoples on the lower rungs of an evolutionary ladder culminating with Western civilization (Hinsley 1981). The exhibition of ethnographic objects has, intentionally or not, served to represent and reinforce these asymmetrical social and political relations.

This book seeks to re-represent Native American peoples and cultures to a general audi-

ence using ethnographic objects from the North American collections of the University of Pennsylvania Museum. As implied above, this task is fraught with challenges and difficulties. Yet it is something that must be attempted if museums are to fulfill their responsibilities to Native peoples and the public at large. Believing that cultural representation is best approached through collaboration, we invited Native individuals to share their written responses to selected objects. The resulting essays are eloquent literary contributions presenting poetry, narrative, biography, and autobiography in novel ways. They are also a testimony to the power and enduring significance of ancestral objects.

A BRIEF HISTORY OF THE NORTH AMERICAN SECTION

In order to provide a historical context for the objects that the Native authors write about, we begin with a brief discussion of the origins and development of the North American Section of the University of Pennsylvania Museum. We identify three broad periods of collecting and exhibition—evolutionism (1887–1912), historical particularism (1912–94), and collaboration (1995–present). In each case, these periods began later and lasted longer than for the anthropology profession as a whole.[1]

Evolutionism (1887–1912)

During the first half of the 20th century, most American citizens popularly believed that Native Americans were rapidly disappearing (Dippie 1982). Diseases, such as smallpox, measles, and tuberculosis contributed to wholesale deaths in Native communities and the loss of much traditional knowledge (Thornton 1987). Government policies and missionization programs forced many Native peoples to give up their traditional subsistence activities and to modify their religious practices. Citizenship for Native peoples was contingent upon the demonstration of modernization and Westernization.

Many museums used the "Vanishing Indian" idea to justify sending out major collecting expeditions to all corners of Indian country. The scope of these expeditions was astounding. In the six years from 1879 and 1885, the Smithsonian Institution collected over 6,500 pottery vessels from Acoma and Zuni pueblos (Berlo and Phillips 1989:14)! By 1925, museums had so thoroughly combed the Northwest that "there was more Kwakiutl material in Milwaukee than in Mamalillikulla, more Salish pieces in Cambridge than in Comox" (Cole 1985:286).

The fledgling science of anthropology emerged in concert with these early collecting activities. The first anthropology departments were established at Harvard University, Columbia University, the University of Chicago, the University of Pennsylvania, and the University of California (Patterson 2001). In each case, there were close ties between department and ethnological/archaeological museums. There were associations between the Peabody Museum and Harvard University, the American Museum of Natural History and Columbia University, and the Field Museum and the University of Chicago. These connections insured that the study of Native American ethnography was an integral component of anthropological theory and basic field training.

Early anthropologists tended to interpret ethnographic objects from an evolutionary perspective. Lewis Henry Morgan, was the major proponent of this view. He devised a three

1. For histories of the University Museum see Madeira (1964), Winegrad (1993), Kuklick (1996), Conn (1998), and Williams (2003).

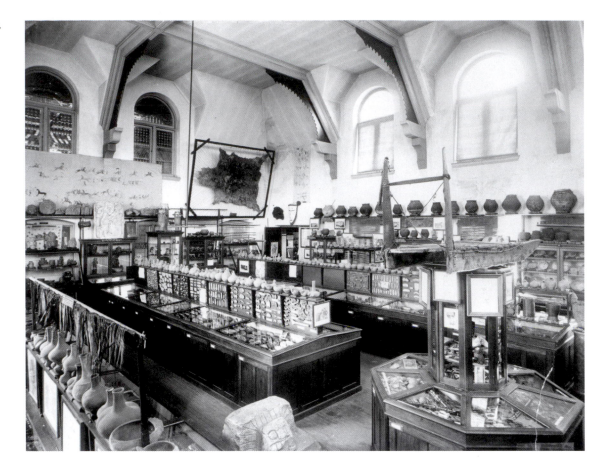

stage model of universal human cultural evolution leading from savagery to barbarism and culminating in civilization. The invention of pottery, for example, signaled the beginning of his "Lower Status of Barbarism" (Morgan 1877). This perspective was quickly incorporated into museum displays. Otis T. Mason implemented it in his ethnological exhibit at the National Museum in Washington, DC, where each class of objects, such as masks and pottery, was organized in a linear sequence from earlier, simple forms to more recent, complex ones (Jacknis 1985:77).

The University Museum was founded in 1887 to further the study of the ancient civilizations of the Near East. Under the influence of Daniel Garrison Brinton, professor of archaeology and linguistics at the University of Pennsylvania, it quickly incorporated Native American material culture into its academic mission.[2] A strong advocate of Morgan's evolutionary approach, Brinton regarded the geographical diversity of Native peoples as examples of different evolutionary stages resulting from local responses to specific environmental challenges (Brinton 1891). Brinton used this approach to organize the first exhibit of Native American artifacts on the Penn campus (Figure 3).

Another proponent of the evolutionary approach was Stewart Culin, appointed curator of ethnology in 1892. Like many of his contemporaries, Culin espoused the Vanishing Indian thesis. He wrote, "The Indian is becoming so rapidly civilized or extinct that with the demand from private collections and American and foreign museums, there will soon be nothing left on the reservations . . . the Indian . . . is soon to disappear" (letter from Culin to the Museum Board of Overseers, 1900, Museum Archives). Although he had an early interest in

2. Brinton was appointed his professorship in 1886, the first such professorship in the United States (Darnell 1988).

4

4. George Byron Gordon and the Penn in Alaska, 1905. UPM Archives, neg. S4-143057.

China and did early collecting with George Dorsey among the Plains Indians, Culin's main collecting activities were in the American Southwest. Funded by Philadelphia merchant John Wanamaker, he made expeditions in 1901 and 1902 to the Hopi villages, Zuni, and other Rio Grande Pueblos to purchase ethnographic material (Williams 2003). He ranked his subsequent collection as "at least fourth among the museums of the entire world" (Fane 1991:18).

Yet another evolutionist was George Byron Gordon who became assistant curator of ethnology in 1903 and general curator of American archaeology a year later (Figure 4). Like Culin, he believed that ethnological objects were valuable data for understanding the human condition and needed to be gathered into museums before their producers became extinct. He wrote the Museum board president, saying "the records of the American Indian are a burning house; they are fast disappearing, when lost, they are gone forever" (Museum Archives). In 1907, he arranged for George G. Heye's extensive collection of American Indian materials to be transferred to the museum with the expectation that it would become part of the permanent collection (Figure 5).[3]

When Gordon became the Museum's second director in 1910, his responsibilities grew proportionally. He worked steadily to increase the size of the Museum's collections and was instrumental in establishing the University's Anthropology Department (Winegrad 1993). Because of his longstanding interest in Alaska and the presence of the Heye collection, he concentrated on expanding Arctic holdings from Alaska and Canada. His goal was to "recon-

3. This did not happen. Heye left the Museum to establish his own Museum of the American Indian in New York City. This collection is now the core of the collections of the National Museum of the American Indian in Washington, DC.

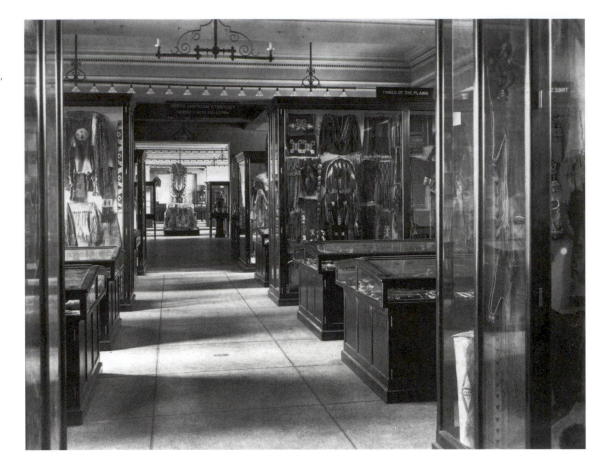

struct, in visible shape, the life history of the human race, exhibiting at once its progressive development and the rich variety and excellence of its attainments" (Museum Archives). There was a strong element of institutional competition here, and Gordon continuously urged his field agents to acquire old "museum-quality" collections (Williams 2003).

Historical Particularism (1912–94)

Franz Boas of Columbia University provided an important challenge to Morgan's thesis with an approach known as "historical particularism." This is the view that ethnological objects are best understood from within their cultural contexts. Objects are not merely the outcome of universal human needs, but rather they possess multiple meanings derived from their particular uses (Jacknis 1985:79). In place of exhibits depicting evolutionary sequences, Boas (1887) advocated ethnic groupings with specific tribal characteristics shown in detail. At the American Museum of Natural History, he pioneered "life groupings" whereby objects were animated by being exhibited with manikins in well-crafted, life-sized dioramas.

Shotridge's interest at the Museum in culture history meshed with Boas's historical particularism. Gordon met Shotridge and his wife Florence at the Lewis and Clark Exposition in Portland, Oregon, in 1905 and quickly recognized their potential to aid his collecting goals. Soon after his appointment as Director, Gordon hired Shotridge first in a part-time capacity and then as Assistant Curator. Shotridge directed two major collecting expeditions to Southeast Alaska and Western Canada. At the Museum, he made scale models of Northwest Coast villages (Figure 6), assisted in the installation of exhibits, catalogued collections, and gave gallery tours.

Much has been written of Shotridge's "exploitation" by Gordon (e.g., Cole 1995). However, it is also important to recognize that Shotridge had his own agenda (Milburn 1997). His goal

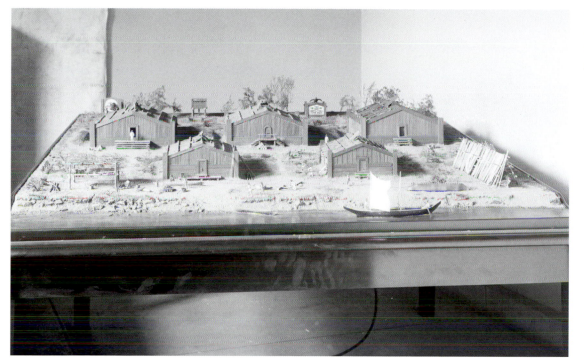

6. Model of Klukwan village made by Louis Shotridge in 1912. UPM Archives, neg. # 12591.

was to record and present to the world a "faithful history" of his own people (Shotridge 1917: 105). This meant collecting Tlingit objects that served as the focal points of a clan's claims to prestige and recording detailed accounts of their movements within and between clans through warfare and exchange. At the same time, he was respectful of anthropological goals and the value of cross-cultural studies. Shotridge thus felt that the old objects would serve a "double purpose" at the University Museum. They would provide "evidence for the Tlingit claim of a place in primitive culture" and they would assist in "the (cross-cultural) work which will benefit the study of man."

In 1911, the University hired Frank Gouldsmith Speck, a student of Boas, to help found the new Department of Anthropology (Figure 7). Speck was an outspoken advocate of historical particularism. At a time when it was widely believed that there were no Native peoples in the Eastern United States, Speck was one of the few anthropologists to focus on the "hidden histories" of these peoples. In 1929, 1930, and 1931, he conducted fieldwork among the small hunting bands living north of the Gulf of St. Lawrence. From 1932 to 1940, he and his student, John Witthoft, worked among the Eastern Cherokee in North Carolina. Speck also sponsored Gladys Tantaquidgeon, a Mohegan scholar and later medicine woman, at Penn. Speck's collections reveal his strong and continued interest in religion and art, as well as his fundamental belief that objects, like myths, rituals, tales, and songs, are manifestations of Native worldviews (Williams 2003).

Another scholar influenced by Boas is Frederica de Laguna, a Museum research associate who died at the age of 98 in 2004 (Figure 8). De Laguna's research focused on reconstructing the cultural histories of the Native peoples of Alaska. Her archaeological work from 1930 to 1935 included surveys of the Cook Inlet and Prince William Sound regions and the middle and lower Yukon Valley. These excavations provided the foundation for an understanding of the prehistory of the region (de Laguna 1934). During this time, she also completed an ethnographic study of the Eyak Indians with Kaj Birket-Smith of the National Museum of Denmark (Birket-Smith and de Laguna 1938). Between 1949 and 1960, de Laguna conducted in-depth ethnographic and archaeological research among the Tlingit Indians. Her mono-

7. Frank G. Speck (rear) with Cayuga informants, ca. 1940. UPM Archives, neg. S4-143974.

8. Frederica de Laguna. Photograph by Ruben Goldberg. UPM Archives.

graph *Under Mount Saint Elias* (1972) is widely regarded as the most complete ethnography of any Native North American group.

De Laguna had strong feelings about the importance of collecting ethnographic objects by museums. She wrote that while "it may be fashionable to condemn people like [George] Emmons," the objects were sold by Native peoples themselves and they received a fair price for the times (de Laguna 2000:39). She noted that museums ultimately served the interests of Native people by drawing worldwide attention to their art and culture and facilitating their civil rights.

The guiding principles of historical particularism also underlie "Raven's Journey," a permanent exhibit, created at the Museum in 1986 to commemorate its Centennial. Susan A. Kaplan and Kristen Barsness (1986) curated it to highlight the traditions of the Tlingit, Athapaskan, and Eskimo peoples. The exhibit places objects in their cultural contexts, giving insights into the significance of the beautifully crafted implements, weapons, clothing, and ceremonial paraphernalia (Figure 9). It makes apparent how the Tlingit used certain objects as symbols of social standing and prestige as well as how the Eskimos encoded their implements with references to the animal spirit world.

Collaboration (1995–present)
In the past twenty years, there has been a major shift in museum anthropology and exhibition methods. This "collaborative period" has involved a commitment to work closely with Native peoples to address the complex issues of representation and interpretation. A convenient starting date for this period is 1989, the date that marks the founding of the National Museum of the American Indian (NMAI). This museum is the only national institution in the United States whose exclusive mandate covers the Native cultures of the Americas in their entirety. For this reason, it bears a unique responsibility to address important issues of cultural interpretation and representation.

The collaborative period is represented at the University Museum by an permanent exhibition curated in 1995 by Dorothy Washburn on the peoples of the American Southwest called "Living in Balance: The Universe of the Hopi, Zuni, Navajo, and Apache." What makes this exhibit distinctive is its process involving the use of multiple consultants. Washburn invited Ed Ladd (Zuni), Edgar Perry (White Mountain Apache), Eric Polingyouma (Hopi), Marlene Sekaquaptewa (Hopi), and Harry Walters (Navajo) to come to Philadelphia to select objects from the Museum's collections that best represented their cultures and to help guide their interpretation (Washburn 1995:xi). Washburn also visited the consultants in the Southwest to work out specific details of the project. In addition, she hired Native photographers from each community to provide images of important places on their landscapes. Their images serve as backdrops to the objects on display.

Some of the highlights of the exhibit are a reconstructed *gowa*, an Apache ritual tipi used to narrate the story of the woman's puberty ceremony, a Navajo *hogan* used to discuss cosmology, a sky dome that introduces the importance of the night sky in marking the seasons, and a video demonstrating the making of *piki* bread (Figure 10). The project also involved a photo exchange between reservation and Philadelphia schoolchildren. Children were given disposable cameras and asked to take pictures of places, things, and people that were important to them. The pictures were then swapped and used in the respective schools' curricula.

In 1998, Judith Berman (1998) and Sally McClendon (1998) curated the "Pomo Indian Basket Weavers" exhibit. Sherrie Smith-Ferri (Pomo/Miwok), Director and Curator of the

9. Raven's Journey
exhibition, 1987.
Photograph by Fred
Schoch. UPM Archives,
neg. 138679, 118.

Grace Hudson Museum in Ukiah, California, was an advisor on the project. This exhibit featured a group of 50 weavers from the early years of the 20th century and examined the market in which they sold their creations. The show opened in Ukiah and then traveled to the National Museum of the American Indian in New York, the University Museum, and the Mashantucket Pequot Museum and Research Center (Figure 11). Susan Billy, a Pomo master basket-weaver, gave a public demonstration of her art at the Philadelphia opening.

THE OBJECTS OF EVERLASTING ESTEEM PROJECT

Given the controversial history of representation of Native Americans at the University Museum and elsewhere, this book seeks to situate ethnographic objects within contemporary Native American discourse as a way of emphasizing their enduring significance.

The vast majority of books and catalogs of American Indian art and material culture available on the market adopt Western art historical perspectives. They emphasize dry debates over art and artifact, tradition and innovation, and authenticity and inauthenticity. These books tend to celebrate an essentialist view of Native American culture as it existed prior to contact or in the early stages of colonization. Only rarely do they acknowledge the vibrancy of contemporary Native cultures today.

Several museums are now beginning to offer richer perspectives on their Native American collections. Significantly, this has been accomplished through close involvement with Native peoples. There are now a small number of exhibits and catalogs that mark this new development. Some noteworthy examples include *The Spirit Within* (1995) published by the Seattle Art Museum, *Gifts of the Spirit* (1997) published by the Peabody Essex Museum, and *Looking Both Ways* (Crowell et al. 2001) published by the University of Alaska.

10. Living in Balance exhibition, 2004. Photograph by Lucy Fowler Williams.

In this spirit, we invited 75 distinguished Native American anthropologists, archaeologists, educators, authors, poets, artists, and lawyers to collaborate with us on this project. We made no effort to secure an even representation of Native American tribal groups. Rather our selection criteria were based upon our personal and professional relationships with Native peoples. We received an overwhelmingly positive response, and 59 individuals accepted.

Some of our collaborators—such as Desirée Martinez, Ann Dapice, Bryan Brayboy, Kevin Maillard, and Steve Johnson—are Penn alumni currently helping us in our efforts to recruit and retain Native American students. Others—such as John Johnson, Richard Hill, and Harold Jacobs—are people we have worked with in the context of NAGPRA requests. Still others—like Marianne Nicholson, Teri Rofkar, Evelyn Vanderhoop, and Jerry Ingram—have visited the Museum as part of the National Museum of the American Indian artist-in-residence program. Others—including Simon Ortiz, Gerald Vizenor, Buddy Gwin, Diego Romero, and Shawn Tafoya—have worked with us, or are currently working with us, on various projects. And still others—such as Nora Dauenhauer, Diane Glancy, Dan Namingha, Roxanne Swentzell, and Mateo Romero—are people whose work we particularly admire. It is important to note that these individuals do not represent all of Native America, and their words and opinions do not necessarily represent those of their own communities, tribal or otherwise.

We had originally hoped to invite our Native collaborators to visit the Museum so they might personally select pieces to write about from the collection of over 40,000 objects. However, due to financial restrictions only a dozen participants had the opportunity to choose objects for themselves, and this was largely because they were visiting Penn for other reasons. Given these limitations, we therefore selected specific objects from the collections with specific individuals in mind. In most cases, we matched participants with objects made

11. Pomo Basket exhibition at UPM, 1999. Photograph by Jenny Wilson. UPM Department of Traveling Exhibitions.

by unnamed members of their home communities. In others, we picked objects that held documented tribal histories or that our participants themselves had made. In some cases, we selected objects because of their evocative qualities. Some of the participants, for their own reasons, chose not to comment on the objects we selected and suggested alternatives. We then photographed the objects and sent letters of invitation asking people to contribute commentaries or statements inspired by the photographs.[4]

We intentionally provided our collaborators with minimal guidance, saying only that we welcomed comments in *any* form such as poems, historical narratives, critical commentaries, stories, personal anecdotes, or the like. We identified a broad range of topics including sovereignty, cosmology, oral history, language, family, education, authenticity, spirituality, kinship, collecting, repatriation, museums, environment, landscape, hunting, gaming, farming, warfare, memory, and time that we thought might appeal to our participants. Not surprisingly, almost all of the essays we received crosscut these topics, underscoring the interrelatedness of all parts of Native life and culture.

BREATHING NEW LIFE INTO MUSEUM COLLECTIONS

The essays offered by our Native collaborators stand on their own as personal commentaries on the multiple interrelations between the past, present, and future of Native America. They can be read in any order, yet because they are varied in style and purpose, we feel it is important to identify some of the broader connections across the essays as a way of highlighting contemporary Native issues for the general public.

Our main challenge was to group the essays according to an organizational scheme. We wanted to go beyond the standard categories such as culture areas, tribal nations, or object types. We began thinking about indigenous categories and turned for advice to several of our collaborators—Sven Haakanson, Jr., Desirée Martinez, Bernard Perley, and Morris Muskett. Some of their suggestions were to organize the objects by the seasons during which they were used or according to the age, gender, and status of the author or by parts of the body with which the objects are associated.

We chose a version of this latter suggestion that we felt evoked major themes raised by the authors—Hands, Hearts, Spirits, Footsteps, and Eyes. *Hands* refers to the important acts of creation through making and teaching, *Hearts* refers to compassion and strength in history and resistance, *Spirits* refers to the guidance provided by the ancestors and deities, *Footsteps* refers to biography and life experience, and *Eyes* refers to looking forward for future generations.

HANDS—ACTS OF CREATION

For many Native people, the acts of making are ways of honoring the ancestors and contributing to a harmonious world order. Carving wood, preparing clay, spinning cotton and wool, and processing hides are all carefully considered actions accompanied by prayers and

4. We are aware of the numerous problems and ironies associated with asking Native people to write about an image of an object and not the object itself. For many Native people, the object often needs to be touched and held in order to establish an appropriate interaction. Photographs, by their very definition, introduce distance and bias (Preucel 1998).

invocations that typically thank the deities for the gifts from nature. This sentiment even extends to modern materials such as plastic and metal. The making of things is thus an important part of the creation of life.

Several authors provide insights into the making process. Morris Muskett hears the sounds of the separating warp as a Navajo belt is woven and emphasizes the living spirit of the belt by imagining its creation (Plate 6) (Figure 12). He compares this process quite literally to the biological processes of cell growth and division, thus associating the process of weaving with the creation of a living entity. Similarly, in her poem, "Origin Tale" (Plate 2) Diane Glancy emphasizes the *making* of a pair of moccasins and the conjugal relationships that endow them with meaning (Figure 13).

The acts of making are gendered differently among different Native peoples. A-dae Romero's poem "Their Hands," for example, celebrates the qualities of Pueblo women's hands in all that they do, touch, and bring to life through the course of a day, a year, a lifetime (Plate 11). Hands in their doing, caring, and relating are what create her Pueblo world. Her poem resonates with notions of movement, making, and the processes of life's spirit. Poet and author Simon Ortiz articulates similar ideas in his essay, "Dyuunih and the Elastic Moment of Creation," relating the formation of a clay water jar to moments in his own life and to those of his mother and grandmother (Plate 7).

Although men are traditionally the weavers in Pueblo society, women have increasingly taken up the craft since the colonial period. Ramoncita Sandoval (Plate 54) discusses how she learned the techniques from two Jemez women. Isabel Gonzalez (Plate 74) talks about the importance of embroidery to her community and how it continues today to help maintain Pueblo peoples' beliefs of their place in the world. One of a small number of Tewa male weavers, Shawn Tafoya writes eloquently about his commitment to Pueblo embroidery (Plate 14), revealing that he sometimes questions the choices he has made to pursue the time-consuming hand spinning and needlework. On these occasions he has to push himself to "think forward" toward the hope and happiness his textiles will bring and to his people's continued gift of life as a Pueblo community.

Today, many Native artisans struggle to gain physical access to the plant, animal, and mineral resources they need. Melissa Darden talks about how she must travel long distances to gather cane for basket making because agriculture and pollution has destroyed most of the riparian habitats along the Bayou Teche (Plate 13). In some cases, the availability of new materials acquired through Western contact has led to new forms of artistic creativity. Desirée Martinez uses glass beads instead of traditional shell beads in her beadwork (Plate 11). This shift is similar to Plains Indian women replacing quillwork with beadwork as discussed by Arthur Amiotte (Plate 58). Importantly, however, the authors do not convey a sense of mere copying or repetition of old methods and ideas. Although the way things are made may be similar, the materials, the maker's experience, and the meanings are always evolving.

For weaver and designer Ramona Sakiestewa, excellence in craftsmanship is an important aspect of her work. Inspired by an ancestral Pueblo cotton blanket (Plate 3), Sakiestewa identifies the prehistoric weaver's technical skill and attention to detail, and suggests that future generations should also value these attributes. The qualities that Sakiestewa admires and seeks in her own weavings is, we believe, related to the richness and quality of Native American relationships in life. It constitutes a depth, a respect, and an attention that is inherent to Native American philosophy, values, and ideals.

In traditional Indian communities knowledge comes with responsibilities. Native artists

12. Morris Muskett. Photograph by Stacey Espenlaub.

13. Diane Glancy. Photograph by Kim Blaeser.

learn their crafts from their grandparents and parents, although today many are self-taught, taking up their craft on their own. Many artists feel a strong responsibility to preserve this knowledge and have dedicated themselves to teaching the next generation. Melissa Darden (Plate 13) and Ramoncita Sandoval (Plate 54) each express concern for the continuance of their crafts. This is a serious problem today that derives in part from competing demands on the time of the younger generation. But there are also encouraging signs that this situation can change due to the leadership of a new generation of artists. Shawn Tafoya, who teaches at the Poeh Cultural Center in Pojaque, New Mexico, observes that among some pueblos the art of embroidery is not only surviving, but thriving (Plate 14).

In many ways, acts of making and creating are a means of honoring the past and insuring the future. Native peoples recognize these activities as a form of cultural continuance and renewal. Objects made with care and attention to the ways of their ancestors provide strength and order and support their ways of life. Even though the materials used may change, these processes and forms are linked to the past through mythology, ancestors, and relatives, to places of creation, and to journeys on the landscape. These acts of creation are thus vital acts of existence and serve as fundamental markers of Native American identity.

HEARTS—COMPASSION AND STRENGTH IN HISTORY AND RESISTANCE

Native American history is usually told from the perspective of Western academics. The Native authors featured here provide alternative views, ones grounded in culture and experience. They offer poignant accounts of the difficulties Native peoples experienced as a result of Euro-American oppression. Religious and cultural persecution, enforced governmental policy changes, genocidal warfare, and disease have all precipitated the devastating loss of Native populations, languages, and ways of life. Many of the essays reveal the immediacy and reality of this loss in the lives of Native Americans today. It is as if time has hardly passed. Yet the authors also resist and reformulate the finality of these events with images of themselves as enduring, changing, and revitalizing individuals and communities. They are not victims, but survivors.

Since the early 1970s, many Native scholars have contributed vital accounts that articulate histories from a Native point of view. Simon Ortiz's important books *Fight Back* (1980) and *From Sand Creek* (1981), Broderick Johnson's *Navajo Stories of the Long Walk Period* (1973), Russell Thornton's *Native American Holocaust* (1987), Richard and Nora Dauenhauer's *Haa kusteeyí, Our Culture: Tlingit Life Stories* (1994), and Diane Glancy's *Pushing the Bear* (1998) all challenge the absence of Native perspectives from standard Western accounts of American history. These revised histories acknowledge the inextricable part and role that Native Americans have played in America, even while under the dominion of an imperialism that has tried to destroy them. Together, they require readers to expand standard definitions of history to include the U.S.'s treatment of Native Americans and to conceptualize a kind of history that is dynamic and living.

Intimately linked to the oppression of Native peoples is the issue of representation. Several authors expose the ways in which the image and idea of Native Americans has been defined by non-Natives on their own terms and to meet their own agendas. In the process, the realities and meaningful nature of Indian experiences has been invalidated. L. Buddy Gwin's essay, for example, examines the limitations of museums in interpreting the meaning of Indian artifacts. Unlike museums, which he says represent Indian objects as hollow

and static, he stresses the animate, living aspects of the spirit-beings that reside within objects, in this case a pair of Mandan Dog Soldier's leggings. Kevin Noble Maillard contrasts the goals of museums to preserve the material culture of a "vanished race" with their neglect of contemporary Indians who use material culture as they live, work, and shop in cities and towns today (Plate 24).

14. Portrait of *Chis-I-se-duh* (Carl Matches) in school uniform, 1879. Courtesy of National Anthropological Archives, Smithsonian Institution (06909400).

Gerald Vizenor exposes the politics of representation in American history in his response to a set of Cheyenne ledger drawings (Plate 15). Prison art is a poignant example of expressive creativity under conditions of extreme cultural isolation. At one level, Vizenor interprets the drawings by a young Cheyenne warrior named Carl Matches (*Chis-I-Se-Duh*) as a means of metaphorically riding out of prison (Wierzbowski 2003) (Figure 14). He invites us to consider Native and non-Native artists alike who have the ability to take us to new places and consider new possible worlds. Vizenor's poem simultaneously evokes the inhumanity of the colonial experience and the important role of artistic expression (Matches' and his own) as an active means by which Native Americans have for centuries opposed the realities, categories, and definitions imposed on them by non-Native society.

Bernard Perley provides a critical commentary on the cultural significance of the famous Eliot bible. This bible is named after John Eliot, a Puritan missionary, who translated the bible into the Massachusetts Indian language (Plate 21). It is a rare book, highly valued by collectors who, ironically, cannot read a single word. Perley, however, regards it as a symbol of America's treatment of Native peoples. It served as an early tool of Puritan ministers in their goal of converting the Massachusetts Indians to the Christian faith. But as Perley argues, it did not save them, since warfare, smallpox, evangelization, and assimilation precipitated the disappearance of the Massachusetts people as a cultural entity. He asks us to think about what it means when a language is "preserved," but there are no Native speakers to use it.

15. Mateo Romero in his studio. Photograph by Phil Karshis.

Commenting on a 1920s painting by Velino Shije Herrera, a noted Zia artist of the Santa Fe Indian School, Mateo Romero (Figure 15) encourages us to look beneath the surface of everyday life to discover the effects of Spanish colonialism (Plate 31). In what appears to be an idyllic Pueblo harvest scene, Romero sees elements of the raw realities of 17th century Pueblo life. He exposes the cultural and religious persecution of the period by telling a story of the slow death of Moonlight Woman's small daughter from disease and starvation, and the family's despair in their inability to properly provide a burial blanket. Romero's account challenges views of Western history that silence the Native point of view. In a similar vein, Sven Haakanson's poem "*Kayaktime*" remembers his Sukpiat ancestors who were enslaved by Russian explorers to hunt and wage war against the Tlingit in the 1790s (Plate 16) (Figure 16). Only a few Alutiiq men survived to share the stories and to pass on the true horrors of this experience.

Other authors invite us to expand our understanding of history by considering the effects of Federal Indian law. At the core of this body of law is legislation known as the Marshall trilogy, three major cases written by John Marshall, Chief Justice of the Supreme Court. *Johnson v. McIntosh*, 21 U.S. 543 (1823), determined that legal title to all Indian lands was held by the U.S. government; *Cherokee Nation v. the State of Georgia*, 30 U.S. 1 (1831), argued that Indian nations or tribes are defined as "domestic dependant nations", and *Worcester v. Georgia*, 31 U.S. 515 (1832), argued for the sovereignty of Indian tribes and the federal government over and against the states on Indian issues. In sum, though Native Americans have special status, the United States claims that federal authority is supreme. As a result of these rulings,

the federal government continues today to control Indian land and defines Indian people as its dependent wards.

Several essays confront this legacy and the shifting federal policies of removal, allotment, and assimilation from the 1800s through the first decades of the 20th century. Bryan Brayboy, inspired by three Cherokee dolls (Plate 18), comments on the terrifying realities of the forced migration or removal of the Five Civilized Tribes (Cherokee, Choctaws, Creeks, Chickasaws, and Seminoles) to Indian Territory, now the State of Oklahoma. This involved the uprooting of children and sending them to boarding schools, the silencing of the Cherokee language, and the collecting of human remains for museums. This example stands for the dozens of tribes that were removed West and the many others that were consolidated in the West and Northwest. Once removed, those people who rejected or challenged the systems of land allotments and new rules of reservation life were disciplined, and in some cases captured and taken as prisoners of the Indian wars.

For many Americans, Plains Indian war bonnets are classic symbols of Native American identity and the American West. Michael Wilcox writes of an eagle feathered headdress whose collection history indicates a dark reality (Plate 33). It was taken by a soldier as a trophy from the body of an unnamed Teton Lakota warrior killed in a punitive raid after General George Armstrong Custer's defeat at the battle of the Little Big Horn in 1876. This headress is an example of removal and assimilation policies in action. For Wilcox, the bonnet represents the honor and strength of an individual willing to die to defend his people. It also reveals the profound contradictions in the U.S. government's policies—the eradication of Native Americans in the Indian wars, and their simultaneous preservation in museums.

17. Ramona Lubo (with baby). Courtesy of Peabody Museum of Archaeology and Ethnology, Harvard University, image N36554.

Several essays address myth and false history. JoAllyn Archambault exposes the hidden story behind a Blackfoot drum collected by the famous painter George Catlin (Plate 20). Prior to her study, the Museum assumed it had been purchased by Catlin for use as a prop in his paintings and exhibitions. Archambault convincingly argues that Catlin painted the buffalo head and eagle depicted on two sides, apparently to give it an authenticity it somehow didn't already possess. Desirée Martinez discusses a myth of Southern California history that links a basket made by Ramona, a Cahuilla Indian, and the novel, *Ramona*, written by Indian Rights activist Helen Hunt Jackson (Plate 32)(Figure 17).

Other authors point out the adaptive abilities of Native individuals and communities in responding to the changes around them. Diego Romero's essay *On the Rez* comments on time and a people's relationship to the landscape (Plate 29). His painted bowl reminds us that Pueblo people are fortunate among Native Americans in that they still retain their original homelands. This is a constant and enduring source of strength and creativity. Theodore Jojola talks of a host of responses, both resistant and adaptive, to the coming of the railroad to Isleta Pueblo, his home community (Plate 19). Similarly, JoAllyn Archambault gathers clues to deconstruct a Lakota spiderweb shield made for sale in the 1930s (Plate 26). For her, the quality of the shield's construction and familiar yet unusual design exemplify the creative vigor of Lakota art that continues to be visible today.

Together these essays narrate a range of Indian experiences that are diverse in their particulars, but united in a common political outcome. They speak of how the history of cultural oppression is intertwined with the European colonization of America and attest to the persistence of this reality in their lives today. At the same time, they demonstrate strategies of resistance by celebrating acts of life, adaptation, and change. The objects and essays resist the finality of the laws and policies, the boarding schools and battlefields, the language and stereotypes non-Indians have continually used to define them. Instead, they assert the continuance, strength, and tolerance of Indian people and proclaim the possibility of new histories.

There is no universal form of Native American spirituality; rather there are many different forms that are expressed both individually and communally through ritual and prayer. Having said this, it is true that almost all Native cultures celebrate their close relationships with the land, the sky, rivers and lakes, plants and animals. Native spirituality is often structured by origin stories that speak of the emergence or creation of the people and provide moral guidance and ethical direction. Traditionally, ritual specialists—shamans, medicine men, healers—acted to mediate the relationships between the community and spirit world. Today, many Native peoples have incorporated different forms of Christianity into their religious practices and these range from the Native American Church, to Catholicism, to Protestantism, to Mormonism.

The depth and variety of Native American spirituality in part shape, and are shaped by, the material world. Some authors identify specific materials as being endowed with power and meaning through the web of life forces from which they are derived. Others explain how the use of visual symbols endows them with meaning. Still others relay nuances of the spirit world and explore the rich visual depictions of specific supernatural entities. Finally, others explore the embodiment of guiding philosophical concepts central to their ways of life. Here, the juxtaposition of object and text provides an enhanced understanding of spirituality's material expression.

The material substances of nature can be seen as gifts from the holy ones. Diane Glancy's poem "Naming", inspired by a set of a Cherokee woman's hair combs, for example, identifies turtle shell, wood, and animal horn, which give of themselves for the wearer (Plate 37). She speaks of a living and natural world in which all things of creation play a role. This is a world that is sacred and holy, where all things hold meaning, and are endowed with their own agency. Her poem abounds with respect and appreciation for the material substance itself with which one has an ongoing relationship. Similarly, Gary Roybal comments on a painting of a deer dance at San Ildefonso Pueblo (Plate 38). He shares details of the dance and its overarching purpose as a communal re-creation of a deer hunt in which the deer (the dancers) give of themselves to the village in the spirit of a real hunt. Again we see the giving of animals to people and the honoring of that gift by the people through ceremony.

Objects are often decorated with elaborate designs that confer sacredness and protection by symbolically representing deities and cosmological principles. Bea Medicine's interpretive essays, for example, illustrate the sacredness of Lakota women's objects conveyed through their construction and decorative symbols. A woman's deerskin dress is endowed with symbols of motherhood, nurturance, beauty, and health—signs that express Lakota women's reasons for being and belonging and that give Lakota people strength and direction (Plates 43 and 50).

Dan Namingha's essay, inspired by 100-year-old Hopi *tihu*, conveys the vitality of Hopi katcina religion and its persistent influence in his own life (Plate 44). Similarly, David Ruben Piqtoukun talks of his belief in the spirit helpers who are watching over the Inuit people in their quest for survival (Plates 45, 46, 47). His own art, which portrays a traditional spirit world, is itself influenced by this process. In a third example, Harold Jacobs explains the significance of the Tlingit octopus cane (Plate 48) (Figure 18). This wooden cane is carved with dozens of suction cups to represent an octopus tentacle. He shares a song that invokes the story of *X'aanaxgáatwayáa*—the spirit who controls the salmon migrations.

18

In some cases, objects represent Native cosmologies and moral principles. Morris Muskett interprets an early Chief-style blanket's construction and design as a material expression of Navajo philosophy (Plate 51). For him, the blanket is a profound expression of commitment to *hozho*, the Navajo state of being balanced in a harmonious world order. More than a mere blanket, it reflects the weaver's thoughts, work ethic, cosmic philosophy, and artistic creativity. Similarly, Roxanne Swentzell's clay sculpture expresses a fundamental Pueblo view of the earth as a mother bowl, "holding us all within" (Plate 52). This concept expresses the central Tewa theme of nurturance, caring, and healing that is ever prominent in Pueblo society. In the Tewa language the word *gia* is used to address the earth. It is also used for the highest super-naturals, for males who are outstanding leaders, for strong community level females, and for biological mothers.

18. Harold Jacobs at the Kaagwaantaan 100th Anniversary Commemoration of the "1904 Potlatch," Sitka, Alaska. Photograph by Lucy Fowler Williams.

As a group, these essays convey a variety of ways in which spirituality maintains a protective sense of belonging for Native Americans today. It provides a healing path to the world around them, and serves as a means of relating individuals to a larger social whole. Spiritual power is linked to personal responsibility. It requires proper behavior such as nurturing others, the giving of thanks by gifting oneself through reciprocal action, the acknowledgement of signs, and the maintenance of balance through action. Significantly, these ideas are embodied in objects, in the materials they are made of, and in the designs with which they are decorated.

FOOTSTEPS—BIOGRAPHY AND LIFE EXPERIENCE

One of the most powerful means of rethinking popular stereotypes of Native peoples is to consider individual life histories. These experiences reveal some of the day to day decisions than people make as they go about their lives. In many ways, these decisions are no different that those of any other people—managing child care, going to work, visiting friends. Some decisions are directly related to activities concerning community health and well-being—feasting, dancing, storytelling, and craft making. Because of their linkages to tradition, these activities are conceptualized differently than they would be in non-Native society.

Many of our participants were inspired to share especially meaningful aspects of their life experiences. Some emphasize specific events or challenges. Others write about influential individuals in their communities—elders, teachers, family members, and ancestors. Together these autobiographical and biographical statements mark the importance of choosing particular lifestyles, of community, and for some artists, the relevance of their craft in shaping and giving meaning to their lives.

Teri Rofkar's essay "Voices from My Past," tells of her personal transformation and growth as she became interested in Tlingit basketry (Plate 69)(Figure 19). Her enthusiasm for her ongoing relationship with her ancestors and this traditional craft is palpable. Stephen Johnson reveals the development of his personal spirituality and the important role that his pipe plays in giving him sustenance and direction (Plate 65). It gives him a way to participate in his Native lifestyle despite the fact that he lives in Singapore, far from his Saginaw Chippewa community. Weaver Mae Clark (Plate 62) and silversmith Cippy Crazy Horse (Plate 60) both explain how their art sustains them through the struggles of everyday life.

Dreams and visions figure prominently in several essays. Bryan Brayboy (Figure 20) shares with us some of the challenges he faces in teaching Native American history to non-

19. Teri Rofkar wearing one of her woven dance aprons. Photograph by Dolly Garza.

20. Bryan Brayboy and son, Quanah. Photograph by Doris Warriner.

Native American students today (Plate 18). He finds strength in a vision he received of an old woman from the mountains of North Carolina. Similarly, L. Buddy Gwin is directed by his knowledge of the Mandan Dog Soldier Society that holds a sacred responsibility to protect the people in times of stress (Plate 63). He identifies himself as a contemporary Plains Indian dog soldier committed to fighting legal battles instead of military ones.

Many authors explicitly acknowledge their ancestors, grandparents, parents, teachers, and mentors. Nora Dauenhauer writes about the Tlingit collector, Louis Shotridge, who recorded detailed contextual histories of objects in his valuable writings, since this is how meaning in Tlingit art is stored (Plate 53). Haida artist Jim Hart comments on the legacy of his great, great grandparents, Isabella and Charles Edenshaw (Plate 55). Rayna Green relates Cherokee baskets to the biographies of Lottie Stamper and Helen Bradley, two Cherokee women who sustained the art of basket making, so vital to traditional Cherokee belief and continuance (Plate 56). Gary Roybal comments on a plate made by the famous San Ildefonso potter Maria Martinez and remembers her kindness and the admiration he felt when visiting her home as a small boy (Plate 57). John Johnson honors the illuminating contributions of anthropologists Frederica de Laguna and Kaj Birket Smith in his discussion of a Chugach seal oil lamp (Plate 72).

These essays convey personal experiences that connect the authors to their communities and tribal cultures. They also illustrate the importance of exemplary and influential individuals in guiding and nurturing the lives of others. At their core, these essays speak of the importance of commitment to individuals, to family, and to ancestors as a means of acknowledging and respecting their Indian identities. By emphasizing story telling, communication, and the creation of community, the authors present themselves as wedded to a larger whole.

EYES—LOOKING FORWARD FOR FUTURE GENERATIONS

In recent decades Native Americans have earned significant political and cultural gains such as the American Indian Religious Freedom Act in 1978, NAGPRA in 1990, and the opening of the National Museum of the American Indian in Washington, DC, in 2004. Despite these successes, Native American cultures and issues continue to be under-appreciated. In national discussions of minority concerns and issues, Native Americans are often left out. In university discussions of minority faculty and student recruitment and retention, they are often forgotten. Many Native activists, like Suzan Shown Harjo and Walter Echo Hawk, are working assiduously to rectify this situation.

According to the 2000 U.S. census, American Indians and Native Alaskans number around 4.1 million people. This is 1.5% of the total population of the United States. They are unique among ethnic and racial groups in their formal tribal affiliations and in their relationships with the U.S. government. Over 500 tribes and Alaskan entities are recognized by the U.S. government, and about 300 others are seeking federal recognition. Dozens of others may attempt this in the future. To do so tribes must meet particular criteria generally approved by the Bureau of Indian Affairs. A host of related issues surround tribal enrollment and membership. At the same time, more than 60% of U.S. Native Americans live in non-Indian urban communities. Only a small proportion speak an Indian language at home. These statistics are rooted in the colonial encounter and indicate the challenges of maintaining a Native identity today and in the future.

Russell Thornton's essay, inspired by a Cherokee booger mask, comments on the issue of tribal sovereignty (Plate 71) (Figure 21). Booger masks were traditionally used to critique the unjust behaviors of oppressors and create a culture of resistance. Today the mask reminds him of the importance of gathering as a community around a common cause, and of resisting through ridicule the acts of domination by Europeans and modern Americans. His essay conveys his tribe's ongoing struggle for recognition and respect within the state of Oklahoma, where Native Americans continue to encounter discrimination and dismissive attitudes of indifference.

21. Russell Thornton. Photograph by Michelle Hamilton.

Some authors hold that effective resolution of political, social, and economic injustices requires effective collaboration between Natives and non-Natives. Joe Watkins, for example, uses Clovis points excavated by a University Museum expedition to argue that American Indians and archaeologists need to work effectively together to protect our nation's archaeological past (Plate 78). Rennard Strickland interprets an Osage peyote box as a symbol of the fight for religious freedom, not only for Native Americans, but for all Americans of diverse faiths (Plate 73) (Figure 22). In telling the tale of the Oregon Peyote Case, *Employment Division v. Smith*, 494 U.S. 872 (1990), he urges Natives and non-Natives to look past our differences and to work together for political strength.

Here and in his book *Tonto's Revenge* (1997), Strickland advocates for the creation of a productive middle ground established by Indian and non-Indian lawyers. He urges Native students to make their work useful to Indian communities today. There are a host of important issues including water rights, health care, and the development of social programs. In addition, tribal resources offer opportunities for economic development. Examples include the leasing of tribal and allotted lands for agricultural and recreational purposes, and mineral and timber resources that offer significant sources of tribal revenues. Some communities are forming coalitions to promote control, preservation, and careful management of their resources.

22. Rennard Strickland.

In 1987 the United States Supreme Court issued its landmark *Cabazon* decision which affirms tribal sovereignty over gambling on reservations. Today, slightly more than one fifth of federally recognized tribes maintain some kind of gambling activities. The National Indian Gaming Association (NIGA), a non-profit trade association, is comprised of 184 American Indian Nations and other non-voting associate members. The common commitment and purpose of NIGA is to advance the lives of Indian people economically, socially, and politically.

For some tribes, gambling has markedly raised the standard of living. Foxwoods on the Mashantucket Pequot Reservation in Connecticut is one notable example. However, it has also resulted in cultural contradictions. The most significant of these is that economic development achieved through gambling can be destructive of traditional and social values. Arwen Nuttall, inspired by a Yokuts gambling tray, writes about Indian gaming as a source of economic opportunity for Native communities in their struggle to remain independent, vibrant, and productive (Plate 75). Diego Romero raises this issue as well (Plate 76). Many Native leaders have argued that casinos are not statements of who they are, but simply a means to get them to where they want to be.

These essays reveal some of the complexities, tensions, and ambiguities of the sociopolitical contexts within which Native Americans live today. They highlight a long-standing and continuous tradition of advocacy for economic welfare and political and cultural sovereignty. They also demonstrate that while many tribes and individuals share a common colonial experience, they often address this situation in different ways. Finally, they draw atten-

tion to Native Americans' experiential, process-oriented ways of living that value the past and give them guidance and inspiration as they seek self-definition and self-determination in the present.

LOOKING BACK AND LOOKING FORWARD

As Duane Champagne (1998) writes, Native American history is not just for Indians, it is for all Americans by virtue of our common national identity and our shared connection to a homeland. These essays succeed in strengthening American history for us all, by creating textured and varied accounts of the past. They reveal the hidden histories of exploitation, colonization, and discrimination. And equally importantly, they speak of persistence, vitality, and growth. Native peoples are agents of their own change.

For some authors, museum objects can embody the painful legacies of colonialism. Native Americans continue to live with this history in ways that most non-Native Americans have difficulty fully appreciating. Many of these objects are directly associated with military campaigns, incarceration in prisons, and forced relocations. The existence of these objects often initiates the retelling of particular stories; stories that honor the courage and endurance of the ancestors who made them. By revisiting and retelling these events, the objects also play a part in strengthening the purpose and direction of people's lives today. In this way, objects are healing.

For many authors, museum objects have the capacity to influence the present by virtue of their being alive. In this view, objects made of life substances are themselves part of the web of life. Because of this, human beings have a responsibility to honor them just as plants, animals, and minerals are to be honored. These attitudes and practices acknowledge one's position within the larger natural order where human beings do not dominate. Here there is an emphasis on each living being's contribution to the balance and harmony of the universe. There is thus no clear divide between material and immaterial, objective and subjective worlds.

Indeed, these objects can be seen as material expressions of kin-based relationships that extend well beyond human beings to the land, water, and sky. Native American material culture is built from and about social relationships, relationships in their broadest sense. This is how meaning in Indian art is related to life. And as is the case with all life, Native American cultures have changed and grown over time. In this process, material culture has continued to play an important role. It represents Indian identity, provides an economic livelihood, and plays active roles in resistance to political domination when necessary.

The essays infuse objects with life as they challenge the static, narrow, stereotypical representations so often found in non-Native histories and museums—what Gerald Vizenor calls "terminal creeds." Many are vibrant examples of how cultures adopt foreign materials and convert them to their own cultural uses. They also show how different Native styles and material culture often influence each other. The essays force us to expand our understanding of material culture beyond limiting Western categories such as "traditional" or "tourist art," by demonstrating the creative vigor that still characterizes Native art and culture today. Though some artists talk about the need to sell their work, they indicate that their greatest satisfaction comes when their work contributes to their community's persistence and renewal.

Material culture may well constitute one of Native people's most important tools of cul-

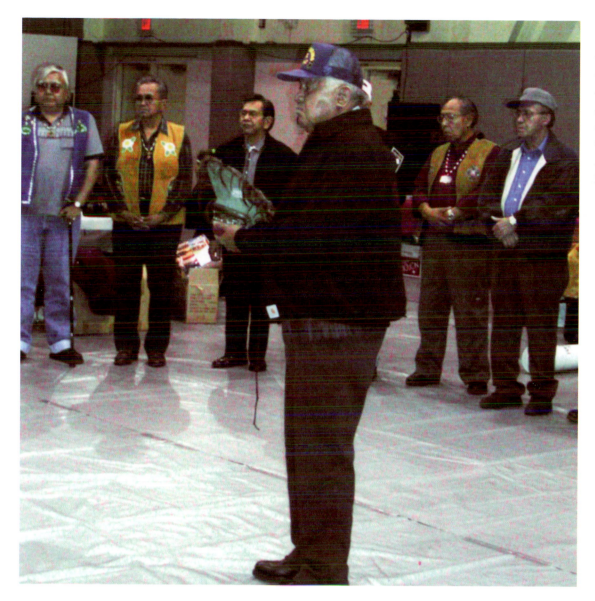

23. Joe Bennett, Jr.,
surrounded by Tlingit
veterans of war, holds
the Shark Helmet at
the *Kaagwaantaan*
100th Anniversary
Commemoration of the
"1904 Potlatch," Sitka,
Alaska. Photograph by
Robert Preucel.

tural survival and revitalization. We witnessed the power of Native objects firsthand during the 1904-2004 Centennial potlatch held on October 23 and 24, 2004, in Sitka, Alaska. We had been invited by Mr. Andrew Gamble on behalf of the Kaagwaantaan clan to bring four hats from the Museum's Tlingit collection to commemorate the "last potlatch" authorized by the Territorial Governor, John Brady, in 1904. These hats were the Eagle hat, the Petrel hat, the Wolf hat, and the Shark helmet (Figure 1), all collected by Louis Shotridge in the 1920s.

We saw the hats come alive as they were worn during the mourning period and then danced during the installation of 18 *Kaagwaantaan* housemasters. Mr. Gamble, who holds the traditional name *Annahootz* as head of the clan, wore the Eagle hat and danced the Wolf hat. Mr. Sunny Enloe wore the Petrel hat and Mr. Joe Howard danced it. Particularly striking, was the use of the Shark helmet. Mr. Joe Bennett, Jr., called on the veterans of World War II, the Korean war, the Vietnam war, Desert Storm, and those in active duty to come forward and stand in a circle to be publicly recognized. He then held the hat and walked it around the circle to honor past and present Tlingit warriors (Figure 23). Through this act, the Shark helmet, which at one time had become a symbol of cultural loss, became a symbol of cultural vitality and strength.

Among the Tlingit people, the importance of clan hats and helmets, ancestor names, land, heavenly bodies, spirits, stories, songs, and artistic designs is embodied in their concept of

at.óow. The term literally refers to "an owned or purchased thing" usually acquired by an ancestor through personal sacrifice often involving the giving of one's life. Objects become *at.óow* as they are brought out and publicly validated in potlatches. *At.óow* is thus about remembering the past while creating the future, about one's origins and one's destiny all at the same time (Dauenhauer 2000). The objects and essays that constitute this book are also about looking back while being conscious in the present and imagining possible futures. Together, these words and things create, in the words of Louis Shotridge, "objects of everlasting esteem."

References

Berlo, Janet C., and Ruth B. Phillips. 1998 *Native North American Art*. Oxford: Oxford University Press.

Berman, Judith. 1998 Building a Collection: Native California Basketry at the University of Pennsylvania Museum. *Expedition* 40(1):23-33.

Birket-Smith, Kaj, and Frederica de Laguna. 1938 *The Eyak Indians of the Copper River Delta, Alaska*. Copenhagen: Levin and Munksgaard.

Boas, Franz. 1887 Museums of Ethnology and Their Classification. *Science* 9:587-89.

Brinton, Daniel Garrison. 1891 *The American Race: A Linguistic Classification and Ethnographic Description of the Native Tribes of North and South America*. New York: N. D. C. Hodges.

Champagne, Duane. 1998 American Indian Studies is for Everyone. In *Natives and Academics: Researching and Writing about Native Americans*, Devon A. Mihesuah, pp. 181-89. Lincoln, NE: University of Nebraska Press.

Cole, Douglas. 1985 *Captured Heritage: The Scramble for Northwest Coast Artifacts*. Vancouver, BC: Douglas and McIntyre.

Conn, Steven. 1998 *Museums and American Intellectual Life, 1876–1926*. Chicago, IL: University of Chicago Press.

Crowell, Aron L., Amy F. Steffian, and Gordon L. Pullar, eds. 2001 *Looking Both Ways: Heritage and Identity of the Alutiiq People*. Fairbanks, AK: University of Alaska Press.

Darnell, Regna D. 1988 *Daniel Garrison Brinton: The "Fearless Critic" of Philadelphia*. Philadelphia, PA: Department of Anthropology, University of Pennsylvania.

Dauenhauer, Nora. 2000 Tlingit at.oow. In *Celebration 2000: Restoring Balance Through Culture*. Sealaska Heritage Foundation, pp. 101–106. Juneau, AK: Sealaska Heritage Foundation.

Dauenhauer, Nora, and Richard Dauenhauer. 1994 *Haa kusteeyí, Our Culture: Tlingit Life Stories*. Seattle, WA: University of Washington Press.

De Laguna, Frederica. 1934 *The Archaeology of Cook Inlet, Alaska*. Philadelphia, PA: University of Pennsylvania Press.

———. 1972 *Under Mount Saint Elias, the History and Culture of the Yakutat Tlingit*. Washington, DC: Smithsonian Institution Press.

———. 2000 Field Work with my Tlingit Friends. In *Celebration 2000: Restoring Balance through Culture*. Sealaska Heritage Foundation, pp. 21–40. Juneau, AK: Sealaska Heritage Foundation.

Dippie, Brian. 1982 *The Vanishing American: White Attitudes in U.S. Indian Policy*. Middletown, CT: Wesleyan University Press.

Fane, Diane. 1991 The Language of Things: Stewart Culin as Collector. In *Objects of Myth and Memory: American Indian Art at the Brooklyn Museum*, Edited by Diane Fane, Ira Jackness, and Lise M. Breen, pp. 13–27. Brooklyn, NY: Brooklyn Museum.

Glancy, Diane. 1996 *Pushing the Bear: A Novel of the Trail of Tears*. New York: Harcourt Brace.

Hinsley, Curtis H. 1981. *Savages and Scientists: The Smithsonian Institution and the Development of American Anthropology, 1846–1910*. Washington, DC: Smithsonian Institution.

Jacknis, Ira. 1985 Franz Boas and Exhibits: On the Limitations of the Museum Method of Anthropology. In *Objects and Others: Essays on Museums and Material Culture*. George W. Stocking, Jr., pp. 75–111. Madison, WI: University of Wisconsin Press.

Johnson, Broderick H. 1973 *Navajo Stories of the Long Walk Period*. Tsaile, AZ: Diné College Bookstore.

Kaplan, Susan A., and Kristin J. Barsness. 1986 *Raven's Journey: the World of Alaska's Native People*. Philadelphia, PA: University of Pennsylvania Museum of Archaeology and Anthropology.

Karp, Ivan, and Steven D. Lavine. 1991 *Exhibiting Cultures: The Poetics and Politics of Museum Display*, Washington, DC: Smithsonian Institution Press.

Kuklick, Bruce. 1996 *Puritans in Babylon: The Ancient Near East and American Intellectual Life, 1880–1930*. Princeton, NJ: Princeton University Press.

Madeira, Percy C., Jr. 1964 *Men in Search of Man: The First Seventy-Five Years of the University Museum of the University of Pennsylvania*. Philadelphia, PA: University of Pennsylvania Press.

McLendon, Sally. 1998 Pomo Basket Weavers in the University of Pennsylvania Museum Collection. *Expedition* 40(1):34–46.

Milburn, Maureen. 1997 The Politics of Possession: Louis Shotridge and the Tlingit Collection of the University of Pennsylvania Museum. Ph.D. dissertation, Department of Fine Arts, University of British Columbia.

Morgan, Lewis Henry. 1877 *Ancient Society*. New York: Henry Holt.

Ortiz, Simon J. 1980 *Fight Back: For the Sake of the People, For the Sake of the Land*. Albuquerque, NM: University of New Mexico Press.

———. 1981 *From Sand Creek: Rising in This Heart which is Our America*. New York: Thunder's Mouth Press.

Patterson, Thomas C. 2001 *A Social History of Anthropology in the United States*. Oxford: Berg.

Peabody Essex Museum. 1997 *Gifts of the Spirit, Works by Nineteenth-Century & Contemporary Native American Artists*. Salem, MA.

Preucel, Robert W. 1998 Learning From the Elders. In *Excavating Voices: Listening to Photographs of Native Americans*. Michael Katakis, pp. 17–25. Philadelphia, PA: University of Pennsylvania Museum of Archaeology and Anthropology.

Seattle Art Museum. 1995 *The Spirit Within: Northwest Coast Native Art From the John H. Hauberg Collection*. Rizzoli Press.

Shotridge, Louis. 1917 My Northland Revisited. *The Museum Journal* 8: 105–15.

——. 1929 The Kaguanton Shark Helmet. *The Museum Journal* 20: 339–43.

Strickland, Rennard. 1997 *Tonto's Revenge: Reflections on American Indian Culture and Policy*. Albuquerque, NM: University of New Mexico Press.

Thornton, Russell. 1987 *American Indian Holocaust and Survival: Population History since 1492*. Norman, OK: University of Oklahoma Press.

Wanneh, Gawasa. 1914 Situwaka, Chief of the Chilkats. *Society of American Indian Quarterly Journal* 2:280–83.

Washburn, Dorothy K. 1995 *Living in Balance: The Universe of the Hopi, Zuni, Navajo and Apache*. Philadelphia, PA: University of Pennsylvania Museum of Archaeology and Anthropology.

Wierzbowski, William. 2003 Native American P.O.W. Art from Fort Marion. *Expedition* 45(3):15–20.

Williams, Lucy Fowler. 2003 Of Spirits and Science: Meaning and Material Culture Crossing Boundaries. In *Guide to the North American Ethnographic Collections at the University of Pennsylvania Museum of Archaeology and Anthropology*, Lucy Fowler Williams, pp. 1–17. Philadelphia, PA: University of Pennsylvania Museum of Archaeology and Anthropology.

Winegrad, Dilys Pegler. 1993 *Through Time, Across Continents: A Hundred Years of Archaeology and Anthropology at the University Museum*. Philadelphia, PA: University of Pennsylvania Museum of Archaeology and Anthropology.

Hands

PLATE 1.
Jars
Ancestral Pueblo, Sityatki
Ca. 1400–1625
Clay, pigment
Collected by Stewart Culin,
Wanamaker Expedition,
1901. 29-77-703 (left),
diameter 36 cm; 29-77-73
(right), diameter 37 cm

Honoring the Clay

Each pot tells a story and these stories are a kind of history. When I see these old jars I think of the woman who made them. I wonder what she was thinking. I think of how she was not just molding the pot by herself and how she had spiritual help if she was in tune with the Creator. I get kind of excited when I make my pots—I wonder how they will turn out, how big they will be. If they turn out well, I don't feel that I should get the credit because the Creator is always helping me.

For me, the clay is alive—it has spiritual power and a kind of energy. You can still gather it today in different colors. You pray about it and we consider this very spiritual. How you care for your clay is like tending a sick patient. You have to keep your attitude straight and you can't loose your temper. If you're worried about something sad or if you are just not feeling right, this can block out ideas until you get back in tune. At those times I just put my pots away. But when you do have a feeling of painting, it flows and comes naturally.

There is a lot of feeling in these two Sityatki storage jars. The designs on the one on the left are of bison's horns and Hopi textile designs. The textile designs are the borders of the mantas. The signs on the textiles have a lot to do with clouds and rain. The birds are cardinals. Inside the horns are butterflies. The cross-hatched area is the weaving. It is common to see a lot of weaving designs on Hopi pottery.

The Squash Blossom Jar (right) is a beautiful design. It really struck me when I first saw it. These are squash blossoms and butterflies. I have a feeling that the middle band represents bird claws. When I made a jar of my own with a similar design I was thinking about the people back then. Every pot is different—they are not real duplicates because you have your own ideas and you do what inspires you. Mine was more about the people and I wanted to have people today see what they were seeing back then.

I am always teaching and am happy to be able to share what I do. It is good to be able to inspire others, it's important to share it—we need to do that all the time. It is never-ending to teach this kind of thing, and it is important to help the people who are trying to learn.

DEXTRA QUOTSKUYVA

PLATE 2.
Moccasins
Cherokee
Ca. 1841
Buckskin, beads;
length 22.8 cm
Collected by John Clark
in St. Louis, MO, 1841
Museum purchase, 1917
NA5862 a, b

Origin Tale

They don't look like they are made of deerskin,
But a merchant's brown velvet, or a trader's bearskin,
Lined with red material and tied with red.
A Cherokee in St. Louis?
Maybe the moccasins were found in a bundle
Of someone who died on the removal trail,
Possibly crossing the Mississippi.
They are beaded in the floral woodland pattern:
Vines, leaves, buds, nuts, berries, a small ball of sun on the underbrush.
Maybe they are ceremonial or wedding moccasins, the two being one (pair).
Could they be a woman's, as well as a man's?
There is mystery in their purpose, their displacement, their survival.
Their mystery is a circle that pulls a story into it.
 A man dreamed a dream
 And told his wife *how lines moved across*
 And there was under it and over something.
 She shaped the words of his dream
 Following what he said.
 A-gi-ha (I have it) he sang these are *u tha wo di gila sulo*
 (There is something that fits tight inside of).
 She beaded patterns, she said
 When she beaded, they were the land dreaming;
 They were a way to know the earth.
The moccasins carry the man, the woman,
The providers, the makers.
 The land I used to hunt. My wife made them for me.
 I wore them in the forest. I put them on.
 I walked sacred on the land.

DIANE GLANCY

PLATE 3.
Blanket
Ancestral Pueblo,
Lake Canyon, UT
A.D. 1050–1300
Cotton; height 111.7 cm,
width 130.8 cm
Gift of Mrs. Phoebe Hearst,
1896
29-43-183

Canyon Lake Tie-dyed Blanket

According to the Southwestern textile scholar Kate Peck Kent, this is one of ten or eleven tie-dyed textile examples from North America. Most are from Anasazi sites that date to A.D. 1100–1300. This blanket is from Canyon Lake, Utah. Other examples may be seen on Casas Grande effigy jars from northern Mexico and in what look like tie-dyed garments worn by female figures in Ancestral Pueblo painted murals. Other tie-dyed examples are found in Mexico and Peru.

It is inspiring to see a textile that is so well made and so simple in design. In creating my own work I have tried to imagine what another artist may have pondered when making a piece like the Canyon Lake blanket. Were they satisfied with the quality of the cotton and the spinning? Were they content with the quality of the weaving and the selvages? The selvage cords were isolated in the tie dyeing, indicating intentional planning on the maker's part. The twenty-five diamonds are perfectly spaced, which tells us that while this is a simple textile the technical proficiency of the maker was extraordinary.

Cotton is a difficult fiber to hand spin; however the surface of this piece is very consistent. Tie-dyeing is achieved by tightly wrapping string around an area of fabric so that no dye penetrates the wrapped fibers. To create the consistent diamond shape, each wrapped section had to be tied in exactly the same way. Development of a dye that rich in color shows mastery of the dyeing process. The dye is probably a tannin-based plant dye. Once a dye vat was prepared, the entire fabric would have been submerged for a period of time for the cotton to fully absorb the color at such intensity. The simple beauty of the Canyon Lake blanket could not have been achieved without years of trial and error.

The fold lines in the blanket are traditional Pueblo style folds. It then appears that it was folded in half again. We might imagine that textiles in general were highly prized because of the difficulty and scarcity of making them. This piece has been well cared for.

The Canyon Lake Blanket tells us that the maker was highly skilled at spinning, weaving, and tie-dyeing. Each task was carried out with care and mastery. And while the blanket appears simple in weave and design, it should inspire all of us to do excellent work.

RAMONA SAKIESTEWA

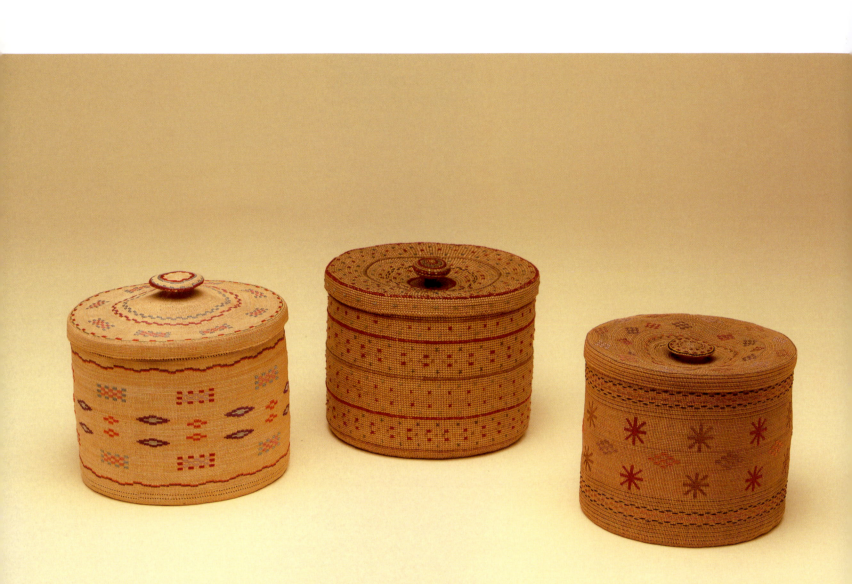

PLATE 4.
Baskets
Alutiiq (Aleut), AK
Late 19th/early 20th century
Plant fiber, wool
76-9-1 (left) height 10.7 cm;
NA3278 (center) height
10.6 cm; 47-11-3 (right)
height 10.4 cm

34

Inartat

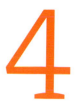

Have you ever felt wind blown beach grass
rustle between your fingers?

Have you ever heard it sway
with each breath?

Have you ever gathered grass
after a rainstorm to weave?

Have you?

Baskets were made,
baskets were used
for our survival

With each strand twisted, stories were made,
stories were told, stories were passed on through time,
woven into one simple basket

Carrying, holding, storing our lives,
covering our homes, our bodies,
passing on our heritage

So simple, so powerful
your strength held our lives together
for generations

Mother to daughter,
generation to generation
your existences carries knowledge
beyond and through time

Gender unknown in woven strands
your true strength was your survival

Woven grass is an art today. Traditionally grass was used for clothing, bedding, containers, and shelter. Looking at grass twist in the wind you would never know how strong it really is until you bind it together, until you work with it and feel its true strength. Each basket that has survived in collections share and hold generations of knowledge that was nearly lost in our region. Thanks to such collections we will always have this information to utilize and learn from our ancestors.

SVEN HAAKANSON, JR.

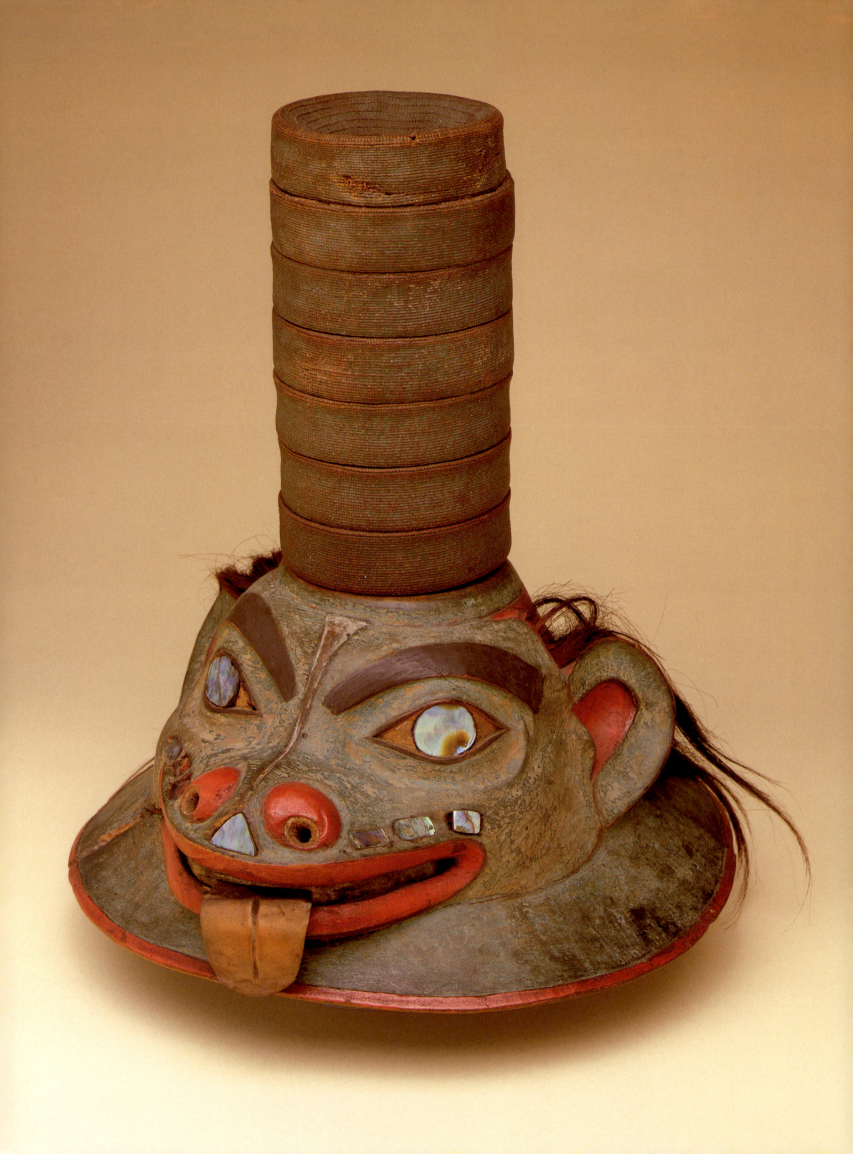

Undersea Grizzly Bear Hat

Clan crest hats are of great importance to the Tlingit people. When attending potlatches high caste or noblemen wear these hats representing their clan.

This hat, known as the Undersea Grizzly Bear Hat, was probably carved of alder wood. The bear's eyes are of abalone inlay. Human hair streams down the back of the hat which is mostly painted in copper oxide blue-green with highlights of red-oxide on the mouth and nostrils and black graphite charcoal lining the eyes and eyebrows. Copper flowing from the mouth represents the bear's tongue. The hat is adorned with seven rings, probably woven with spruce-root.

Having made a few of these hats myself with modern-day tools, I know what it takes to make a hat. I can only imagine what it would have taken in those days using the stone and bone tools of that time. The craftsmanship of these masterpieces is truly remarkable

When creating new *at.óow* or regalia such as a clan hat, or other ceremonial headdress, a member of the opposite clan will commission the piece. Then at a potlatch the new *at.óow* is brought out for all to see. Money or something of great value would be placed on the item and then it would be given a name as if it was a person being adopted into the clan. The money would then be given to a member of the opposite clan, Eagle or Raven, signifying the item has been paid for.

TOMMY JOSEPH

PLATE 5.
**Undersea Grizzly
Bear Hat**
Tlingit, Klukwan, AK
Ca. 1850
Wood, metal, abalone;
height 34.6 cm
Collected by Louis Shotridge,
1917
NA5739

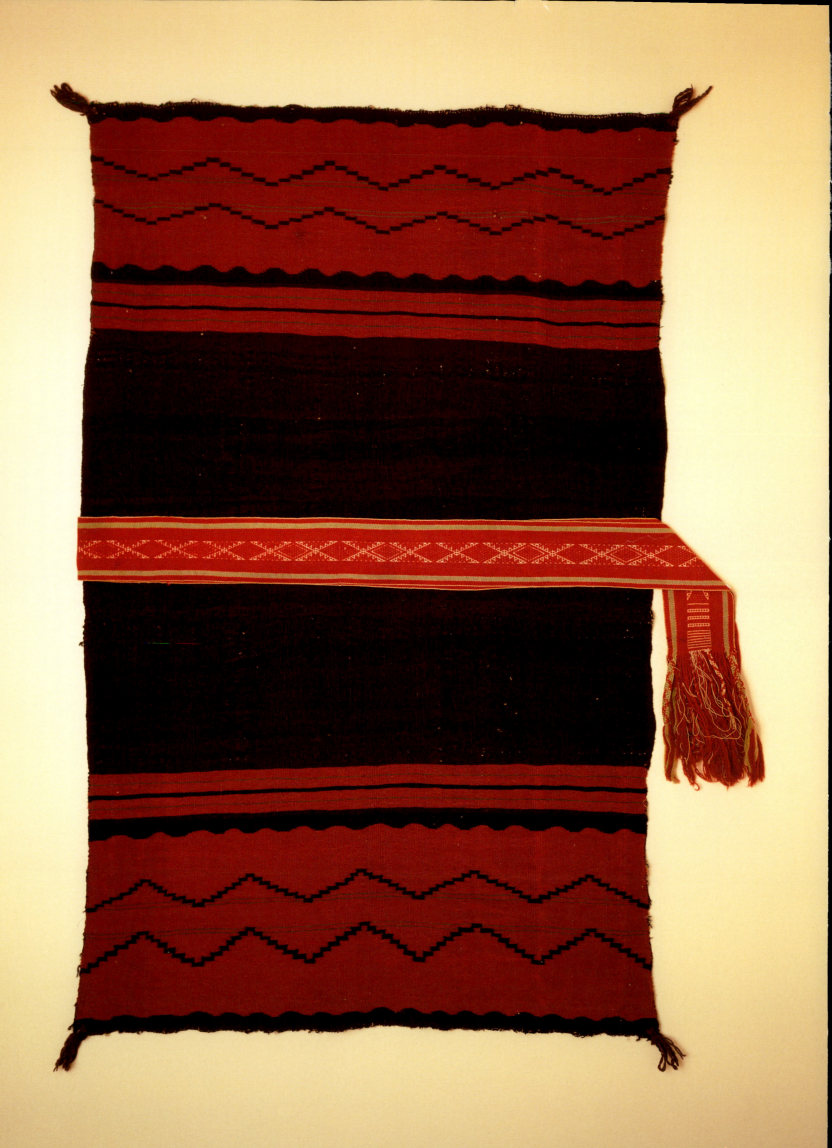

Navajo-style Belt

This belt, shown here with a traditional style Navajo dress, is woven in a distinct Navajo style where the geometric design is outlined by the negative design on one side and raised on the opposite side. The red, green and white colors symbolize elements in Navajo culture. This belt is an example of a classical Navajo belt. I believe contemporary Navajo belts woven with different colors (other than red, green & white) are called traditional belts and not classical style belts. Most people do not make this distinction, but I feel these distinctions need to be recognized and noted.

The function of this classical Navajo belt ranged from use in ceremonies, childbirth, and everyday wear by predominantly Navajo women. This belt was collected at Hopi so it demonstrates cross-cultural interaction through trade between Navajos and Hopis when this belt was woven.

Each time I see and touch a completed Navajo belt I can hear the front and back sheds of warp separating so the weft yarn can be inserted during the weaving process. This repetitious separation of the warp during the weaving process mimics the process of cell growth although at a slower rate. In my culture, handwoven textiles are considered to have a living spirit like a human so the analogy of weaving to cell growth seems logical.

MORRIS MUSKETT

PLATE 6.
Belt
Hopi, AZ
Late 19th/early 20th century
Cotton, wool; length 190 cm
Gift of Anne W. Meirs, 1918
NA9106

Dress
Navajo
Ca. 1860-70
Wool, Length 132.2 cm
Museum purchase, 1924
29-138-1A,B

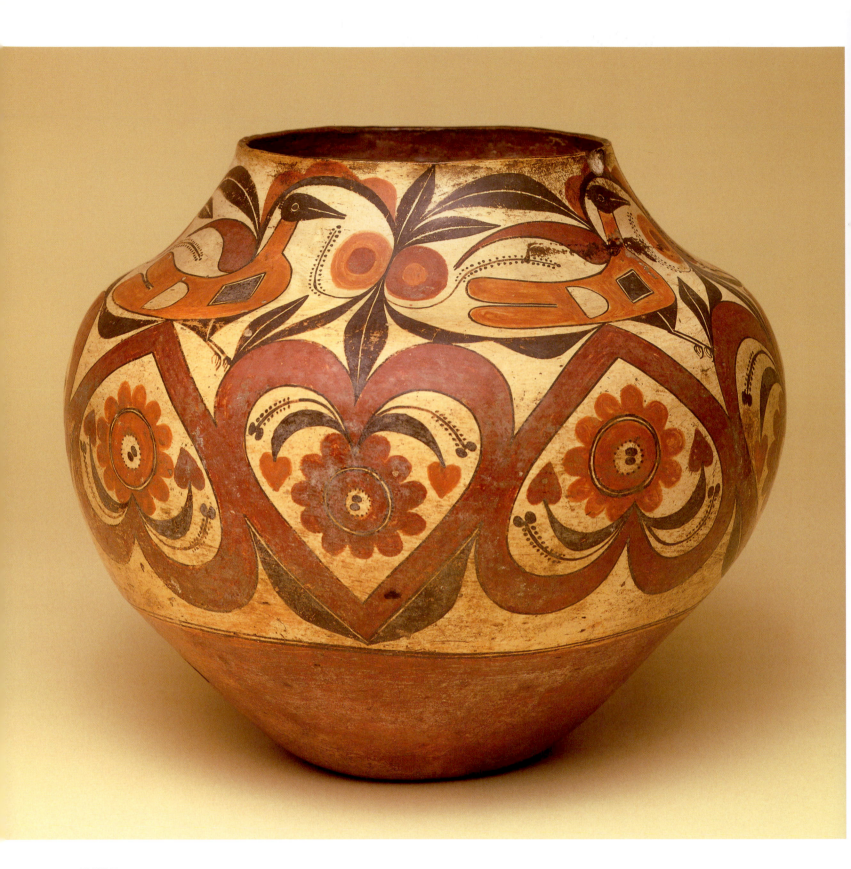

PLATE 7.
Water Jar (*Olla*)
Acoma Pueblo, NM
Ca. 1860
Clay, pigment; height 32 cm
Collected by John Wesley
Powell
Gift of Mr. and Mrs.
Frederick D. Hunt, 1988
88-14-1

Dyuunih and the Elastic Moment of Creation

7

Walking, wandering, looking. That's what I like to do once in a while. My Southwestern homeland. This is my home. Dryland plateau, canyons and arroyos, mesas. *Kahnee* and *dyai-yahnih* trees. Juniper and pinon. Yucca. Prickly pear cactus. Thin grasses. Sandy soil easy to walk on. I like the warm air especially if the wind's not so brisk and pushy. I belong here. The sky is so eternal and forever blue. I am home. Going along and coming to a small mounded rise, I look down and see pottery shards.

I knew my grandmother-*shaatah* made pottery. Jars. Large ones. I've heard. I didn't know her very well; she passed away when I was quite young. I didn't know her much. But I knew she made large jars. When I come upon pottery shards I feel their contours. Worn by time and weather. My grandmother-*shaatah* was very ill and I was too young to have any knowledge of this pain. Except for the fear it provoked in me. When my grandmother-*shaatah* called me to go to her I resisted physically. I was afraid. Darkness seemed to surround my grandmother-*shaatah* in the house in which she sat in the shadows. I did not want to go near her.

Northeast of Flagstaff once, a friend and I visited an archaeological site. A restored place. Old times. A pre-Pueblo community. Ancient. Walls and rooms and a human presence *is* the landscape and the context. Sandstone cliffs and blue sky and well-worn trails. Nearby, just thirty yards away, is the tourist information center run by the U.S. Park Service and shopkeepers.

I think of the jars made by my grandmother-*shaatah* which I've been told about but never saw her make. I used to watch my beloved mother-*shaatah* work at her pottery. She would take a gray lump of heavy moist clay into her hands; with her long fingers she would form and roll and stretch the clay until *it formed. It formed.* I've marveled at the elasticity of the moment; it felt like being within the dynamic of creation that can't be described by telling about the moment. You just can't and you must not in a sense. Because it is in the act of that elastic moment that formation comes about. Sandstone cliffs, pottery jars, grandmothers-*shaatah, stahnaayah-shaatah*, clay, finger, myself-all of these comprise the elastic moment.

And you are within that creation.

SIMON J. ORTIZ

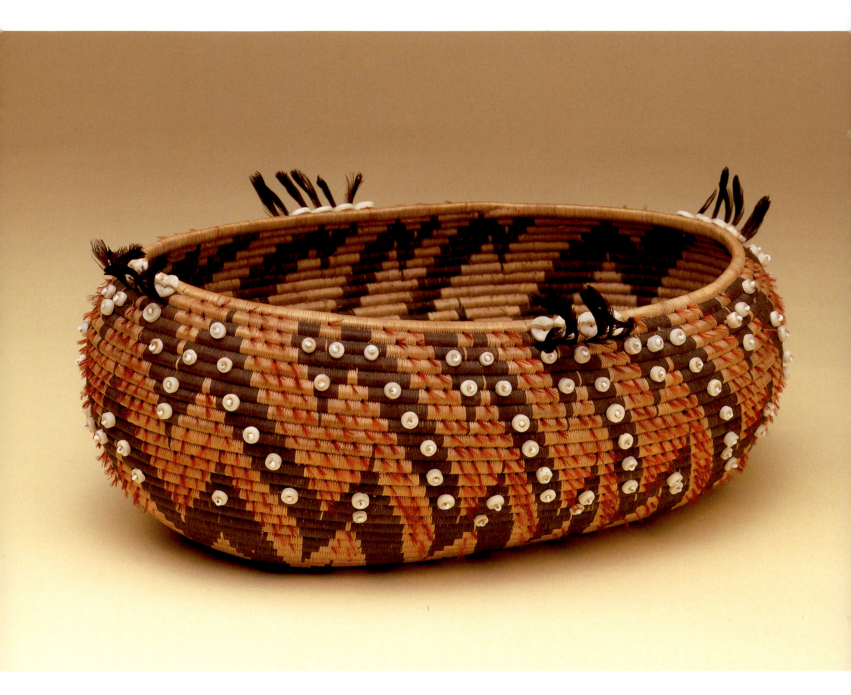

PLATE 8.
Basket
Artist, "Lil"
Pomo, CA
Ca. 1905
Willow, sedge root, bulrush
root, woodpecker and
quail feathers, clam shell,
glass beads
Deisher Collection
Museum purchase, 1918
NA7871 length 26.6 cm

Coiled Pomo Basket

8

"Pomo people make the best baskets in the world." I heard this axiom repeated countless times when I was growing up and I never questioned its validity. Woven nearly a century ago, this piece, with its vibrant coloring, impeccable workmanship, elegant shape, dazzling design, and rich ornamentation of feathers and shell beads, eloquently confirms what I always knew. Baskets don't get any better than this.

This is a three-rod coiled gift or art basket with foundation rods of willow shoots and weft of sedge root. The black design material is dyed bulrush root. The red feathers are acorn woodpecker, the black feathers are quail plumes, the white, round flat circles are clamshell disc beads, and the small white beads are made of glass. The basket was made by "Lil" from the Upper Lake Rancheria, Lake County, California.

SHERRIE SMITH-FERRI

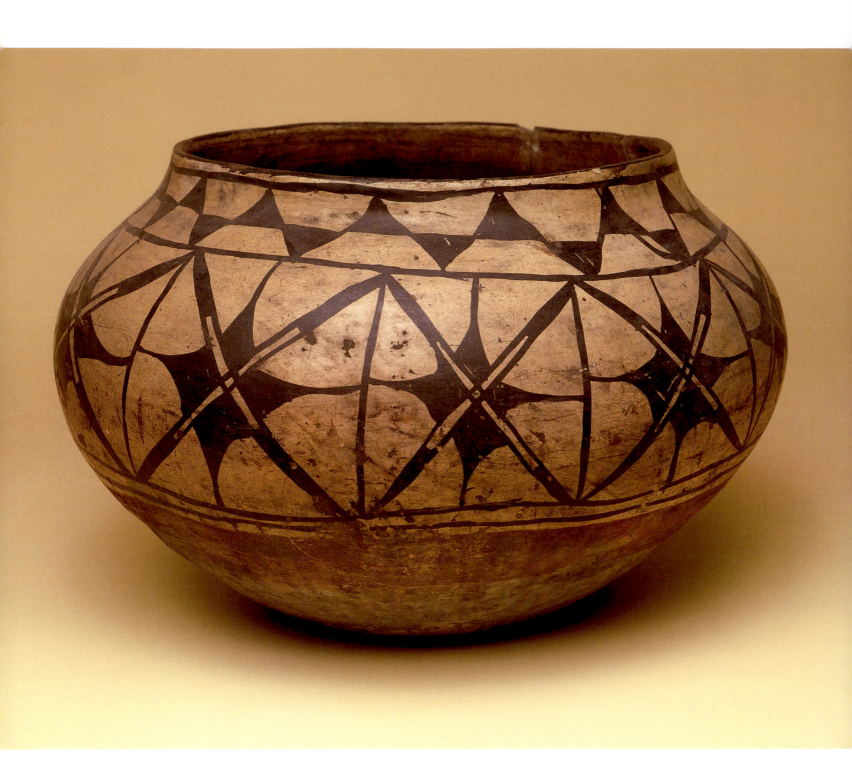

44

Ah-tash

When I look at this Santo Domingo storage jar (*ah-tash*), I think of my grandmothers and how they used to make their potteries. In the old days, they never cared about how the pot came out since they were making them for their own use. For this reason the older pots have a lot of smoking and uneven firings. They were only after the "ring." This sound would tell them that the pot was completed properly. The pot is "born" after it comes out of the fire. It is bad luck to talk about the pot before this time, because it is not yet a finished thing and it might break in the firing.

I have tried to learn from my grandmothers and use traditional methods in the making of my pottery. I use different plant juices, such as prickly pear cactus, in painting my designs to show that wild spinach (beeweed) is not the only plant that we used. These juices are brown when they are first applied on our famous white slip, but they turn black after firing. I use cottonwood bark in my firing to show how the people would have fired their potteries before the coming of the White tribe and the availability of sheep and cow dung.

Today, most potters make pots for the art market. This provides for their livelihood and allows them to buy the things that they want. I am one of the few potters to produce both for sale and for pueblo use. I am pleased when other Pueblo people come to me with requests for my pottery. I am especially honored when my own pueblo comes to me and asks to use my pots in ceremonies.

ROBERT TENORIO

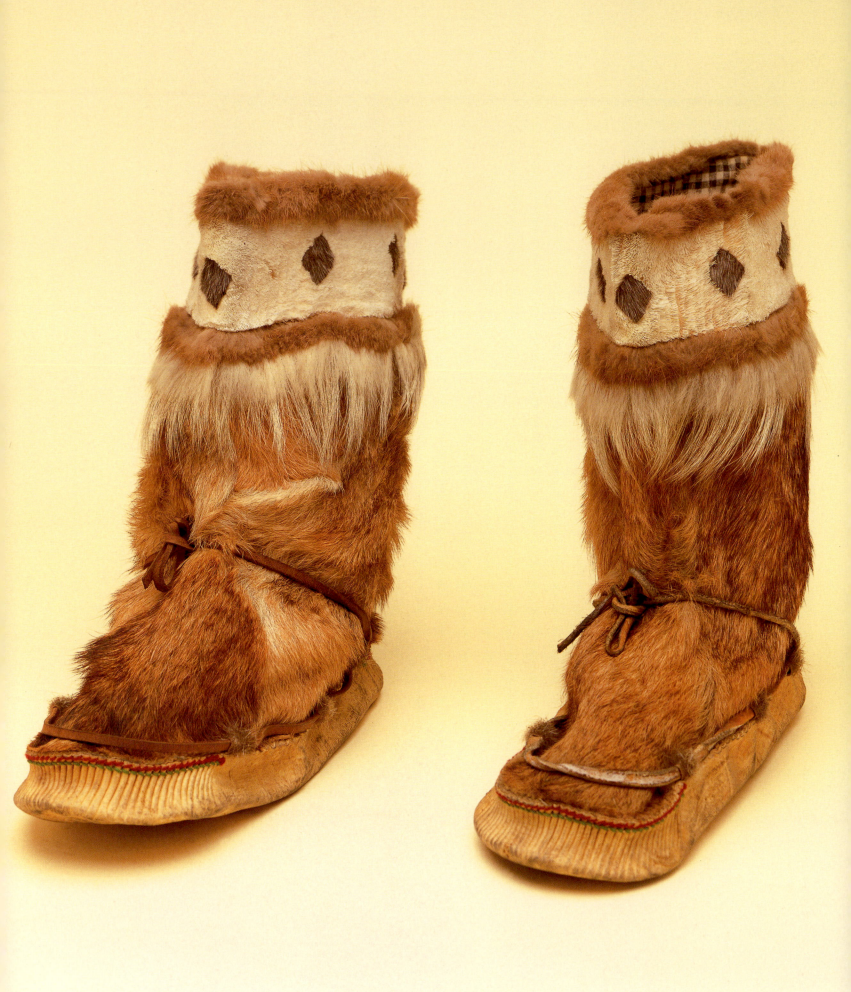

Pretty Booties

O'bootie don't
Don't walk in that wet snow
Don't step in that puddle
Watch out for that dog p . . . , yuck!

Too pretty to wear,
Your fur is fine,
Your souls are strong
Your ruff is long
Making me look good
Keeping my feet warm
For my honey

Let me set you here to show
Bare foot is easier you see
Stepping here and there
Without a care

You bootie are
Too hard to make,
Too hard to care for
Your role is celebrations
only

SVEN HAAKANSON, JR.

PLATE 10.
Boots
Inuit (Eskimo),
Kodiak Island, AK
Late 19th/early 20th century
Moose hide, mink fur;
height 43 cm
Gift of Mrs. C. E. Dickerson,
1928
NA11803 a,b

PLATE 11.

Necklaces
California
A.D. 1200-1700
Shell
11916, 26 cm, Gift of
Dr. Robert Lamborn, 1893;
L-80-1021, L-80-1022,
length 25 cm, collected by
Amos H. Gottschall, gift
of Academy of Natural
Sciences, Philadelphia, 1998

Abalone Shell
San Nicolas Island, CA
length 19 cm
Gift of Academy of Natural
Sciences, Philadelphia, 1998
L-80-184

48

Reconnecting with the Ancestors

I never knew my maternal great-grandmother but when I walk into a bead store looking for materials for my latest project, I think of her. My grandmother, Lupe Martinez Cortez, tells stories of the beautiful purses, handbags, belts, and other objects her mother would bead while raising seven children alone in Montebello, California.

In order to provide for her children during a time of great economic strife, five were sent to Sherman Institute, an off-reservation boarding school for American Indians in Riverside, California. My family had already lost many of our Gabrieliño (Tongva) traditions during their forced conversion to Catholicism during the Mission period (1770-1834). The stay at Sherman erased the rest. With the death of my great-grandmother in 1934, the art of beading was also lost.

As a modern beader, I tend to forget the amount of work that goes into creating beads by hand. I am content to go into a store, select beads from all over the world, and pay for them with my credit card. However, when I look at the shell beads in the collections at the University of Pennsylvania Museum, I appreciate the amount of time and energy the ancestors used to produce them.

I see family members walking the shoreline collecting shells, laughing, and telling stories. I hear chipping, grinding, and polishing, done by a master beader, until the shell is just the right thickness, size, and shape. I hear them say a prayer as the hole is drilled in the middle; at any time the bead can break. All the while, the next generation is watching so they can be ready to take over when the time comes.

As an archaeologist, I know shell beads hold not only aesthetic value, but also a social and economical value. Beads were given as gifts to create and maintain social relationships with other band members and people from other nations. They were also used as payment for items from these same communities.

The use of modern glass beads in my jewelry hints at the changes the Gabrieliño (Tongva) dealt with as the Spanish, Mexicans, and the Americans settled on our traditional lands. Although the beads originate from a foreign country, they are incorporated in traditional ways by community members. Hopefully the younger generation will see these beads and know that they come from a long history of people who used what was available to them to create and sustain a place for themselves in a changing world.

DESIRÉE RENE MARTINEZ

PLATE 12.
Bowl
Artist, Juanita Arquero
Cochiti Pueblo, NM
Ca. 1950
Clay, pigment;
diameter 32 cm
Gift of Marshall Becker, 1986
86-39-36

Their Hands

Dedicated to: the Da-oo's (Auntie Juana, Da-oo Percy, Auntie Ada, and all others) who have shaped clay and our lives since before anyone can remember

Their Hands
 Mapped out with blue and green colored
 River beneath the skin
 That lead into places
 Where stories become real life
 And real people become stories

Their Hands
 Soft
 Like worn leather and sifted sand
 have touched dozens of babies, hard cast iron skillets,
 Hot chile, bread dough, pain, and granddaughters' thick hair

Their hands
 Dipped in red clay
 Smell like summertime rain and
 Look like my skin after feast day,
 The soil in Pa-pa's cornfield,
 And evening skies in early august

Their hands
 Aged and worn
 From smoothing out rough spots
 And slight imperfections, wrinkled dreams, and wounded children,
 Broken hearts and beaten lives

Their hands
 Steady and clear
 Cheating water of its natural movement
 Imprinting old designs of animals and shapes, moons and suns,
 Painting with love, knowledge, intuition, and instinct

Their hands
 Gifted in creation
 Raise pots, bowls, and munos for kitchen stoves and counters
 Museum shelves and collectors' cabinets and
 Happy days in their children's mouths and hands

Their hands
 Shaping, sculpting
 Lives that live beyond now and then
 Here and now
 Lives that can not be forgotten
 Lives that rise
 That rise like laughter around fiesta tables

A-DAE ROMERO

PLATE 13.
Baskets
Chitimacha, LA
Rivercane, pigment
Ca. 1900
NA3628 (left), length
25 cm, height 15 cm,
Museum purchase, 1915;
34-5-1 (center), length 12 cm,
height 12 cm, gift of Mrs.
Edward Bok, 1934; NA1365
(right), length 20 cm,
height 16 cm, Museum
purchase, 1906

Chitimacha River Cane Baskets

13

The split cane basketry of the Chitimacha people, living along the Bayou Teche in St. Mary Parish, Louisiana, has been known for countless generations as the best in the Southeastern United States. Formerly, basket makers found the cane nearby; today they sometimes must travel many miles from their homes because modern agriculture and pollution have destroyed most of the local cane.

Chitimacha baskets are truly homemade. After the cane is gathered, it is split into long strips. The split cane is then peeled with the teeth, or sometimes grasped under the chin and peeled with the fingers. The cane is dyed-black from the black walnut, red from the dock plant, and yellow from a lime solution-the cane is then peeled a second time. After the second peeling it is ready for use.

Single- and double-weave baskets are made into many shapes and sizes; double weave baskets are made with lids, and their shapes include a carba (square), the trunk shape (rectangular), and a tobacco case. The single-weave shapes include a heart basket, a triangular-shape basket used as a wall basket, square shallow fanning-tray baskets in which cornmeal is prepared; open-weave square sifter baskets; taller square baskets to hold prepared corn, cornmeal, wild fruits, berries, and fish, wall pouches, elbow baskets, bowls, and mats. The trays and sifter baskets were once "nested," but now these are made and sold singly.

The Chitimacha basket makers have kept the traditional colors, shapes, and designs of their baskets alive. Some designs include worm tracks, bulls eye, perch or little trout, blackbird's eye, mouse tracks, bottom of basketry (bow tie), rabbit teeth, turtle with a necktie, dots, muscadine rind, alligator entrails, snake, bears' earring, broken plait, and many others. Certain baskets are made for the sole purpose of being kept by the basket makers because they have the traditional intricate designs woven into them.

At the present time, the future of split-cane basketry among the Chitimacha is not bright. Out of approximately 960 descendants of the ancient Chitimacha Tribe, only four people are active weavers. Most of our younger people refuse to learn the time-consuming processes to prepare the cane, to dye it, and to weave the basket. Some weavers have made attempts to pass their basketry knowledge to the younger generation. I have been teaching my three sons. Hopefully, one day they will pass on the tradition to their children.

MELISSA DARDEN

Thoughts from a Santa Clara Pueblo Traditional Embroiderer

14

Often I am asked if what I do is a dying art? And my response? Absolutely not! Today among most Pueblo peoples, embroidery is not only surviving but in some villages thriving. The artists who embroider include many men, women, and young people as the creators of new and traditional designs on cotton, wool, and other fabrics. The importance of textiles in Pueblo life is what keeps the embroidery tradition alive.

> They are the clothing of the gods and dancers,
> They are the clothing of our sacred spaces,
> our holy places, our homes and us.
> They are symbolic and full of meaning,
> They are powerful and sacred,
> and yes,
> They are beautiful.

For myself, embroidery is a major undertaking requiring a great deal of vision and technical planning. Physically it is hard on the eyes, hands and legs. Work is repetitive and slow. Sometimes it is spiritually and mentally challenging. Often I ask myself, "What am I doing?" It is during these times of stress and frustration that I have to remind myself to "think forward." To "think forward" is to encourage or help lift one's self spiritually to continue working. Visualizing how the finished piece will be used or how it will be worn by dancers often helps to put one back into harmony with one's work.

> Think forward, for here your reward awaits,
> Among beautifully clad buffalo maidens,
> Among beautifully clad corn maidens,
> Among beautifully clad rain maidens,
> Happily they dance.
> Think forward, for here your reward awaits.

It brings great satisfaction and relief when one finishes a embroidered piece. All the hard work of designing, graphing, spinning, sewing, washing, pressing, and of course embroidering is all but forgotten. Anticipation and excitement now follow. For the greatest reward an embroiderer can receive is to see one's creation being used or danced. Embroidery is indeed a labor of love.

As Pueblo people we are truly blessed. We continue to observe, honor, and respect our traditional ways of life. Our endurance, perseverance, and struggle for our way of life has kept the traditions of Pueblo embroidery alive.

SHAWN TAFOYA

PLATE 14.
Breechcloth
Artist, Shawn Tafoya
Santa Clara Pueblo, NM
2002
Cotton, wool; length 48.2 cm
Collected by Lucy Fowler
Williams, 2002
2002-17-3

55

Hearts

COMPASSION AND STRENGTH IN HISTORY AND RESISTANCE

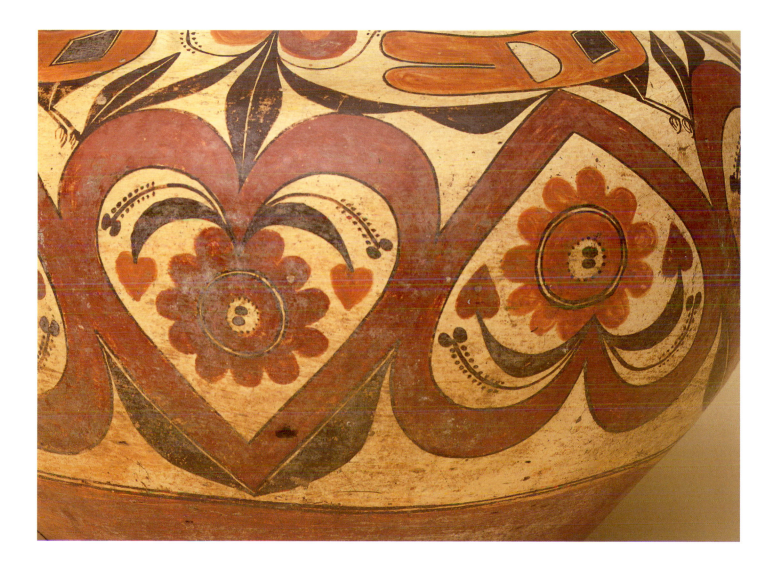

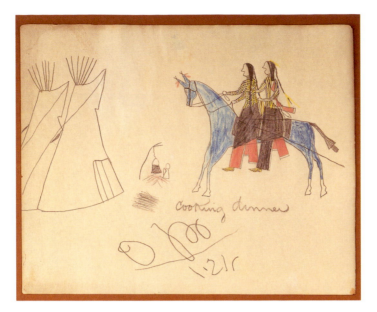

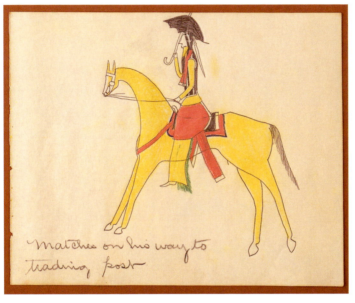

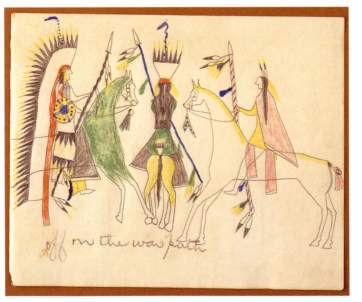

PLATE 15.
**Drawings from a
Sketchbook**
"Cooking Dinner," "Matches
on His Way to Trading Post,"
"Off on the Warpath"
Artist, Carl Matches
(*Chis-I-Se-Duh*)
Tsistsistas (Southern
Cheyenne), OK
1875–79
Paper, colored pencil; height
16.5 cm, width 20.9 cm
Collected by Mrs. E. W.
Lehman, 1875–79
8016

Prison Riders

I ride out of prison
on a painted horse
blue at dinner
yellow at the trading post
green on the war path
forever mounted
in ledger art

I tease your manners
chintz and parasol
the traders
and my resistance
fade with the colors

You name my ride
a true representation
of primitive art
and envy my liberty

My visionary mount
always captured
in prisons and museums
the politics
of expressionism
and the book

Come ride with me
once again
on a blue horse
Franz Marc
Chagall
Kandinsky
Quick To See

GERALD VIZENOR

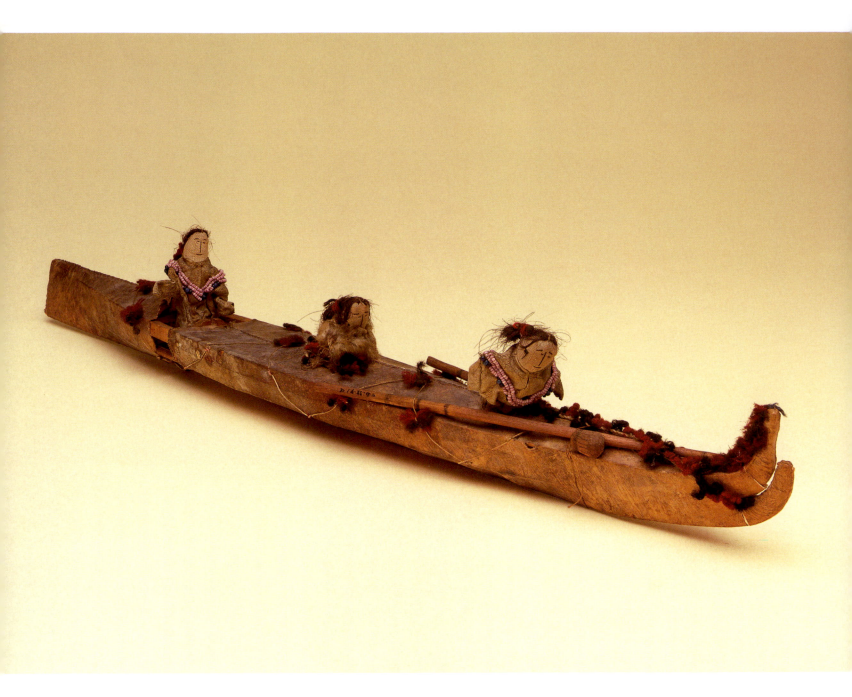

PLATE 16.
Kayak Model
Inuit (Eskimo),
Kodiak Island, AK
Early 20th century
Skin, wood; length 58 cm
Gift of W. Hinckle Smith,
1940
40-33-71, a-d

Kayaktime

Three man kayak!
Did you come with the Russians?

Were you made to transport the lazy
middle man?

What was your role
as *Sugpiat* paddled you across
Shelikov Straights to
hunt the last sea otter
that lone whale
that last great battle

Leaving behind your families
forced to hunt
forced to kill
for nothing in return

Your spruce frame wrapped in seal skin
slid across the waters
carrying the last
of our great hunters
our warriors

Time soaked skins collapsing
under the strain of each stroke
water leaching, pouring in,
consuming your contents

Desperately our men tried
to continue on
desperately, honorably
knowing their time was gone

One by one
they were consumed
by the deep green god

Until only one was left
to share the loss
to pass on the horror
of true contact,
of an honorless war

I write to remember the men who were forgotten because they never returned to Kodiak in
their kayaks. Over 400 kayaks left the island with Baranov in the 1790s to hunt for furs and
war with the Tlingits. Baranov did not allow the men to dry their kayaks out as they traveled
south and as they returned back. With time the sealskins became soaked and gradually fell
apart as they were traveling. Only two men managed to survive to tell of how they watched
their friends drown, knowing all the while if they took on another, they too would not return.

SVEN HAAKANSON, JR.

61

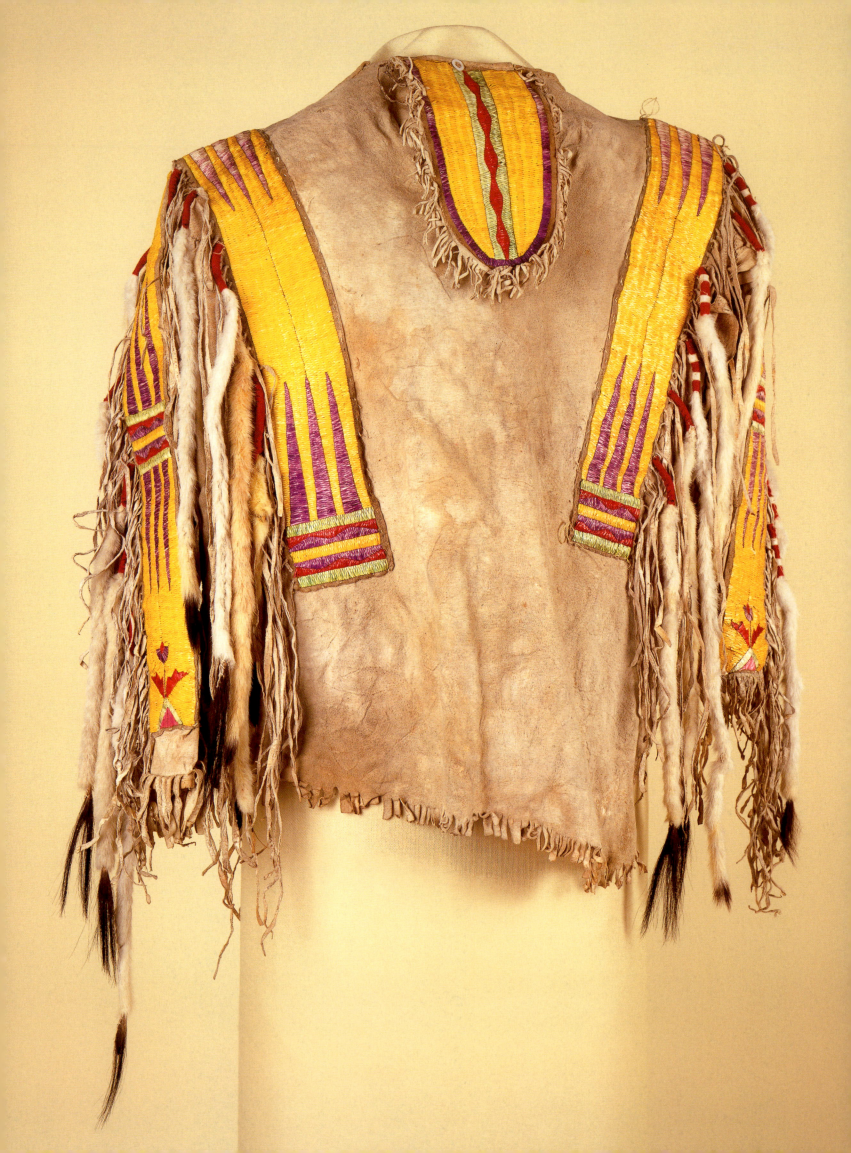

Leather Shirt

For many of us today, the traditional world of the American Indian is where old is better. The long ago world was directed by traditional life styles and values. The males defended the tribe and were hunters and the females did most of the art work and nearly everything else. Because they lived in a similar environment they shared the flora and the fauna and their cultures resembled one another in many ways. The clothing "fashion" reflects the available material. Initially, the clothing they created adhered to the sizes and shapes of certain animal hides. The thick fall hides of the shaggy buffalo worked best for robes in the cold winter, and the thinner, more supple mountain sheep hide was preferred for clothing.

Two mountain sheep hides comprised the body of this classic shirt. With the soft tanned hides placed as if the animal was standing on it's back legs, flesh side inside, with the sleeves sewn or laced to the body and ties holding it together on the bottom of the sleeves and sides. Worn like a poncho the garment could be enhanced with paintings of heroic deeds or decorated with strips of quillwork and the skins of worthy animals. When the pony beads arrived in the early 1800s they eventually replaced the quills, but some tribes maintained their usage of this material long after the smaller seed beads began to replace the pony beads.

This leather shirt is an ideal example of an early traditional shirt, although the animal's leg tabs do not drape and hang down around the "hem" like the earlier styles. This shirt design has been collected from most Plains Indian tribes. The front and back can be difficult to determine unless one places the item in such a position that the arm fringes can hang freely- they always hang toward the back, avoiding entanglement with the arm and gracefully enhancing movement. The tubular fur appears to be ermine skin, a popular American Indian decoration. The strips are porcupine quills embroidered on decorative strips that are strategically sewn on the arms and main body of the shirt.

This shirt is identified as "Quilled Leather Shirt (War), Aidotsa- Wyoming, Circa 1900, Collected in Yellowstone Park, Wyoming, 1920". It would be more accurate to state that this item was probably created at least 20 plus years earlier near Ft. Berthold, North Dakota by one of the Affiliated Tribes who live there, perhaps the Hidatsa.

GEORGE P. HORSE CAPTURE

PLATE 17.
War Shirt
Plains
Ca. 1900
Mountain sheep hide,
porcupine quills, ermine
skin; length 79 cm
Collected at Yellowstone
National Park, WY, 1920
62-16-2

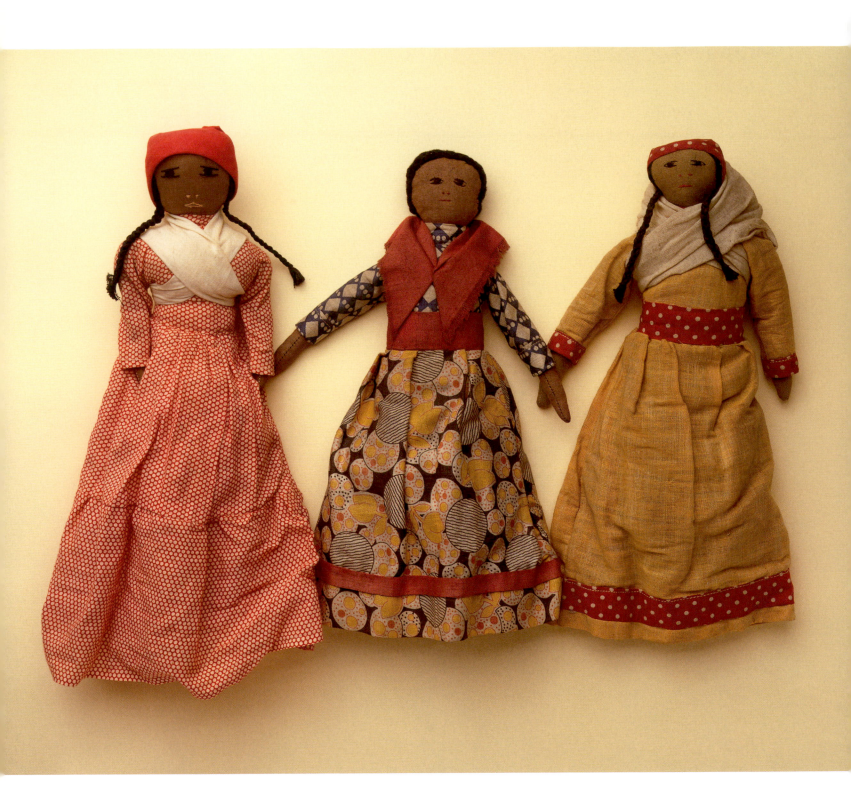

PLATE 18.
Dolls
Cherokee, NC
Early 20th century
Cotton calico cloth
70-9-794 (left), height
30 cm, bequest of Samuel
Pennypacker, 1969; 46-6-127
(center), height 28 cm,
46-6-128 (right), height
29 cm
Collected by Frank G. Speck
and John Witthoft, 1932–40

Waiting

I had had a particularly hard week in my job as a professor of American Indian Studies. One of my students had called me a "dumb Indian." This came shortly after another student had pointed out that "There is a natural order to things and the white man won. He conquered you Indians and you just need to get over it." This student and I had a conversation in front of his 67 classmates about how things were never quite that simple and that what it means to be "conquered" is quite different depending on from whence you look.

I came home, snuggled with my one-year-old, and I lay down. I fell asleep. As I slept, I dreamt that an old woman from the mountains of North Carolina came to me. This woman told me a story and asked that I pass it on to you:

One day, three sisters went walking in the woods looking for berries, acorn, and bark. They kissed their mother and father as they walked out the door and told them that they would see them before the sun was down. While they were out, they encountered a man with yellow hair and eyes the color of the sky over Grandfather Mountain on this warm, fall day. This man promised the sisters "civilization" and spoke to them of a one true god. The sisters nodded politely and tried to be on their way, but the man forced himself to be heard. He took the sisters away and put them in school, even though they already knew how to read. Their newspaper, *The Phoenix*, was read by almost everyone at home. The man and his friends cut the sisters' hair and forbade them from speaking their "savage" language. Eventually, the man split the sisters apart, moving one to Oklahoma, another to Georgia, and the third to Pennsylvania.

At home, their mother waited for them and prayed to her own god. She waited for many years, grew old and feeble, and mourned the death of her husband who never recovered from the loss of his three girls. Mother cried for her daughters to come home; they never did.

Mother went out to the same woods where her daughters were last seen; she lay down and went to sleep. She dreamt of her daughters in a place with tall buildings, lots of noise, and stuck in a place from which they could not escape. She longed to be with them. When she awoke, she was beside her three daughters—together, at last—behind glass and in drawers . . . waiting. Waiting to come home.

BRYAN MCKINLEY JONES BRAYBOY

PLATE 19.
Bowl and Jug
Isleta Pueblo, NM
Late 19th century
Clay, pigment
Collected by Amos H.
Gottschall
Gift of Academy of Natural
Sciences, Philadelphia, 1998
L-85-842 (left), diameter
19.6 cm; L-85-873 (right),
height 15 cm

Where Memories Exist, Sleeping Dogs Lie

The year was 1879. The newly hammered steel rails of the Atchison, Topeka, and Santa Fe Railway had reached the Tiwa-speaking Pueblo of Isleta. The railroad threaded its way alongside ancient Pueblos, colonial Spanish towns, and proto-Anglo settlements. But when the Atlantic and Pacific Railway crews began construction of a westward spur on the outskirts of Isleta, villagers protested the unwelcome advance. In the darkness of night, they tore up portions of the track.

Legend says that railroad officials dispatched the Mission's priest to stave off the trouble. The flushed padre trudged into the village with a wheelbarrow brimming with gold and silver coins. The money, along with a brokered deal that gave Isletans free ridership, ended the protest.

Isleta became a whistlestop like no other. The locomotives idled beside the little Isleta depot, replenishing their powerful steam boilers while waiting for oncoming trains to clear the route. With little else to do, train passengers gawked at statuesque native women bedecked in ornate shawls, black mantas, and white deerskin moccasins.

The women plied the passenger cars with bowls of aromatic breads, hand-picked grapes, apples, and peaches. For want of a spare penny, emboldened children shook the hands of amused Easterners and giggled. Scraggly dogs slept in the cool of the shade.

The trains parked alongside a unique settlement called Orai'bi. In 1880, Keresan-speaking traditionalists had fled Laguna Pueblo and were enjoined by Isletans to resettle next to them. Protestant missionaries and zealous Indian converts had made their lives unbearable. At Orai'bi they immediately found solace under the shade of verdant cottonwoods that dotted irrigated fields.

They quickly adapted to their new sacred surroundings. Among the skills that Laguna women ushered forth was pottery making. Unlike the Tiwas—who had long given up this art in favor of neighborly trade and barter—they found that souvenir-seeking train passengers provided a ready market.

Sacred designs and large utilitarian ollas quickly gave way to fanciful designs and smaller basket-bowls. The decorations became distinctively floral, mimicking the harvest plants of Isleta. Polychrome dots harkened images of seeds, and lacy eyelets were fashioned into the shape of leaves. Furrows hewn in irrigated cornrows were drawn into intricate hatchmarks. Like snowflakes, no two pots are exactly alike.

After WWII, this curious enterprise waned. After several generations, Orai'bi children assimilated into Isleta lifeways. Farming was displaced by wage work. People no longer traveled on trains. And when the tiny Isleta depot was finally razed, basket-bowls and scraggly dogs disappeared altogether.

TED JOJOLA

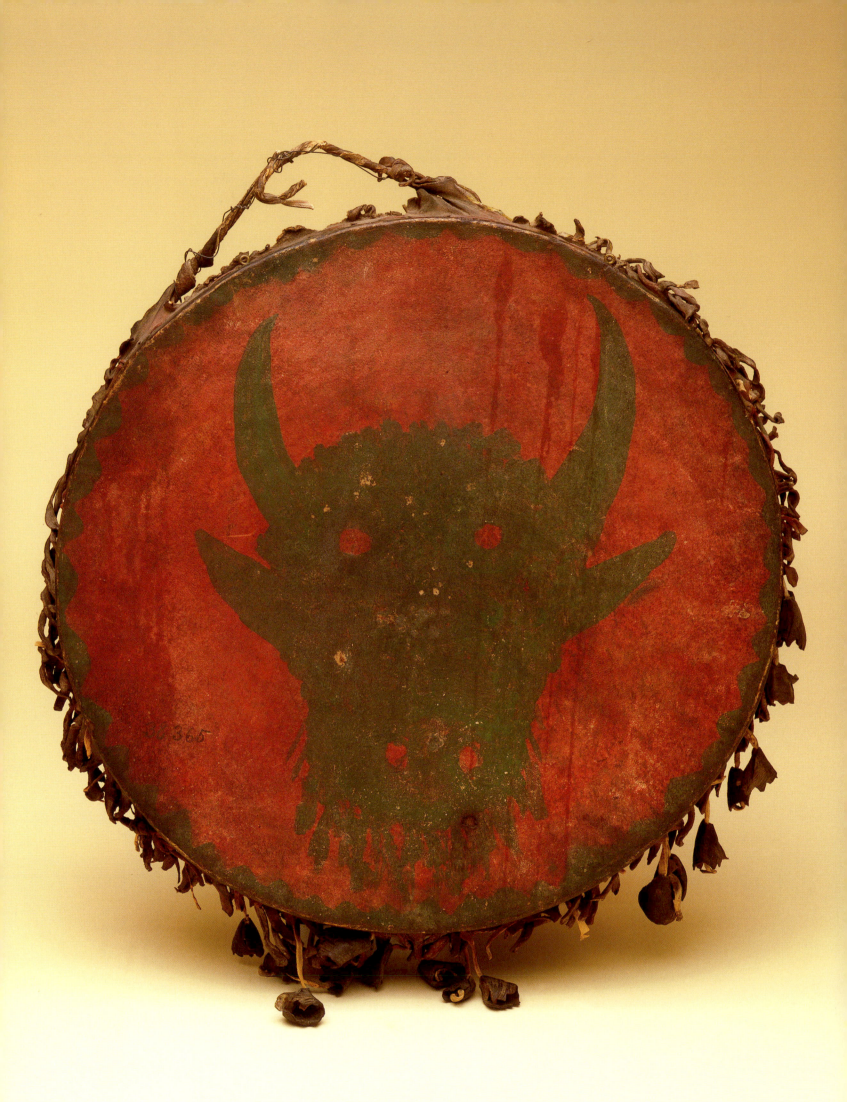

A Tale of Two Drums

This drum was made by a skilled artisan who laced two rawhides over a wooden frame to create a double headed drum typical of many groups in the northern Plains. He used at least two thongs simultaneously to secure the two hides in place, very taut in order to create a surface that would produce a sound. When in use these drums are tuned by placing them close to a heat source which tightens the rawhide and creates a higher pitch. Once the two hides were in place the edges of the hide were cut into fringes, which dried hard in place. The entire surface of one or both sides may have been painted at this time, although that is uncertain.

At some point, this drum seems to have come into the possession of George Catlin, the famous American artist who visited and painted images of many tribal peoples of the Great Plains 1830–36. Catlin took his paintings on tour in the eastern United States and later in Europe and was initially a great success artistically and financially. He collected native objects while he visited the tribes, and these were exhibited as part of his "Indian Gallery." There is circumstantial evidence that this drum was in Catlin's collection since it is associated with Thomas Donaldson who rescued the Catlin collection by paying the latter's debts and then shipping the paintings and objects to the States where it was held in storage for years.

The strongest evidence for the Catlin association, however, is the artist's additions to the original drum. On one side he painted a buffalo head, complete with chin beard, round eyes, and nostrils, and on the other side appears an eagle painted with a brush and in a style that smacks more of the Euroamerican artist and less of the Indian. The buffalo head depiction is identical to others produced by Catlin so there is no doubt of its creator. On both sides he painted a meandering line which is consistent with other Catlin collection items and is clearly by his hand. Apparently, Catlin felt the need to augment the initial decoration of this piece, perhaps to add more color or drama to his public presentation.

So this drum was created by one artist and redecorated by another. Used originally in native social life and then as a means of public presentation and entertainment in America and Europe, this drum has witnessed many different scenes. If only it could talk.

JOALLYN ARCHAMBAULT

PLATE 20.
Drum
Piegan Blackfeet
Ca. 1830
Hide, pigment,
deer dewclaws;
diameter 40 cm
Collected by George Catlin,
1830–36
Thomas C. Donaldson
Collection
Museum purchase, 1901
38365

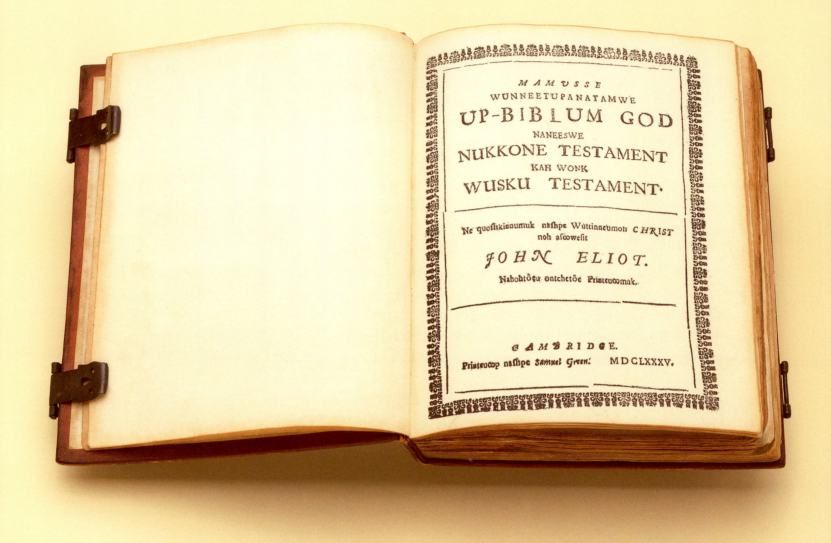

Bibles in Dead Languages

In 1658 John Eliot completed his translation of the Bible into the Massachuset language. It would be the first Bible printed in North America. The Eliot Bible is rightly treasured as a valuable piece of American cultural patrimony. On one hand, it has great value as tangible property because it is one of the rare surviving originals printed in Cambridge, Massachusetts, in 1661-63. On the other hand, as intangible property, its value lies in the fact that it is a *Bible*. In a country that stamps and prints its money with "In God We Trust," sings "God Bless America" in public events, and continually begs "so help me God," it is understandable that the Eliot Bible is highly valued as an icon of American foundational ideology.

However, the Bible must also be seen as an icon of the Massachusetts Bay colony's treatment of the native peoples of New England. Titled "*Mamusse wunneetupanatamwe Up-Biblum God: naneeswe Nukkone Testament kah wonk Wusku Testament / ne quoshkinnumuk nashpe Wuttinneumoh Christ noh asoowesit John Eliot; nahohtôeu ontchetôe printeuoomuk*," the Bible was a tool for delivering the Christian faith to the Massachuset people. John Eliot's evangelical work may have saved their souls but it did not save the people. Warfare, smallpox, evangelization, and assimilation precipitated the disappearance of the Massachuset people. Today, the Bible remains as one of the few pieces of tangible evidence of the Massachusets. Fortunately, the Bible preserved their language. Unfortunately, the language conveys not Massachuset ideals but Christian ideals. Consequently, the Bible is a text written in a dead language for a dead people. It is an icon of the "original" American Christian evangelization, Euro-American civilization, and assimilation programs inflicted upon American Indians for the last 400-plus years. In those years many American Indian languages and peoples have disappeared, and the survivors are in varying degrees of endangerment.

As an Indian and an anthropologist working to revitalize American Indian languages I regard Bibles written in dead languages with ambiguous esteem. Rather than esteem for the dead, I prefer esteem for the living. We must have the same high esteem for living American Indian peoples and languages as we do for the Eliot Bible. We must learn the complex histories of objects such as the Eliot Bible. We must recognize the ambiguity of esteem so we can truly appreciate such "objects of everlasting esteem."

BERNARD PERLEY

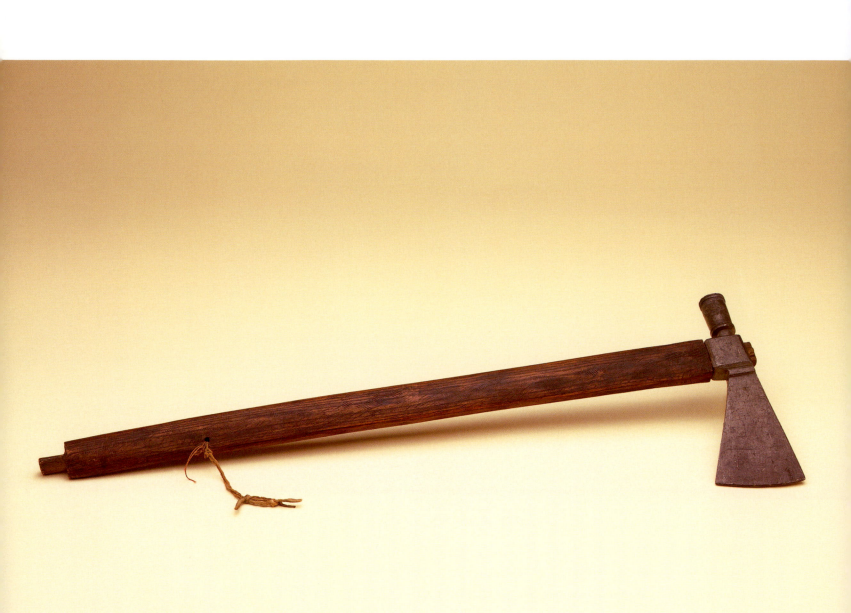

PLATE 22.
Pipe Tomahawk
Anishnabe (Ojibwa),
Leach Lake, MN
Late 19th century
Wood, metal; length 60.9 cm
Collected by Amos H.
Gottschall
Gift of Academy of Natural
Sciences, Philadelphia, 1998
L-84-2121

The Council Pipe

This special pipe was used by the Anishnabe people as a voting tool. Whenever an important decision was to be made, the tribal leaders would all sit down in a circle to engage in discussion. They brought this pipe with them when they needed to make a decision on going to war or making peace with an enemy. After everyone had spoken and the discussion was over, each member of the tribal council would cast their vote by putting their pipe into the ground in front of them. If the decision was to fight, the bowl of the pipe would be put into the ground and the hatchet side would face upward. If the decision was to make peace, the pipe bowl would be facing upwards and the hatchet side buried into the ground.

STEPHEN J. JOHNSON

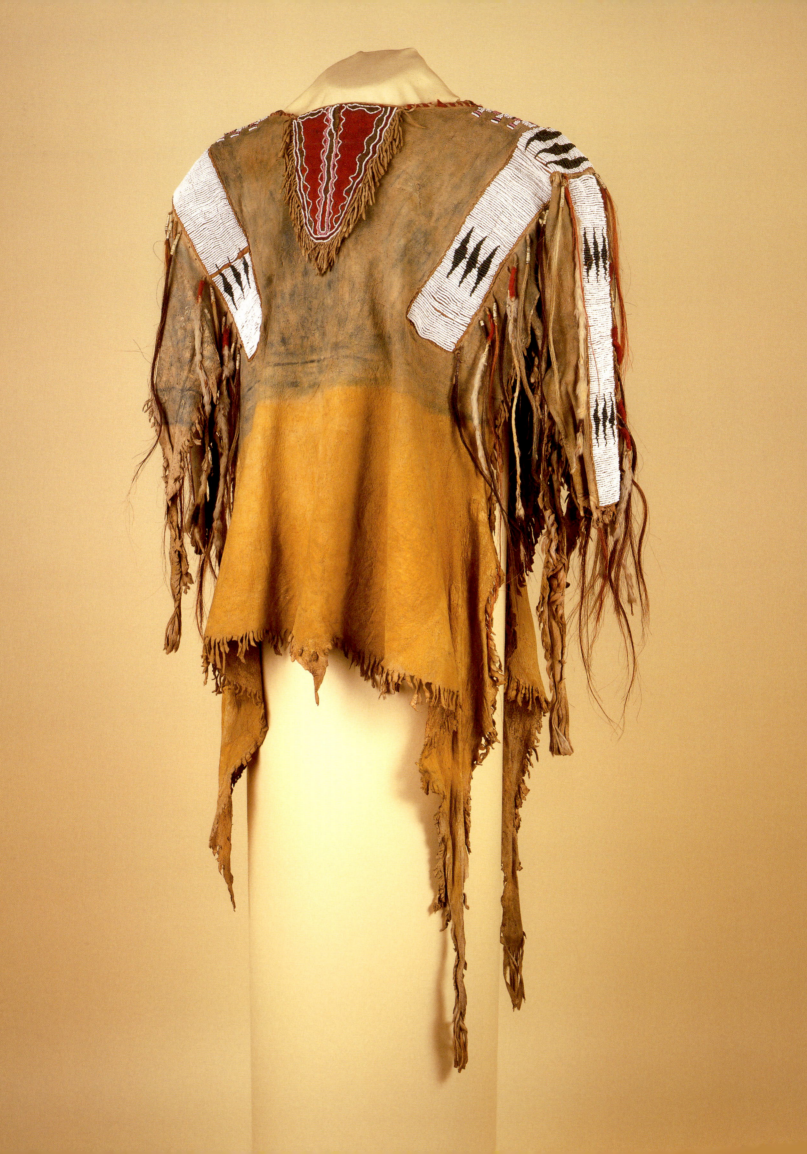

In a Flowing World

Shirts like this Pawnee war shirt just naturally inspire us to ponder aesthetic, cultural, and historical matters. But studying a photograph of it, I am drawn first to its physical emptiness. To fill it, I try to visualize its maker at work and the person for whom it was made.

Unfortunately, the sparse documentation for this shirt does not identify any past Pawnee owner. We learn that it entered the University of Pennsylvania Museum with the Thomas Donaldson Collection and that it had been "collected by McNeal" in 1878 at the Pawnee reservation in Oklahoma Indian Territory.

This mysterious "McNeal" must have been General John McNeil, a Missouri Civil War veteran and an inspector for the Office of Indian Affairs from 1878 to 1880. In 1876 McNeil served as the Missouri commissioner at the Philadelphia Centennial Exhibition, where he had the opportunity to meet Thomas Corwin Donaldson, commissioner for Idaho.

In 1878, McNeil visited the Pawnee reservation in Oklahoma. The tribe had recently removed from Nebraska, and upon settling in their new homeland, hundreds of people were immediately swept away by "ague" and "malarial" diseases. Removal also demolished the Pawnee economy, forcing the tribe to rely on funds from the sale of their Nebraska reservation. Some of this money was used to purchase clothing, which many Pawnees—in desperate straits—then sold in nearby Kansas towns. They were essentially buying clothing from Americans and selling it back at bargain prices.

The Pawnee agency floundered in administrative turmoil during these early years in Oklahoma, and in the late summer of 1878, McNeil was dispatched to the agency. He probably acquired the Pawnee shirt during this inspection tour, and subsequently passed it along to Thomas Donaldson. It has since dwelt in Pennsylvania.

When this shirt was made, the lives of Pawnees and Americans were already flowing together. Throughout the 19th century, the two nations became enmeshed in expanding political, economic, and cultural interfaces. By the 1870s, Pawnees were regularly collecting beads, fabrics, and other materials from the Americans to display in clothing, while Americans were collecting Pawnee-made objects to exhibit in museums.

The year after this shirt left the Pawnee homeland, young Pawnees began leaving for American boarding schools, foreshadowing the coming dispersion of Pawnees throughout the American world. New configurations of culture were in progress by the end of the 19th century, jointly shaped by the intentions of both Pawnees and Americans. This shirt may look empty, but it is filled with the world that gave rise to 20th century America.

ROGER C. ECHO-HAWK

PLATE 23.
War Shirt
Pawnee, OK
Ca. 1850
Deerskin, wool, beads, horse hair, ermine; length 109 cm
Collected by McNeal, 1878
Thomas C. Donaldson Collection
Museum purchase, 1901
37997A

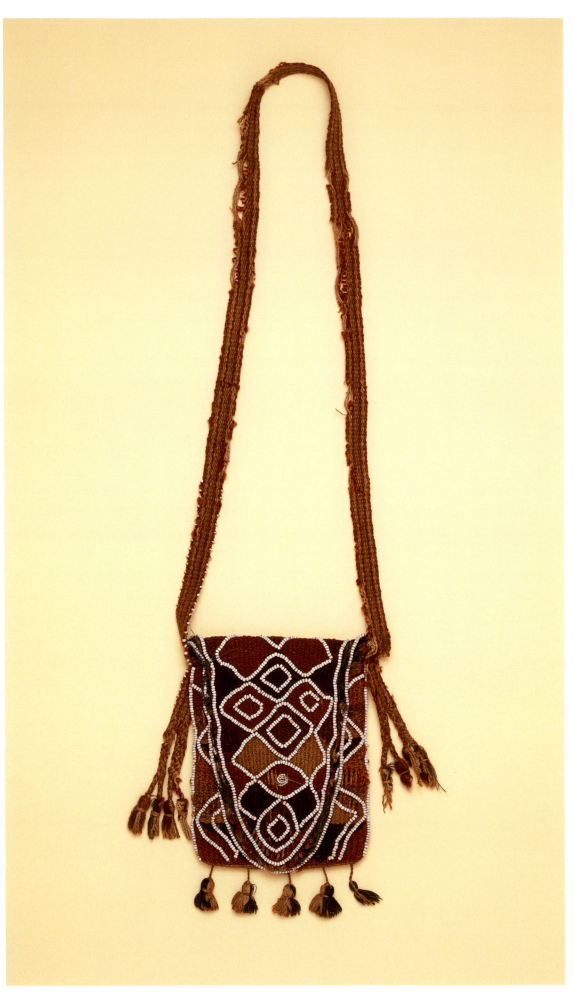

PLATE 24.
Bandolier Bag
Seminole, FL
Ca. 1850
Plant fiber, wool, beads;
length 69.8 cm
Charles H. Stephens
Collection
Museum purchase, 1945
45-15-817

24

ave mixed feelings about "Indian artifacts." On one hand, museums preserve old objects o that successive generations may enjoy them and picture the cultures that preceded them. These remnants of another time foster a temporal continuity, connecting past and present in a way that shows reverence and respect for our ancestors. By collecting everyday objects, we witness life as it may have occurred long ago, and we imagine how these things, once useful, may fit into the rhythms of our contemporary lives. Through the preservation of things once used and loved, we allow the voices of our forebears to speak across time.

On the other hand, anything that is to be considered an "artifact" must necessarily have outlived the people that once possessed it. For Indian objects in particular, I always balk at the cultural fantasy of the inanimate objects surviving the fateful demise of the "Vanished Race." In this way, the only remnants of this disappearing culture exist under glass in museums. In direct contrast to the contemporary Indians that live, work, and shop in cities and towns, the archived objects discreetly dictate a cultural authenticity that privileges the past over the present. No matter the tribe, time, or place, the enclosed object is the modern American's permanent example of Indian culture: Many Nations, Under Glass, with Nostalgia and Romance for All.

I wonder about museums of the future, and what kinds of objects would be included in a museum of Indian objects. It also brings a smile to my face to think of objects that belonged to Indians but challenge the expectation of what is "Indian." I imagine my Seminole ancestors in Florida wearing brightly striped calicos, carrying beaded bags, and covering their feet with moccasins. But what about more recent generations? Who would be interested in the dulled butcher's knife from my grandfather's grocery store that my mother refuses to throw away? Or my mother's first pair of shearing scissors in which she inscribed her name: NOBLE? Or the computer that stores all of my writings? It is these cherished objects, like those of my predecessors, that will carry our voices to the ears of our descendants.

KEVIN NOBLE MAILLARD

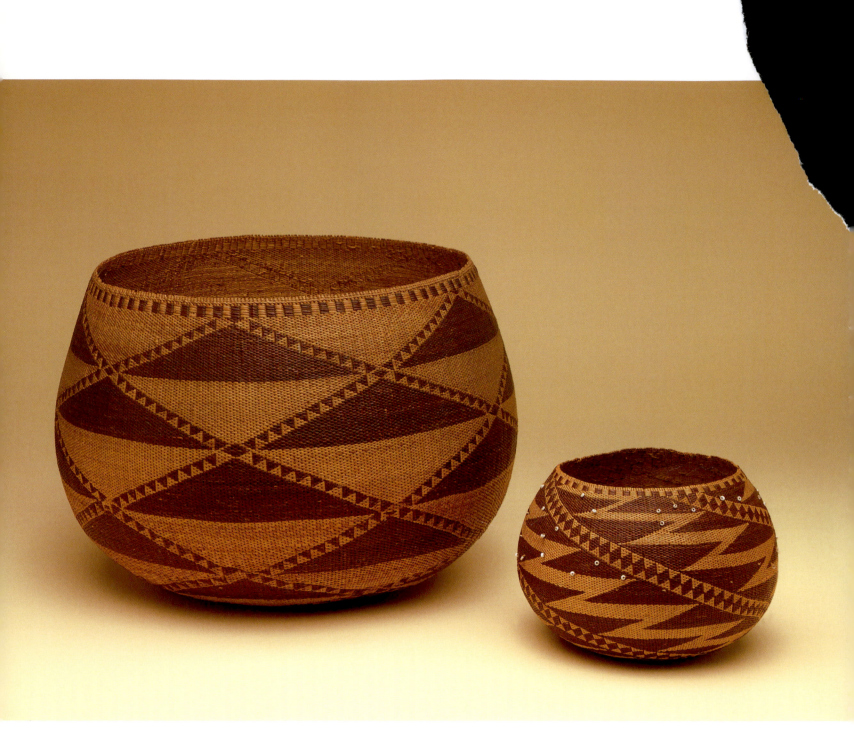

PLATE 25.
Baskets
Artists, Mary Knight
Benson (right), Louisa
Rickabaugh Riggs (left)
Pomo, CA
Ca. 1895–1900
Sedge root, willow,
and redbud
NA7911 (left), height
24.7 cm, Deisher Collection,
Museum purchase 1918;
NA2065 (right), height
13.3 cm, Plimpton Collection,
Museum purchase, 1907

Pomo Twined Baskets

These two Pomo baskets are mush bowls. Their main weaving material is sedge root, the foundation rods are willow shoots, and the sienna colored weaving material is redbud shoots. The smaller basket is attributed to Mary Knight Benson, from the Yokayo Rancheria in Mendocino County, California. She is arguably the best-known Pomo basketmaker, circa 1895–1905. The larger one was made by Louisa Rickabaugh Riggs, also known as "the wife of Chief Liquid Eye," Upper Lake Rancheria, Lake County, circa 1895–1900.

This pair of Pomo mush bowls was constructed using a very different weaving technique—diagonal twining—than the coiled Pomo basket (Plate 8). Diagonally twined baskets have a smooth, shiny finish, a surface as pleasing to the hand as it is to the eye.

Both these baskets were created to be sold. They came to Philadelphia, far from the hands that made them, to live in the homes of wealthy Eastern basket collectors. In this process they provided their weavers with a livelihood, during a time when it was very difficult for Pomo Indian women to find any type of paid work beyond that of back-breaking, low-income farm labor.

SHERRIE SMITH-FERRI

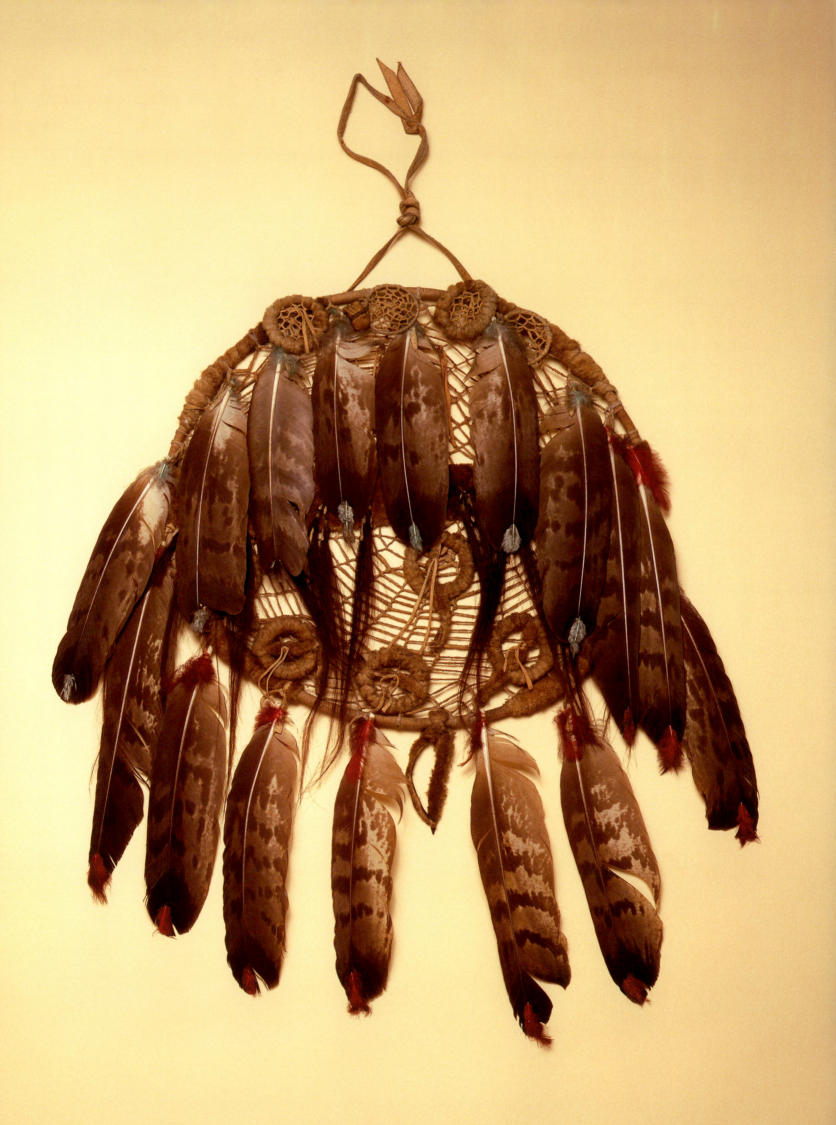

Spiderweb Shield

The Lakota maker of this shield was gifted with artistic vision and skilled craftsmanship. He was certainly male, as no woman in this time period (1930s) would have made such an object. The shield is typical of many such "traditional" creations that were produced for an external market in the post World War I period.

The shield is based on earlier protective amulets that were much smaller in size (2–3"). The spider and its web were imbued with protective power, associated with thunder, and its image was painted on hide robes and shields. Small rings with webbed interiors like those on this object contained the spider's power and both painted images and hoops protected their owners from harm.

Several clues suggest that this shield was made for sale and not ceremonial use. The hoop is made of heavy metal, probably iron, which was not used for ritual purposes and would have been too heavy to be used as a dance shield. The otter skin was commercially tanned, cut, pieced, and sewn into larger pieces with a sewing machine, yielding a smooth surface that only a professional furrier could produce and was probably taken from a coat or jacket. The bunches of black hair attached to the otter strip are horse, not buffalo or human which would have been the case if the shield had been a religious item. Webbed hoops that contained spiritual power were always small and were tied to medicine bundles or personal objects or the head where their protection would have been immanent. A hoop of this size with smaller ones attached to it is a creative innovation by someone familiar with older forms who then enlarged the size of an ordinary spider web and combined it with the format often found on shields (horizontal stripes, eagle feathers attached to the circumference, hair pendants, a small "medicine" pouch).

This piece illustrates the creative vigor that was and continues to be a feature of Lakota culture and art. Older forms are reinterpreted and made anew as each generation creates its own version of tradition and commerce. The original symbolism of a protective device is visible to any knowledgeable viewer but so are the changes and materials that signal an object made for sale.

JOALLYN ARCHAMBAULT

PLATE 26.
Shield
Lakota (Sioux),
Standing Rock or
Pine Ridge Reservation
Late 19th/early 20th century
Iron, string, hide, feathers;
length 83 cm, width 55 cm
Gift of Dr. Samuel W.
Fernberger, 1938
38-1-1

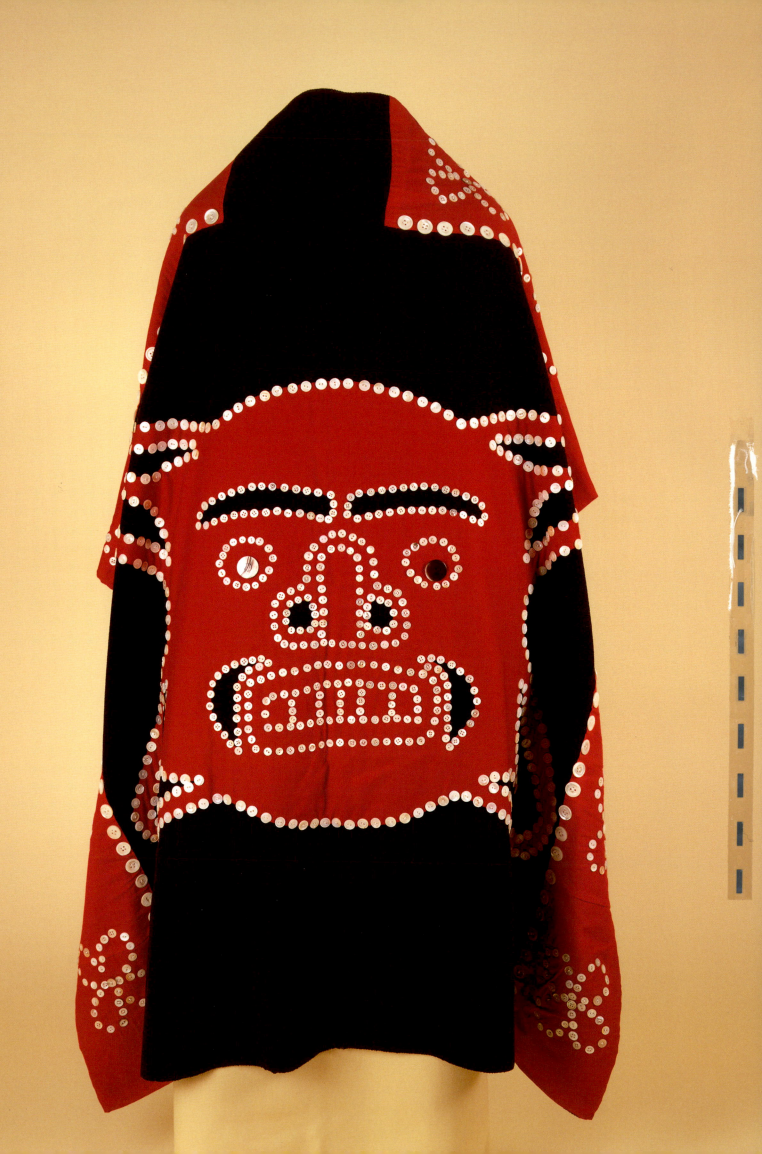

The Contemporary Execution of Ancient Ideas

27

Button blankets did not exist prior to contact with the Western world. For this reason, collectors of the late 19th and early 20th centuries prized "authentic" indigenous objects such as masks, rattles, boxes, and houses far above the collection of blankets though by this time blankets had been fully integrated into the culture of the Pacific Northwest Coast Peoples.

Unfortunately, button blankets, and their associated forms such as aprons and tunics are not well represented in Museum collections. Yet, the button blanket is an invaluable example of how a thriving culture can absorb introduced materials and convert them for their own purposes, posing fascinating questions regarding the relationship of cultural ideology and material manifestation that certainly merits a more in-depth analysis. Perhaps, as well, part of the institutional neglect was due to the fact that blanket making was mostly a women's prerogative.

Well-conceived blanket compositions are no less great art than well-conceived masks, poles, and paintings, and much of my own artwork has been inspired by their complexity.

MARIANNE NICHOLSON

PLATE 27.
Button Blanket
Artist, Gertrude Dick
Kwakiutl, Alert Bay, BC
Wool, buttons; length
60 inches, width 56 inches
Collected by Ruben Reina,
1994
94-15-16

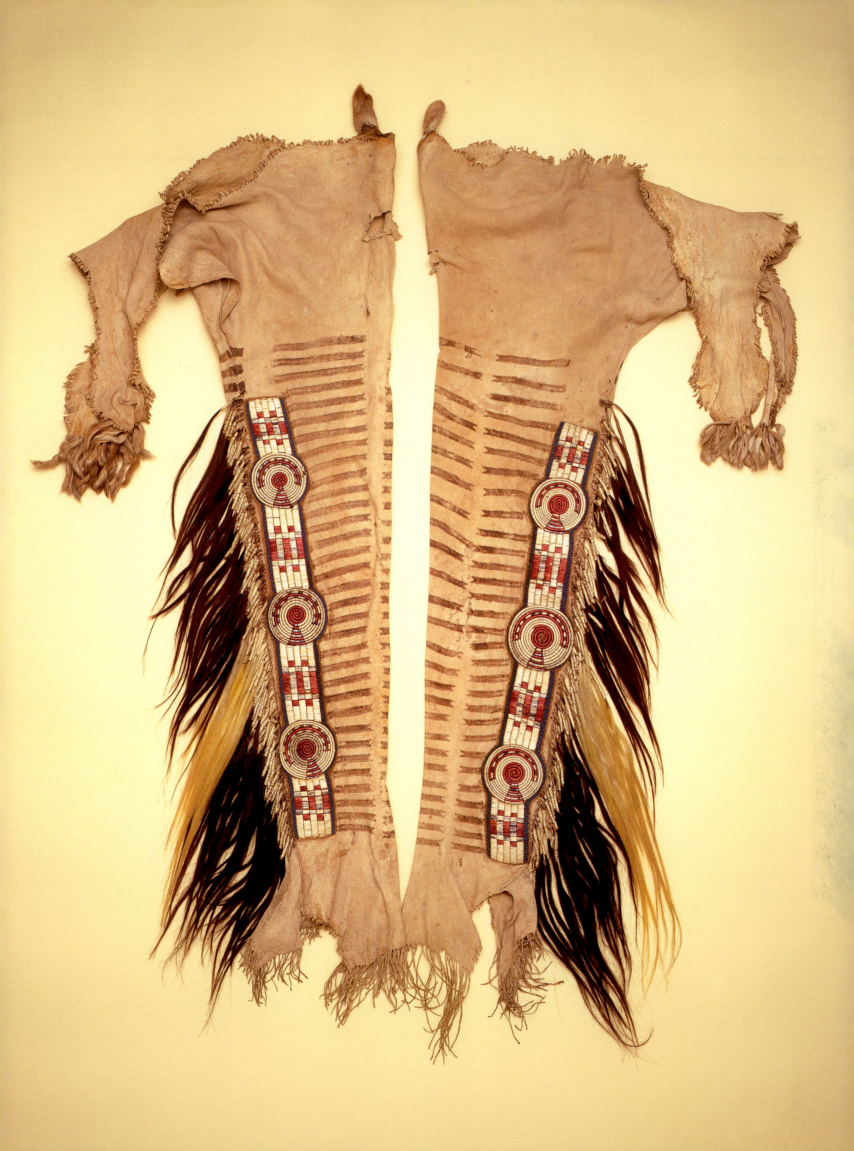

Dog Soldier Leggin's

Inanimate; intrinsic; thing; object; are some of the hollow words used to characterize the Dog Soldier leggin's that you once wore so proudly.

Others have referred to your Dog Soldier leggin's as a funerary object, object of cultural patrimony and or a sacred object.

We live in the world of beings.
In the world of beings we are merely the human beings.
We believe that all beings have a life spirit.
That spirit emanates and permeates from and through our world.

Your Dog Soldier leggin's retain a part of your spirit
along with the spirit of the deer which gave of itself.

Gifts from other beings and from grandmother earth helped you to properly adorn your Dog Soldier leggin's.

You, in turn blessed those leggin's with words of prayer;
words that came in a dream from the Creator.

The people looked upon your leggin's with admiration,
They blessed you and the other Dog Soldiers with their
 songs of protection.

The essence and energy of the world of beings was sewn into every stitch that ultimately gave birth to your Dog Soldier leggin's.

The spirits living in those Dog Soldier leggin's became a part of you as they merged with your spirit that first day you put them on.
They came to life as you became one.

Those Dog Soldier leggin's protected you from the elements and kept you from harms way as they brought you home safely after each outing.

How can we help them to understand that your Dog Soldier leggin's are more than mere things; funerary objects or cultural patrimony and that they need to be brought back to the land of your spirit.

L. BUDDY GWIN

PLATE 28.
Leggings
Mandan, ND
Ca. 1830
Buckskin, porcupine quill, pigment, horsehair;
length 106 cm
Thomas C. Donaldson Collection
Museum purchase, 1901
38251B

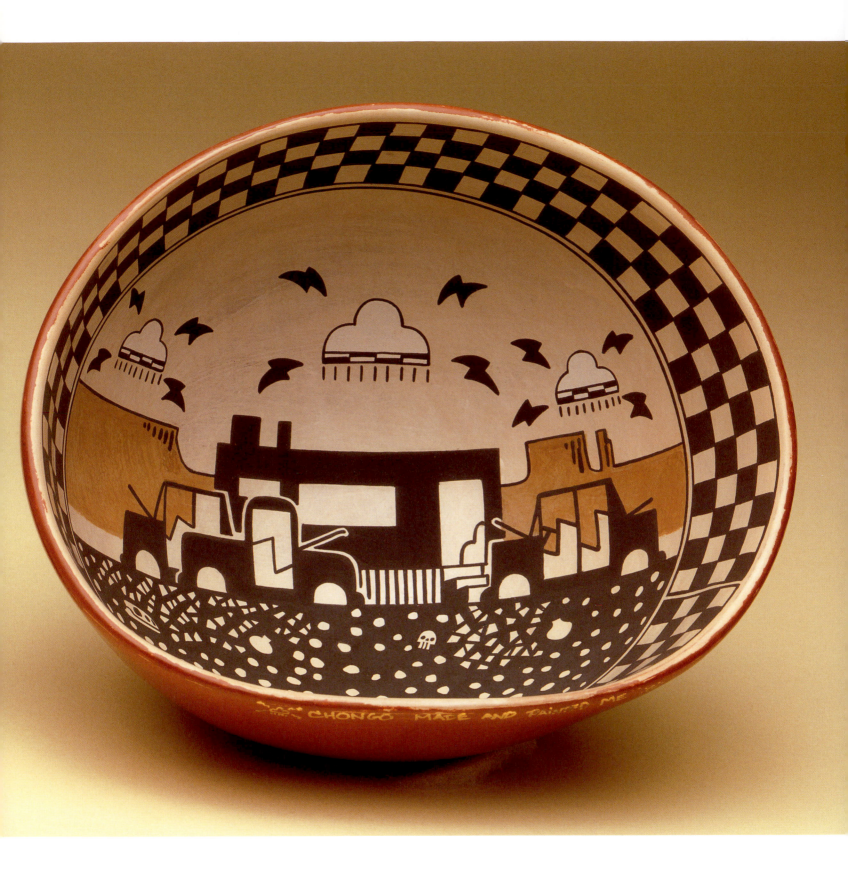

PLATE 29.
Bowl, On the Rez
Artist, Diego Romero
Cochiti Pueblo, NM
1997
Clay, pigment;
diameter 21.7 cm
Collected by Lucy Fowler
Williams, 1999
99-9-8

On the Rez

My pot "On the Rez" addresses an ongoing dialogue concerning the ever-changing and not so ever-changing landscape and man's relationship to it. This particular view is of Santa Clara canyon, but it is generic in the sense that it could be any canyon and any particular rez. The trailer as well as the abandoned cars and rain clouds are portrayed in a language of symbols and metaphors rather than actual literal interpretations. They sit above a cut-away view of the earth and the scattered bones of the ancestors. It thus emphasizes the landscape, time, and man's place within these constructs.

DIEGO ROMERO

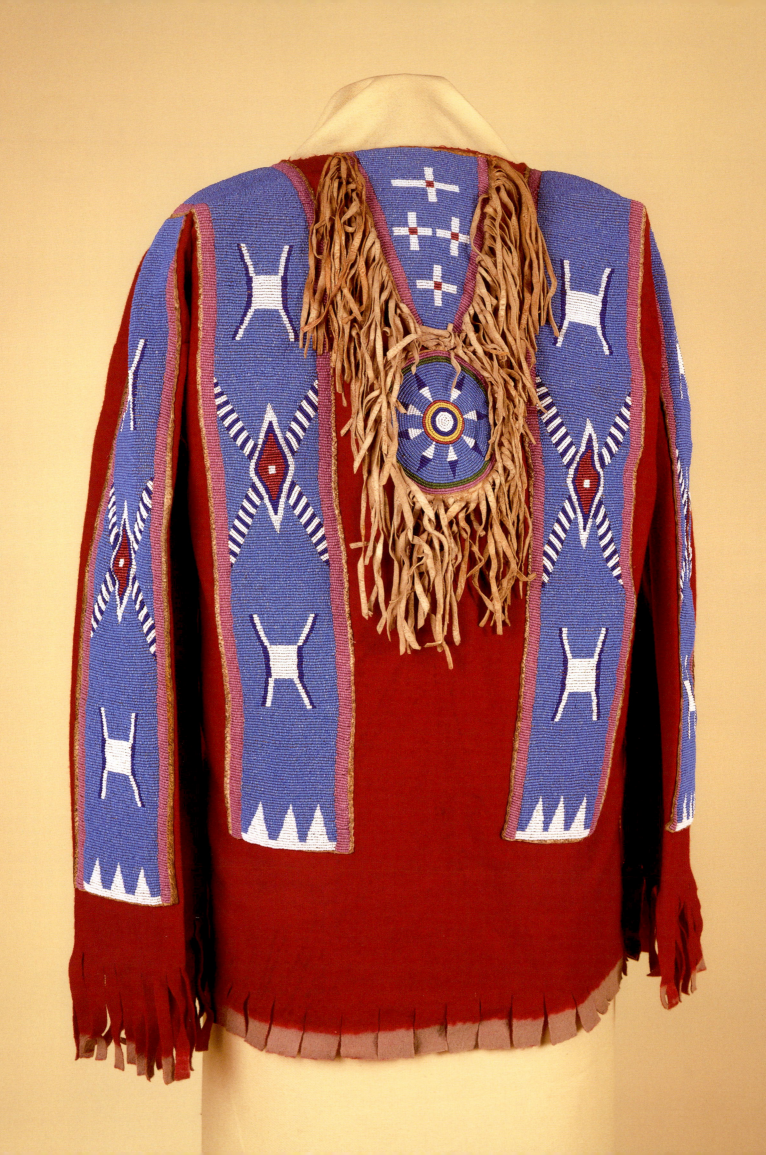

Red Shirt

Some Plains Indian rock art and early European painters, such as Karl Bodmer and George Catlin, recorded that many of the Plains Indian people of the early 1800s often did not wear shirts of any kind, instead preferring to keep their "fighting arm" (the right arm) unencumbered and bare with a tanned buffalo robe or blanket around their body and over the left shoulder. These hardy people probably preferred freedom of movement over an encumbrance. Only when the trade goods arrived was there a dramatic change in clothing style.

The red shirt is recorded as "Shirt, Gros Ventre, Blood- Alberta, Canada, Blood Indian Reserve. Charles H. Stephens Collection from Mrs. Owen Stephens." As a tribal member of the Gros Ventre *(A'aninin)* Indian people of Montana, this item and identification is quite interesting to me. The red wool is a trade material frequently used by the Indian people as soon as it became available. The bead colors, design elements and construction do relate to a Northern Plains origin.

The association with the Blood Indian people of Southern Alberta is unknown to me. My son Joseph, a curator at the Minneapolis Institute of Art, agrees that this shirt was made in Northern Montana, most likely on our Reservation, Fort Belknap, but we may never know the exact tribal creator because the two resident tribes, the A-aninin and the Assiniboine, have lived there together since the 1880s.

GEORGE P. HORSE CAPTURE

PLATE 30.
Shirt
Gros Ventre, AB, Canada,
Blood Indian Reserve
Ca. 1900
Wool, hide, glass beads;
length 72 cm
Collected by Charles H.
Stephens. Museum
purchase, 1945
45-15-256

89

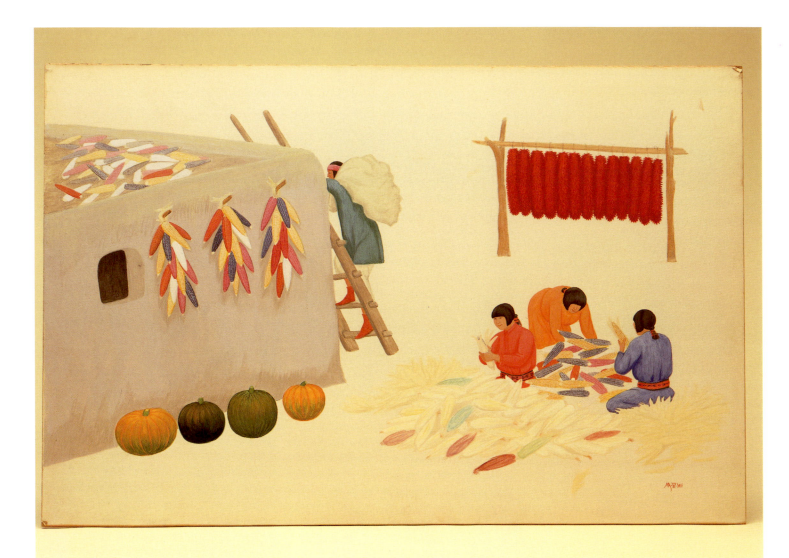

PLATE 31.
Painting
Artist, Velino Shije Herrera
(Ma Pe Wi)
Zia Pueblo, NM
Ca. 1930
Cardboard, pigment;
width 58 cm
Collected by Ann Rowland,
1930
Gift of collector, 1977
77-6-4

Moonlight Woman's Daughter

31

Harvest comes late this year, the year Moonlight Woman's baby died. We pressed corn gruel in between her lips, her head felt like it was on fire. In the end, we moistened scraps of textiles with water from cool pots and pressed them against her lips. Everything has become shit since the coming of the Clanking Metal People.

Arrow Boy spoke up against the thefts, the lies. He was taken in the night. We have not seen him again. Not long after, Moonlight Woman was taken to the stronghold of the Metal People, to serve as a slave. Her husband spoke up, and his foot was taken as well. The image of the crossed pieces of wood is strange. The priests in their brown robes pray to this cross, but they are oblivious to our cries of pain and loss. Night by night our underworld fills.

Harvest was a time for celebration. Now the Clanking Metal People come with their fanega pots, smelling of steel and burnt flesh, and demand part of each crop, part of each batch of textiles. There is never enough to eat.

Moonlight Woman's daughter got hungry, then sick, then died. They have taken her burial cloth. Who will bury Moonlight Woman's daughter, with her eyes of fire?

MATEO ROMERO

PLATE 32.
Basket
Artist, Ramona Lubo
Cahuilla, CA
Late 19th century
Plant fiber; diameter 45.7 cm
Collected by Amelia S.
Quinton
Gift of Amelia S. Quinton,
1896
19095

The Ramona Myth and California Indian Survival

As an undergraduate at the University of Pennsylvania, I never saw the California Mission Indian baskets in the basement of the University Museum. I was excited to view them for this book. This basket, made by "Ramona of Helen Hunt Jackson fame," according to the catalogue card, immediately drew my attention. As I delved into its history, I discovered a story of the mythic origins of California's Spanish and Indian past.

Helen Hunt Jackson was a social activist and Special Agent for the Office of Indian Affairs. She published numerous accounts of the government's ill treatment of American Indians. Her first-hand experiences inspired her to bring national attention to the landless Indians whose rights were constantly being trampled upon by non-Indian settlers. She drew attention to this tragedy by publishing a romantic novel, *Ramona* (1884), with a half-Indian, half-Irish heroine.

At first the novel accomplished its goal and boosted interest in California's history. Entranced by the love story, tourists flocked to California locales associated with Ramona and Alessandro's fabled romance. Many bought "Ramona" baskets, plaques, pincushions, and pillows from Indian peoples.

However, the romantic images eclipsed the actual history of forced labor, involuntary resettlement, and the religious conversion of native Californians. This romanticized past is still taught in California public schools. The Hemet Chamber of Commerce still produces a play, the *Ramona Pageant*, based on the book.

Most people do not realize Ramona, the book's heroine, is a fictional character. While it is true that Mrs. Jackson based the death of Alessandro on the real-life shooting of the Cahuilla Indian Juan Diego, it was a coincidence that Juan Diego's wife was named Ramona. This amused Mrs. Jackson, who learned this fact only after *Ramona* was half written (T. B. Aldrich Papers, Houghton Library, Harvard University). When readers searched for the "real" Ramona they found Ramona Lubo, Juan Diego's wife, living alone on the Cahuilla reservation with her children.

This basket speaks on many levels. It is a witness to the mythic origin of California and a testament to the harsh reality of Indian living conditions at the turn of the 20th century. It also reveals that the more things change, the more they stay the same. One only needs to look at the *Cobell v. Norton* case regarding the BIA mismanagement of American Indian trust money to see that the U.S. government continues to ignore the welfare of the native people it promised to protect. Most importantly, the basket demonstrates the strength and perseverance of Indian nations who continue to survive despite all obstacles put before them.

DESIRÉE RENE MARTINEZ

PLATE 33.
War Bonnet
Lakota (Sioux), SD
Ca. 1876
Wool stroud cloth, feathers;
length 198.1 cm
Collected, 1876
Gift of Dr. Samuel
Fernberger, 1942
42-3-1

Schizophrenia on the Frontier

For most Americans the War Bonnet is the most potent and enduring icon of Native American culture. The power and beauty of Lakota religion and artistry is embodied in the graceful, swept lines of its silhouette, motion in the trailing leather and horsehair tassels.

But the story of this Bonnet reveals a second set of equally powerful historical and cultural meanings. "Removed from the body of a Teton Lakota warrior after a punitive raid following Custer's defeat at the Little Big Horn," the Bonnet embodies the parallel yet contradictory policies of the U.S. government in the 19th and early 20th centuries- the desire to preserve and archive the material culture of a people while at the same time actively and aggressively working to facilitate their demise.

In one building along the Mall in Washington, DC, was the Department of War, bringing the full force and resources of the state in campaigns designed to annihilate a people. A few doors down was the Smithsonian, a museum largely dedicated to the preservation of the material culture of these same people *before it was too late*. Therein lies the absurdity and insanity of the colonial ethic and mindset. Coexistence was never considered-unless the body and the human being had been removed from the equation.

Given the survival of the Lakota, we can reinscribe this artifact, this work of art, with perhaps its most significant and transcendent meaning. The owner of this headdress was a father, a son, a brother, a husband-a person who was willing to die for the right to *be* and the rights of his family and kin to *exist*. This is the story of all of our brothers and sisters. It is a story of persistence and perseverance.

MICHAEL V. WILCOX

Spirits

GUIDANCE FROM ANCESTORS AND DEITIES

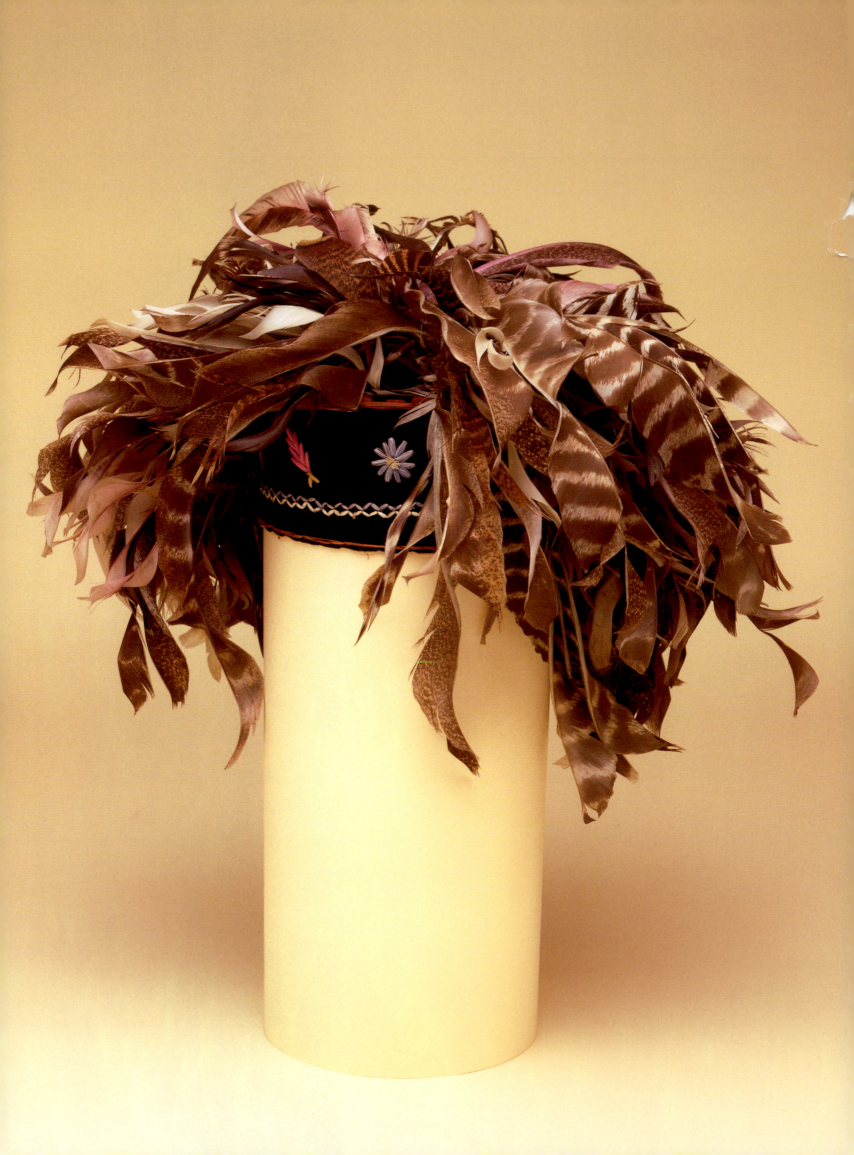

Gustoweh—A Real Headdress of the Haudenosaunee

The Great Feather Dance is one of the most important expressions of who we are as Haudenosaunee. By dancing in a circle in the same direction as the original Sky Woman walked when this world was first created, we are reliving our origins. The men and women are supposed to dress in their "best" dance outfits to show the Creator that we are truly happy and thankful for all that has been provided for us in this beautiful place. This *gustoweh* expresses that sense of beauty.

For Haudenosaunee men, the *gustoweh* is the primary symbol of our male identity. The idea is to make the *gustoweh* "float" as you walk or dance. Think of the *gustoweh* as a collection of dancing feathers, blowing in the breeze or shaking to the beat of the drum, and you can then begin to imagine this headdress as it was intended to be. It is alive and continues to share the spirit of the birds through their feathers. Now imagine a huge circle of dancers, each with their own *gustoweh*, moving in harmony with the drum. That makes for a great feather dance indeed.

This *gustoweh* is unusual. It is not like those commonly seen today. It represents some interesting transitions and cross-cultural experiences. At first glance, one might say that it is probably the result of the fact that many Haudenosaunee in the past served as performers in Wild West entertainment troupes or presented cultural performances at international exhibitions. In either case, our people came into contact with other native "performers" and there was a great exchange in stories, ideas, songs, and modes of dress. Some of our people began to model their style of dress after their fellow performers. Some scholars might view this as a contamination of the "pure" local culture. I prefer to think of it as a lively creative interplay. One generation's innovation becomes another generation's tradition. That is the nature of creativity. It is also why it is hard to define a tribal aesthetic, as change is inevitable.

No matter what the source of the designs, or whether these headdresses were worn in ceremonies or circuses, they become a symbol of our collective identity and shared history. However, as I look at the photograph of this *gustoweh* I can't help but wonder how the feathers feel. They don't get out much anymore. They don't hear the music, don't feel the wind. They don't get to dance in that great circle of life. All they get is a short visit from a distant relative.

RICHARD W. HILL, SR.

PLATE 34.
Headdress
Haudenosaunee (Iroquois)
Early 20th century
Velvet, feathers; height
33 cm
Gift of Anne W. Meirs, 1918
NA8733

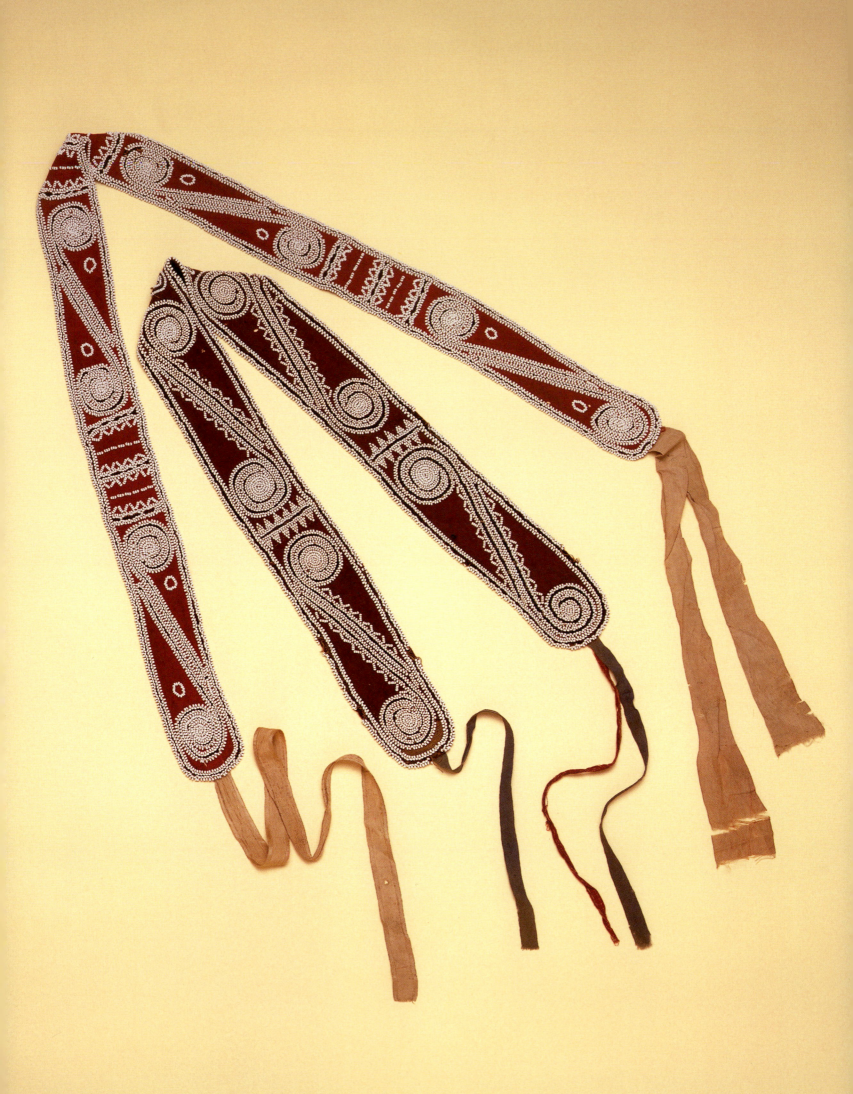

The Serpent Uncoils

The serpent uncoils
time is born
and the universe expands

The white beaded snake
emerges
from the blood of my ancestors

It winds through the stars
shedding its skin
for each generation

Landing on my shoulder
it crawls across my heart
around my back
and across my heart again

The mighty serpent
looks me in the eye
spreads its wings
and swallows me and itself

I am the serpent
I wear the great coat
of the blue sky
and the white clouds
and the red crosses

"The time has come," the turtle reveals
"for my coronation to begin"
the universe quits expanding
I begin to coil.

MARCUS AMERMAN

PLATE 35.
Shoulder Sashes
Choctaw, Mandeville, LA
Ca. 1870
Wool stroud cloth,
glass beads
Collected by Stewart Culin
from Earnest Fauve (John
Wanamaker Expedition),
1901
38473 (top), length 134 cm;
38472 (bottom), length
114 cm

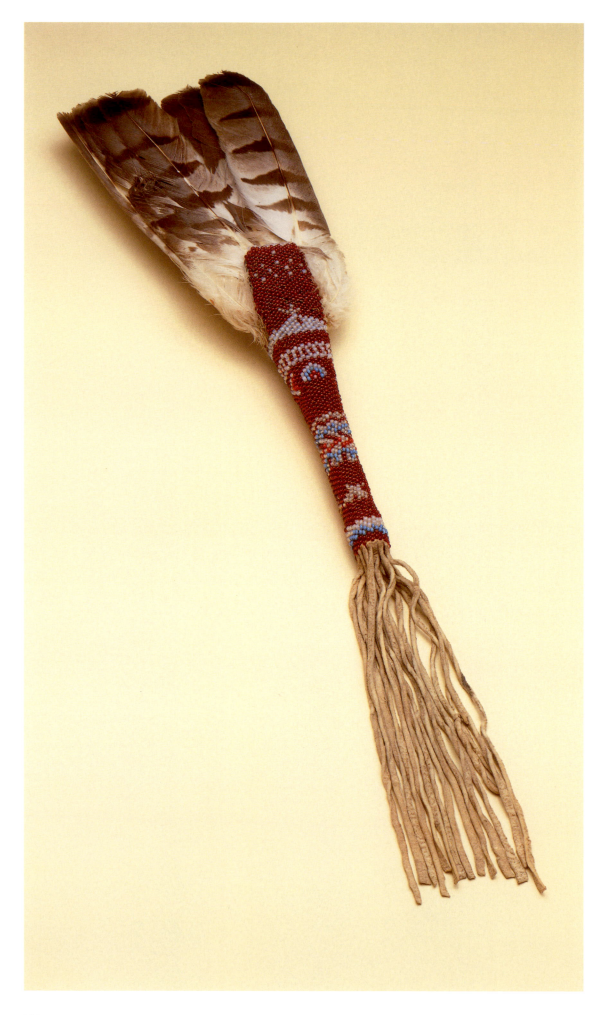

PLATE 36.
Peyote Fan
Lenape (Delaware), OK
Ca. 1930
Skin, feathers, beads;
length 37 cm
Bequest of Samuel
Pennypacker, 1969
70-9-476

Delaware Peyote Fan

This fan is a Delaware peyote fan of hawk or osprey feathers. The fluff or plume feathers are dressing the convergence of feathers and handle. The leather handle is meticulously stitched in beads of all-American colors of red, white, and blue. It appears to depict cosmological symbols representing earth (nearest the stringed tassel) and ascending to the stars (near the feathers). The fan's beauty is in its simplicity and delicacy, yet the construction required practical knowledge, artistic talent, and divine guidance.

Over a century ago two men brought the peyote religion to Indian Territory (now Oklahoma). They were Quanah Parker (Comanche) and John Wilson (Delaware). Wilson was of the "Absentee" band of Delaware from Western Oklahoma near Anadarko. He was called "Moonhead" presumably because of the crescent moon earthen altar that is a part of the religious ceremony. The fan or other feathers are brought out by the participants at midnight during the ceremony. We use them to fan smoke about ourselves to bring about spiritual purification. The smoke comes from placing cedar boughs in the ceremonial fire. It is the Indian belief that we carry the spirit power of an animal when we carry their feathers, fur, or other parts in our ceremonial practices. So it becomes a powerful combination of spiritual blessings to use this fan during the ceremony.

Today, the Native American Church of Oklahoma is a bona fide religion with federal law that protects the legitimate use of (among other things) feathers and other parts of protected animal species and the use of the herb peyote (classified by pharmacology as a hallucinogen). As ceremonial participants we use fans such as this to bring healing power into our midst. We may also use fans such as this for personal prayer or healing ceremonies. In spite of the fan being in a museum collection and represented as an artifact, I see it as a religious instrument that still possesses spirit power. It may be laying dormant since coming into the collection, but it can be brought out in the appropriate ceremonial setting and its power released once again.

CURTIS ZUNIGHA

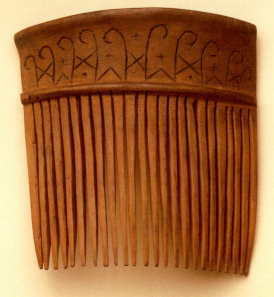

PLATE 37.
Hair Combs
Cherokee, NC
Early 20th century
Wood
Collected by Frank G. Speck
and John Witthoft, 1932–40
Gift of Frank G. Speck
46-6-133 (top left), height
9.0 cm; 46-6-135 (top right),
height 4.3 cm; 46-6-134
(bottom left), height 7.5 cm;
46-6-132 (bottom right),
height 10.0 cm

Naming

He carved for me
From bone or horn or wood or tortoise shell
These combs for my long hair
They are *a-li-ta-wo-sdi*
These combs combing for me my hair
These combs using their teeth for me
These holy ones who take nothing for themselves.

DIANE GLANCY

PLATE 38.
Painting, "Deer Dance"
Artist, Romando Vigil
(Tse Ye Mu)
San Ildefonso Pueblo, NM
1930
Cardboard, pigment;
width 75 cm
Bequest of Margaretta S.
Hinchman, 1955
55-37-9

106

The San Ildefonso Deer Dance

The deer dance is performed usually in public at many of the 19 Indian Pueblos of New Mexico in the winter months. There are many variations.

This painting by San Ildefonso painter Romado Vigil depicts the moment in the dance when a gun goes off, representing the "deer hunt." The deer dancers have the option of running out of the plaza and purposely falling to the ground to be "caught" by female family members. Thereafter, a male family member places the dancer over his back and takes him home. Once the dancer arrives at a family home, a "basket of gifts" (which may include oven-bread, pies, or cookies) is offered to the dancer in gratitude. Eventually the dancer returns to the kiva.

The deer dance not only represents a "deer hunt," but it makes a spiritual connection. The dancers take on the spirit and movements of a deer in the same way that the deer give of themselves to the people during a real hunt.

GARY S. ROYBAL

PLATE 39.
Hunting Visor
Inuit (Eskimo), Norton
Sound, Alaska
Late 19th century/early
20th century
Wood, ivory; length 36 cm
Collected by Captain
Joseph F. Bernard, 1909–13
Museum purchase, 1915
NA4252

108

Dressed to Kill

This truncated bentwood hat, collected from the Norton Sound area of Alaska, is an impressive example of Native Alaskan artistry. Though we may look at this hat and see a utilitarian object, it is far more. Within its exquisite design a story is told of life and death, the importance of the kill, and the honoring of the animal that is hunted.

Carved ivory bracing swoops powerfully around from the back of the hat and ends in stylized birds' heads with toothed beaks encircling a carved ivory seal. Birds were considered helper spirits for ocean-going hunters. The circle and dot motif used to represent the birds' eyes are powerful talismans of clear eyesight. The artist has portrayed the birds with toothed beaks to ensure that the kills will be swift.

The seal sculpture swimming in the middle of the hat indicates that this hat was worn during seal hunts. Unquestionably this headdress would have been a very powerful hunting tool and worn by an accomplished hunter. When the hunter donned his headdress he would be dressed, in a very real sense, to kill.

The use of elegant line and refined surfaces speaks volumes about the artist's mastery of design and fine craftsmanship. There is nothing extraneous in the construction or adornment. All structural elements of this piece serve a spiritual purpose of helping to provide a successful hunt. Elegant simplicity and powerful symbolism give this masterpiece beauty and meaning.

REBECCA LYON

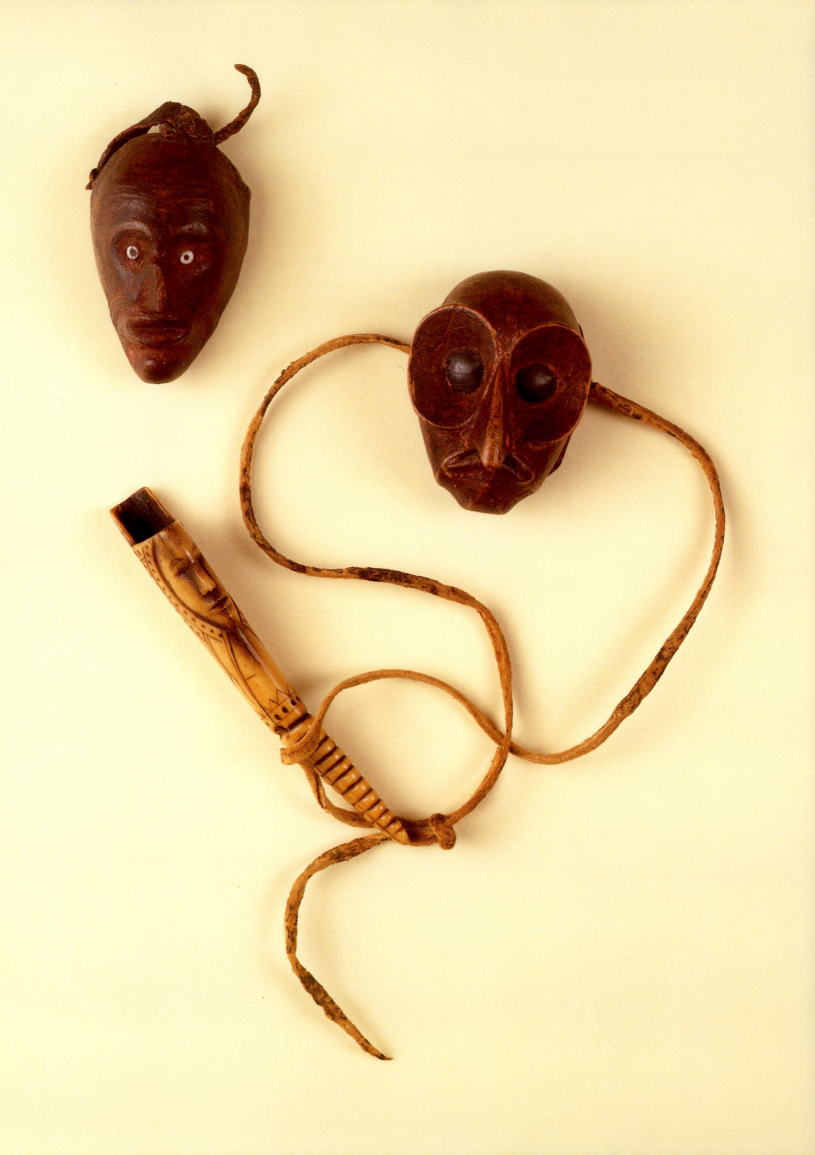

Delaware *Mesingw* Mask

An integral part of the (now extinct) Delaware Big House Church (*xingwekaon*) ceremony was the use of the *Mesingw* mask or carved face. It is a representation of a powerful spirit (*mesingwhalikan*) that came to our ancestors centuries ago and became incorporated into religious ceremonies. The mask would be painted red (ochre) on the right half and black (charcoal) on the left. The *mesingw* face would also be carved upon the wooden posts that held up the wooden longhouse. These faces would also be painted in the ceremonial colors at the appropriate time.

The wooden mask was also worn by a specially appointed ceremonial participant and worn with a bearskin cloak or suit to give an eerie spiritual presence. He would accompany messengers who announced the meeting, hunters who provided venison for ceremonial feasts, young vision seekers who traveled alone in the forests and danced with the participants during the twelve-day ceremony. He also served to take care of children with a frightening presence that would render a near-immediate response from those who were weak, sickly, lazy, or disobedient.

A mask that has been in the presence of our ancient ceremonies still possesses spirit power that has lain dormant since its last use. Such power can still be brought out by those of the blood and used for benevolent purposes. Only by using the Lenape language to call forth to *Kishehlamukong* (the Creator) will the true spirit power be realized. The ancestors took time out each year to pray and conduct ceremonies for continuous blessings upon their people. Only when these things were put away did the blessing stop and our people lose much of their cultural identity.

CURTIS ZUNIGHA

PLATE 40.
Maskettes
(one with powder
charger attached)
Lenape (Delaware)
Early 19th century
Gift of Emlyn Stewardson,
1913
Wood, hide, glass beads;
NA3882 (left), height
6.34 cm;
NA3881 (right), height
5.07 cm

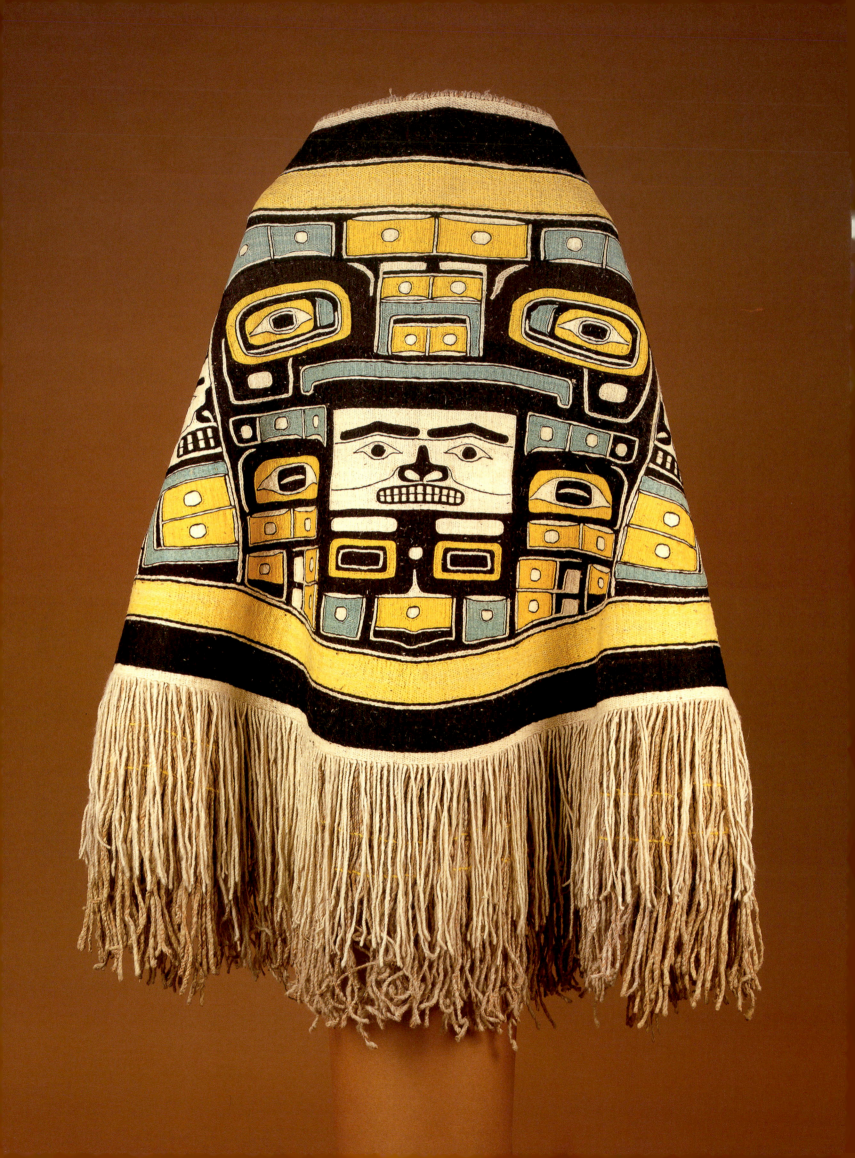

Naaxein

Ceremonial robes woven by Haida, Tlingit, and Tsimshian women were twined from mountain goat wool and cedar bark. The bold flowing formline and strong colors of black, yellow, and blue depicted mythical crest figures patterned from a man's painted board. The combined effort produced the most exquisite and prized possession of Northwest Coast chiefs. Haida and Tlingit people call this prestigious robe of ceremony *naaxein*. The Tsimshian name for their robe of power is *gus-halai't*.

During winter ceremonies of the past, when a Tsimshian chief wore his *gus-halai't*, headdress, apron, leggings, and rattle, he became a *Wihalai't* or great dancer. He had the ability to throw spirit power to young initiates of secret societies. The long fringed border of the *gus-halai't* served as a dramatic vehicle for the throwing of power during the *Wihalai't* dance.

A Haida legend tells the story of *Haayaas* and *Lukaslas*, two village chiefs that meet in a property-destroying competition. *Lukaslas* ridiculed *Haayass* over a gambling debt. *Haayass* had to show and destroy items of wealth to overcome the apparent shame. One of the first things he did in preparation was to have a figured robe woven for him. His sister wove a robe with a beaver figure on it.

The highly stylized complex designs of the ceremonial robes hold mysteries whose answers are in the mythological past. The following paragraph from a Tsimshian myth illustrates the interaction of clan ancestors with the supernatural:

The Sun Father erected for him a house of cedar on the heights facing his lodge, saying, "Its sacred name shall be Gus-Tatkeeya [Garment come down from the sky to shelter your lives]. It shall belong to your posterity throughout the ages." And he painted human faces in red and yellow ochre around its walls for a symbol and memorial.

The above story suggest that the crests protect through symbolizing ancestral power and wealth. Wrapped in the woven crest symbols, a high-ranked person simultaneously displayed wealth, ancestral origin, accomplishments, and all his clan's prerogatives.

Today, few clans have been fortunate enough to retain the robe through the vast cultural changes of the last hundred years and only a few women possess the knowledge of weaving a robe. To collectors, there is often no greater prize than a traditional *naaxein* robe. It continues to be a rare object of high esteem.

EVELYN VANDERHOOP

PLATE 41.
Blanket
Klukwan, AK
Late 19th/early 20th century
Cedar bark, mountain goat
wool; length 170 cm
Collected by George B. Gordon,
1905
NA1285

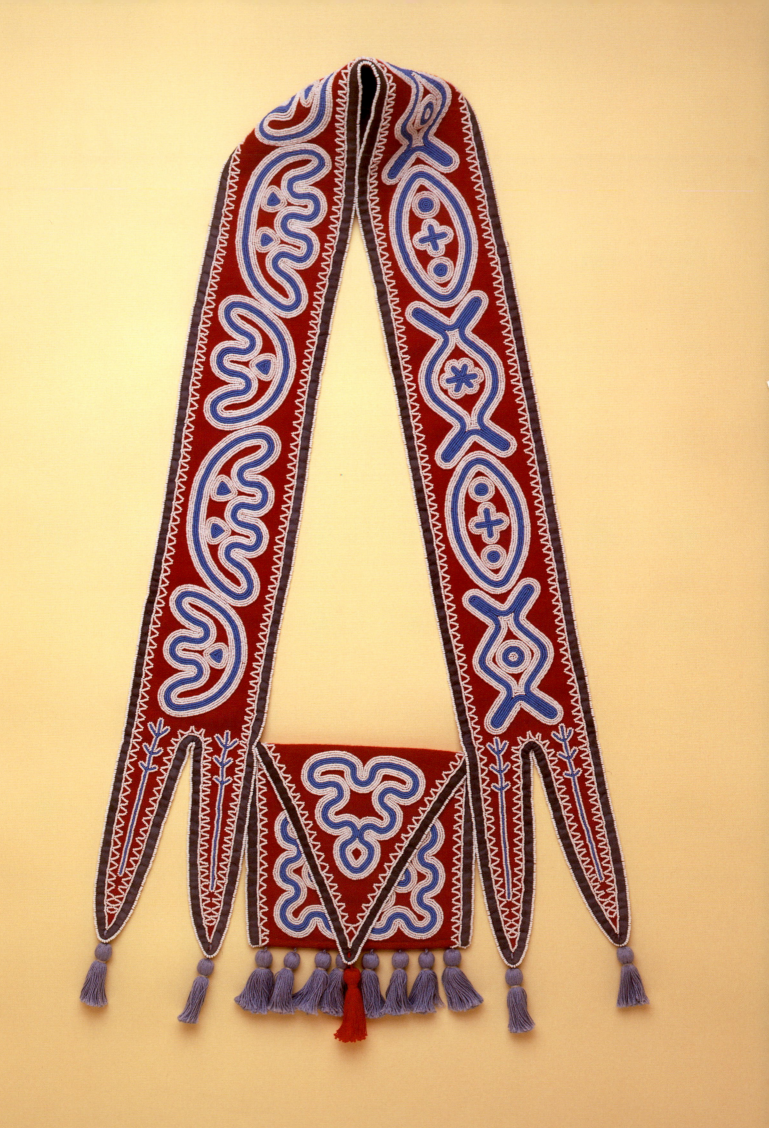

Creek/Seminole Shoulder Bag

42

My shoulder bag is similar to the bags made in the 1840s by the Creek and Seminole peoples in the Southeastern United States. Originally the concept of the shoulder bag came from the Northeastern tribes where the bags were used for shot bags or bags for carrying paraphernalia for flintlocks. The idea for the bags probably reached the Southeast through trade, but the peoples styled them using their own symbols and designs. During this time the strap of the bag was commonly made with two distinct patterns, one on the left side and another on the right side. Individual symbols often represented the world around the people. Diamonds with turned-up ends represent turtles. Many traditional designs represent herbs for medicines, trees, and animals such as snakes, alligators, raccoons, or deer, or heavenly bodies like the stars and the sun or the four winds or four directions. Designs, whether spiritual or natural, were selected depending on the needs and social standing of the maker. They were often chosen for protection medicine.

My bag has traditional shapes such as the four plant forms at the bottom of the strap and the fat X-shape on the right, as well as designs of my own making on the rest of the bag. The colors and materials used were commonly available at the time represented; cotton canvas, red wool fabric, blue silk ribbons, powder blue and white seed beads, and dark blue wool yarn tassels are all sewn with cotton thread.

JERRY INGRAM

PLATE 42.
Bandolier Bag
Artist, Jerry Ingram
Choctaw
1995
Wool, cotton, glass beads;
length 78.7 cm
Museum purchase, 2002
2002-9-2

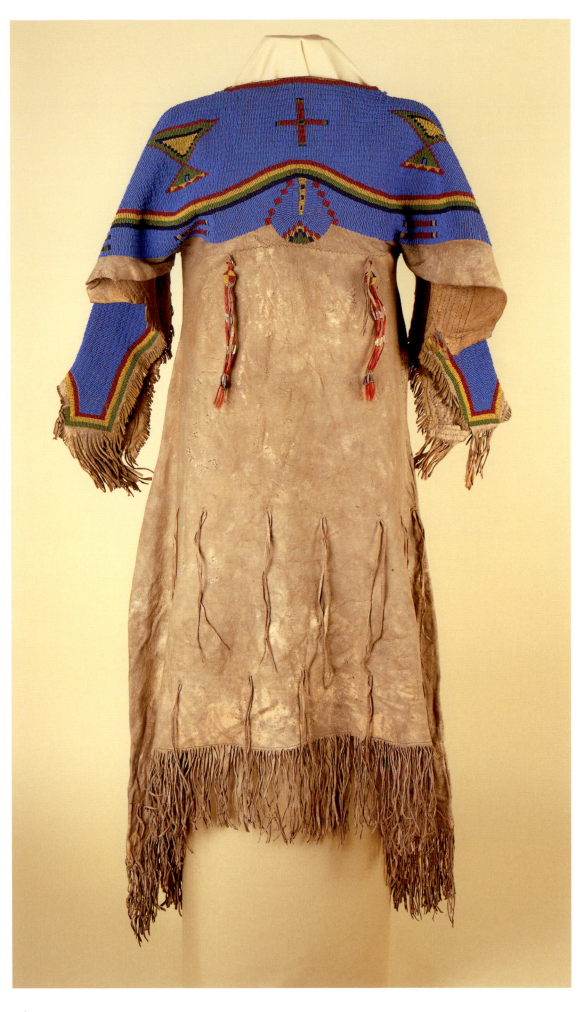

PLATE 43.
Woman's Dress
Lakota (Sioux)
Late 19th century
Buckskin, beads;
length 132 cm
Collected by General
Frank C. Armstrong,
ca. 1890
Gift of Mrs. Archibald
Barklie, 1915
NA2447

116

What This Lakota Dress Means

This Lakota woman's dress is typical of ceremonial garb. It is simple in style, but rich in meaning and metaphor. The dress utilizes the natural form of the skin of the deer or antelope. Two skins are usually used and sewn together. This dress has added insets at the corners to extend the imagery of the animal's legs and movement. This device allows greater ease in movement in walking and dancing. The hem is treated with finely rolled leather fringes to enhance its beauty in the Lakota view. Some art historians have said that fringes represent prairie grass. To the Lakota, fringes are beautiful and pay tribute to the agility of the fleet-footed animals.

The quilled fringes attached to the breast area by round balls are a great honoring of Lakota motherhood. These miniature balls may represent the larger beaded balls used in the *Ishnati* (puberty rite of Lakota girls entering womanhood). These small balls might indicate the nipples of the woman's breasts to symbolize nurturance and love for the children called *Wakan Yeza* (Sacred Beings). The quilled strings which hang from the balls reinforce the sacred colors of the Lakota as well as the sacred number 4. The colors emphasize the ordinal numbers: red for the East; yellow for the South; dark blue (or black) for the West; and White for the North.

The beaded yoke is added to the skirt. It is easer to work on a smaller piece than the entire skin. An opening is left near each arm pit to allow for feeding and cuddling an infant. As lactating Lakota women often nursed a child up to five years, this was a very functional opening. The fringes on the forelegs of the yoke are shorter to allow for the functions of the woman's body.

By contextualizing forms and colors, a realistic incorporation of Lakota art forms and belief are seen with greatest clarity. These *Tipi* designs rich in meaning are in a background of light blue beads which is a favorite color for all Lakota women's garments. Light blue is the color of an all-encompassing sky which contains the Sun—the bedrock of Lakota belief and ritual. The constancy of light blue beads for most Lakota dresses may be appreciated by the words of a Lakota woman:

T'oh na T'oh
Lela waste' na wakan

Blue and blue
Very beautiful and sacred

This dress is imbued with sacredness.

BEATRICE MEDICINE

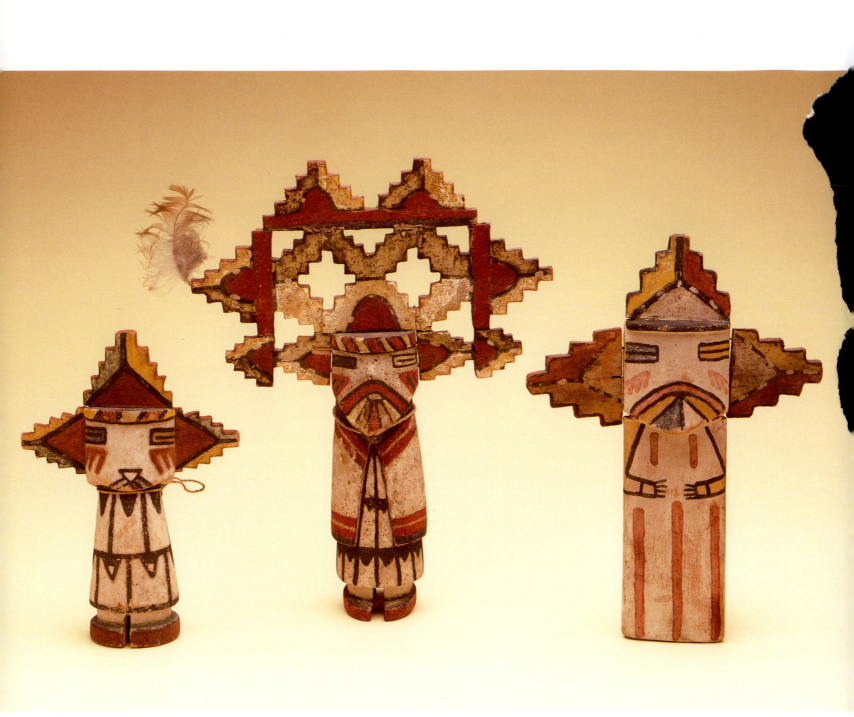

PLATE 44.
Salakmana Katsinas
Hopi, Oraibi, AZ
Late 19th/early 20th century
Wood, pigment
45-15-740 (left), height
23.4 cm, Charles H. Stephens
Collection; 38921 (center),
height 36.8 cm, 38913 (right),
height 30.4 cm, collected
by Stewart Culin (John
Wanamaker Expedition),
1901

118

A *Katsina*'s Gift

The first time I ever attended a *katsina* ceremony was with my grandfather at Hopi on First Mesa. I was about seven years old. As a young kid I was mesmerized by the appearance of the *katsina* dancers and their chanting as they moved. These *katsina* ceremonies left a lasting impression on me. In the summer months ceremonies are held outdoors in the village plaza, and during the winter they are held in underground ceremonial chambers called *kivas*.

I recall that one winter during a severe snowstorm at Hopi, the road leading up to First Mesa was closed. Late that evening my grandfather and I hiked up the mesa in a foot of snow. When we arrived at the *kiva* we climbed down a stepladder through an opening in the roof and down into the warmth of the ceremonial chamber. We waited patiently for the *katsinas* to appear. When they arrived at the top of the stepladder an elderly man seated below asked them in the Hopi language to enter. The *katsinas* began their descent one by one down the ladder and formed a half circle in the center of the *kiva* and started chanting and dancing. This went on until early morning as different groups of *katsinas* made their appearances. Before the *katsinas* left the *kiva* both my grandfather and I received gifts of fruit and bundles of fresh-baked sweet corn.

Some young boys in the *kiva* received bow and arrows or rattles, and the young girls were given elaborately painted carved *katsina* dolls. My grandfather explained that a *katsina*'s gift is a gesture of friendship and insures you of good health. *Katsinas* are spirit messengers from the sacred mountain west of Hopi known as the San Francisco Peaks, they represent goodness, clouds for moisture, and blessings for the people.

When the ceremonies were over we left the *kiva* and began our descent down the mesa, trudging through deep snow to my grandfather's house in the crisp early light. That was the best experience of all. Eventually I was initiated and became a participant in the same rituals I witnessed as a child. Today these ceremonies are still sacred to me and continue to have a lasting impression on my life.

DAN NAMINGHA

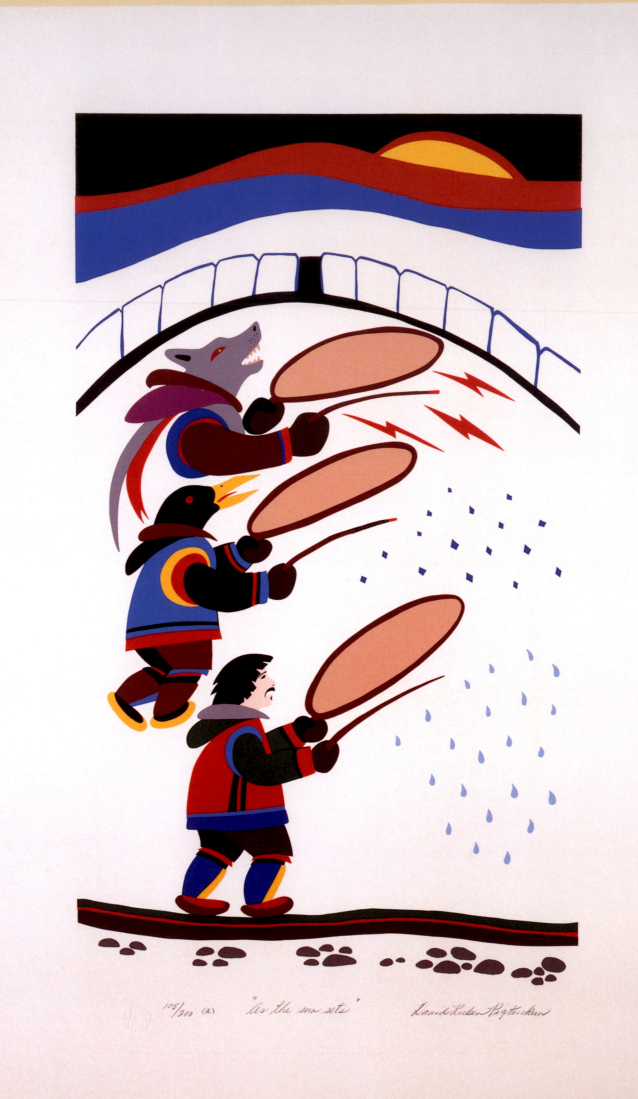

105/200 (a) "As the sun sets" David Ruben Piqtoukun

As the Sun Sets

45

As the sun sets the ceremonies begin inside the large snow house built before the cold sets in on the land.

The Shaman drummers from the Western Arctic summon the spirits to bring good fortune and a successful hunt. The energy created by the power of the drumming transforms into rain, snow, and lightning bolts.

At the bottom of the panel lies the Inuit underworld, which is inhabited by mischievous evil spirits named *Tupiloks*. They periodically break into the real world, creating chaos and confusion. Powerful spirits usually keep the *Tupiloks* confined.

DAVID RUBEN PIQTOUKUN

PLATE 45.
Serigraph Triptych, "As the Sun Sets"
Artist, David Ruben
Piqtoukun
Canadian Inuit, NT
1995
Paper, pigment; height
20 cm
Gift of Carol Heppenstall,
2000
2000-9-1

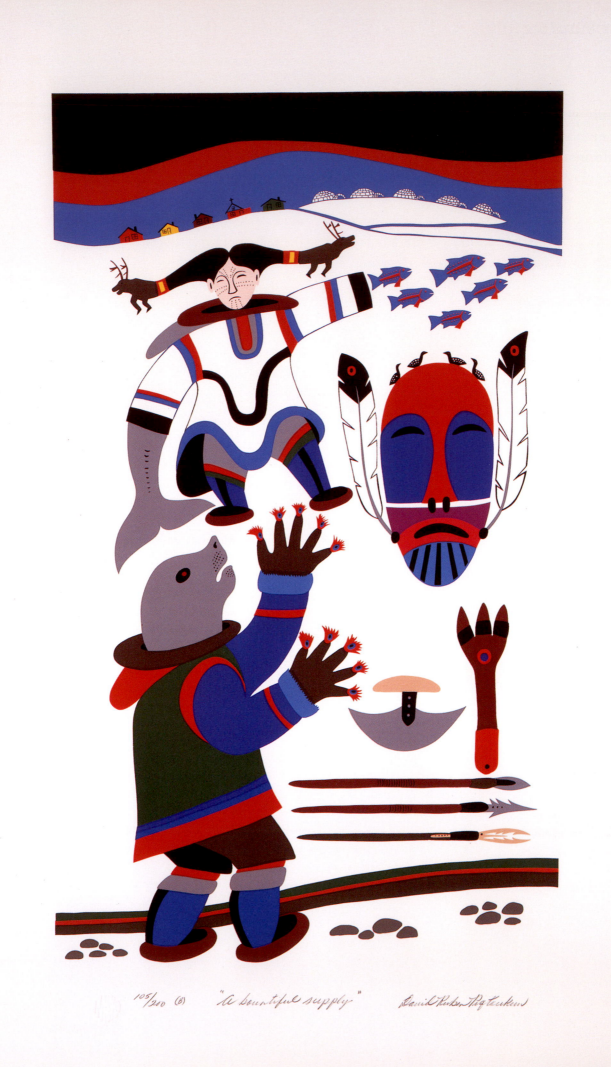

105/200 (B) "A bountiful supply" David Ruben Piqtoukun

A Bountiful Supply

46

The spirits of good fortune, awakened by the drummers, listen to the requests of the Inuit people. The seal-man dancer frightens away evil spirits. The broken mask with feathers represents a plentiful supply of wild fowl. The woman symbolizes fertility-a variety of bountiful images springs forth from her body. Tools for hunting and harvest are the implements of survival.

The transition from igloos to colorful prefabricated houses demonstrates the Inuit adaptability to change, past and present.

DAVID RUBEN PIQTOUKUN

PLATE 46.
**Serigraph Triptych,
"A Bountiful Sky"**
Artist, David Ruben
Piqtoukun
Canadian Inuit, NT
1995
Paper, pigment; height
20 cm
Gift of Carol Heppenstall,
2000
2000-9-2

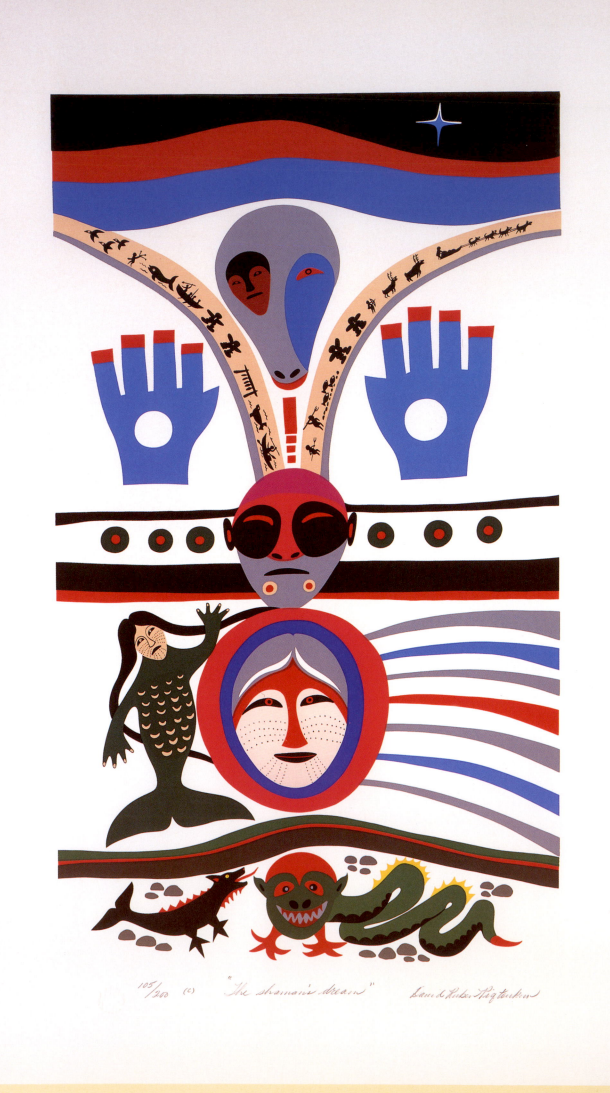

105/200 (C) "The shaman's dream" David Ruben Piqtoukun

The Shaman's Dream

47

The dark Arctic sky is illuminated by the brilliant North Star. The central masklike figure is the Shaman in a dream state remembering the old ways of hunting and food preparation. Believers never question his powers and abilities. The red mask signifies the cutting of the cord of life. Above the Shaman the Alaskan mask with a human face inset represents the fact that all humans and animals are protected and guided through life by spirit helpers. Many animals pass through the blue hands of the hunter. He takes only what is needed for survival. *Sedan*, the sea goddess, brings good fortune and a bountiful supply. The wise old woman stands by, as the moon watches over the Inuit in their quest for survival. Life on the tundra continues.

DAVID RUBEN PIQTOUKUN

PLATE 47.
Serigraph Triptych, "The Shaman's Dream"
Artist, David Ruben Piqtoukun
Canadian Inuit, NT
1995
Paper, pigment; height
20 cm
Gift of Fred Boschan, 1999
99-18-1

X'aanaxgáatwayáa

This is a story from the "Raven Cycle," one of the many stories telling of Raven and his antics.

The "House of Migration" used to be far out in the ocean and was known as *Kádátaan Kahídee*. Salmon came in only every once in awhile, not at regular intervals. The one who controlled the salmon migrations was a creature known as *X'aanaxgáatwayáa*. Raven knew he had a cane shaped like an octopus tentacle and that *X'aanaxgáatwayáa* would stretch this cane out and chant to bring the salmon in. Raven offered to trade him his halibut hook for the cane, bragging about how much he could catch with it. *X'aanaxgáatwayáa* thought it over and agreed and handed the cane to Raven and told him, when you stretch out the cane, you must chant my name, "*X'aanaxgáatwayáa*!"

Raven could hardly wait to use the cane, and he would stretch it out, shortening the name of *X'aanaxgáatwayáa* and chant *"Xeit gaat waa yaa haa, wiy!"* One by one he called in the species of salmon, from the Pink Salmon, to the Red Salmon, and the King Salmon, then the Silver Salmon, and the Chum Salmon. Then he commanded them to come in at the same time every year without using the cane. He pulled and pulled on the house of migration, using all his strength so the house wasn't so far out in the ocean. His footprints can still be seen south of Yakutat, mounds of sand pushed up as he pulled the house of migration shoreward.

Several clans use this story, as it is again a "Raven Cycle" story. This particular cane belongs to the *L'ooknax.ádi* (Coho Salmon Clan), and another clan in Hoonah also uses the Octopus Finger.

There is a song for the salmon migration still done today that is owned by the *Deisheetaan* clan. The chant is repeated four times, and the ending signifies the salmon jumping. In it is the name of the creature and the chant used to bring salmon ashore with the Octopus tentacle:

Oooooooooo	Oooooooooo	[ENDING]
Xeit gaat waa yaa haa	A hee yaa aa haa yee yaa	Hei haaw—(hei haaw)
Oooooooooo	A ha hei ei hei — yei ei yei	Hei haaw—(hei haaw)
A hee yaa aa haa yee yaa	A hee yaa aa	
A ha hei ei hei—yei ei yei	L gaat waa yaa haaa	
A hee yaa aa	Oooooooooo	
L gaat waa yaa haaa		
Oooooooooo		
Xeit gaat waa yaa haa		

HAROLD JACOBS

PLATE 48.
Octopus Staff
Tlingit, Sitka, AK
19th century
Wood; length 157 cm
Collected by Louis Shotridge, 1925
NA10513

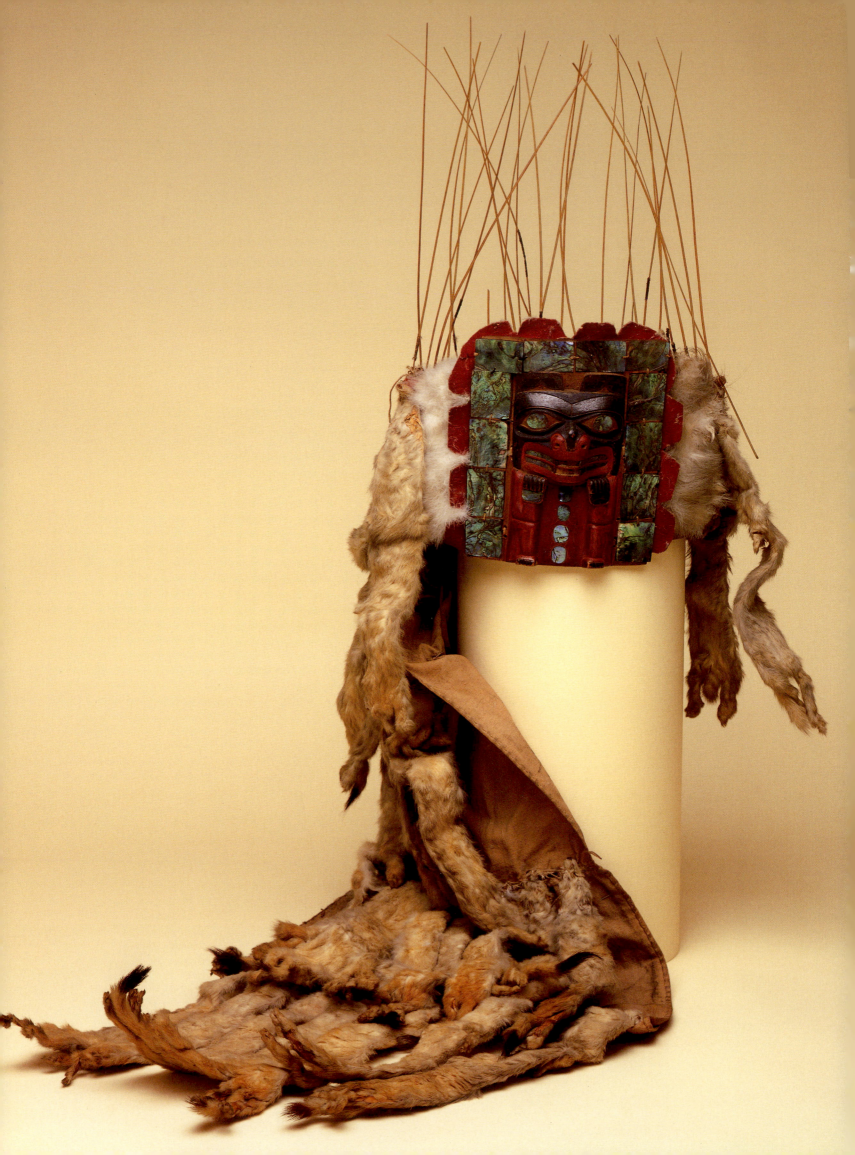

Jahk'a

The crest-carved frontlet inlaid with abalone, topped by sea lion whiskers, and trailed by ermine fur is a ceremonial headdress that remains an important part of the regalia of Northwest Coast cultures. The Haida call the frontlet headdress *jahk'a*, the Tlingit call it *sha'kee.at'*, and the Tsimshian call the crown, *amhalai't*.

In times gone by a high-status person would use the elaborate headdress, crest robe, apron, leggings, and rattle during ceremonies for conveying friendship as well as in spirit power transfers of secret societies. These regalia were essential for the *Halai't* spirit-throwing ceremonies of the Tsimshian and identical to the ceremonial dress used during secret society dances of the Haida. Secret Societies were introduced from southern tribes of the Northwest Coast and came relatively recently to the Tlingit. Spirit-throwing was not part of a Tlingit chief's responsibility. During clan feasts, the Tlingit chief wore the carved frontlet while dancing welcome songs.

Ermine pelts, sea lion whiskers, and abalone inlay were elements of the headdress that designated this a possession of chiefs and wealthy high-ranking clan members. Ermine or marten skins were ancient currency among Northwest Coast clan chiefs. Abalone inlay used on crest objects was the prerogative of chiefs. Long sea lion whiskers were rare and difficult to obtain. The Haida include the red feathers of the flicker in the headdress.

These chiefly headdresses are in use today during friendship and welcome ceremonies of the Northwest Coast people. During the chief's or dance group's welcoming dance, eagle feathers fly out from the magnificently adorned crown when the dancers shake their heads. The down feathers are sacred symbols of peace and friendship. The welcome dance and the use of the carved frontlet headdress are continuing essentials for contemporary ceremonial traditions.

EVELYN VANDERHOOP

PLATE 49.
Frontlet headdress
Haida, Masset,
Queen Charlotte Island, BC
Late 19th century
Wood, ermine skin, cloth,
abalone, feathers, sea lion
whiskers; length 101.5 cm
Collected by C. F. Newcombe
(John Wanamaker
Expedition), 1900
37812

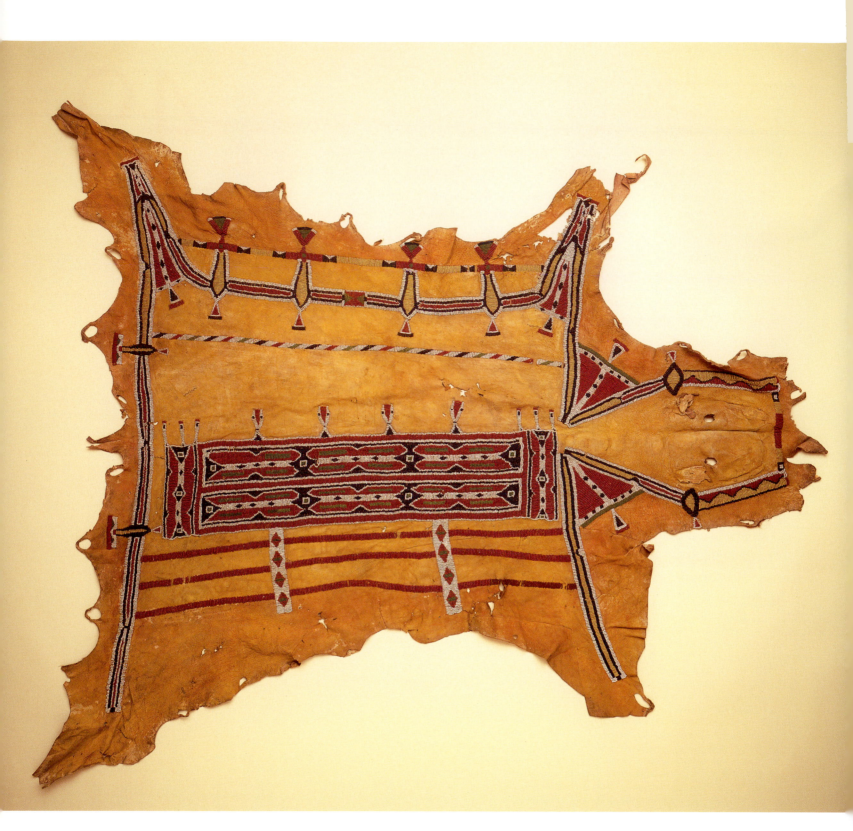

PLATE 50.
Robe
Lakota (Sioux)
Late 19th century
Skin, glass beads;
length 126.9 cm
Collected by General
Frank C. Armstrong,
ca. 1890
Gift of Mrs. Archibald
Barklie, 1915
NA2446

More Than Mere Coverings

This Lakota robe is a woman's elaborate ceremonial robe. Its surface is covered with beautifully conceived and executed patterns rendered in beads. The robe reflects the core of the Lakota life-way (*wiconi*) which is woman centered in the *tipi* (lodge or home). In traditional culture, the *tipi* rested upon the image of *Ina Maka* (Mother Earth). The Lakota woman must be adorned in beautiful attire for special ceremonial events, but also to honor the person and her individuality.

The entire design of this robe is construed to enhance the human form as the robe is draped around the woman's shoulders. The main design is the oblong in the lower half of the skin. This design element is common to many robes, but the added designs allow for individualization. It is often stated in art journals that the oblong on women's robes indicates the internal organs of an animal. This design, however, appears to be a transfer of *parfleche* (rawhide container) designs rather than viscera. Emphasis is on the geometric designs—squares, oblongs, and conical shapes. Straight lines reflect the expansiveness of the Plains landscape with flat-topped buttes and hilltops.

Yellow beads outline the large oblong. The color and size of the beads possibly date this piece to the 1850s. Within this outline, red, white, and dark blue beads fill the space with geometric elongated forms interspersed with blue diamonds which resemble arrow shafts. This is a complex design. Of importance is the use of the sacred colors—red, yellow, dark blue, and white. Beaded strips at each end of the oblong give closure to the design.

The lines underneath the neck portion of the animal are unique. These extend to the end of the neck section and enclose what resembles a face. The lines on each side of the face are divided by a diamond shape outlined in blue with a yellow center as ear rings. Two beaded lines resemble eyes. Unusual small leather bags in a tear shape are attached below the eyes. A line in the face indicates a nose, with a red line for the mouth. On the forehead is a red line. The "tears" are of a lighter hue than the skin of the face. It is possible to imagine the robe to be a burial item. Lakota persons were encased in beautiful robes for scaffold burials.

This is a remarkable robe—a tribute to the artistic creativity of the wearer, who was possibly also the maker. The design elements are all symbolic representations of a woman's love and commitment to a Lakota woman's reason for being and belonging. This is readily acknowledged and appreciated by the Lakota people.

BEATRICE MEDICINE

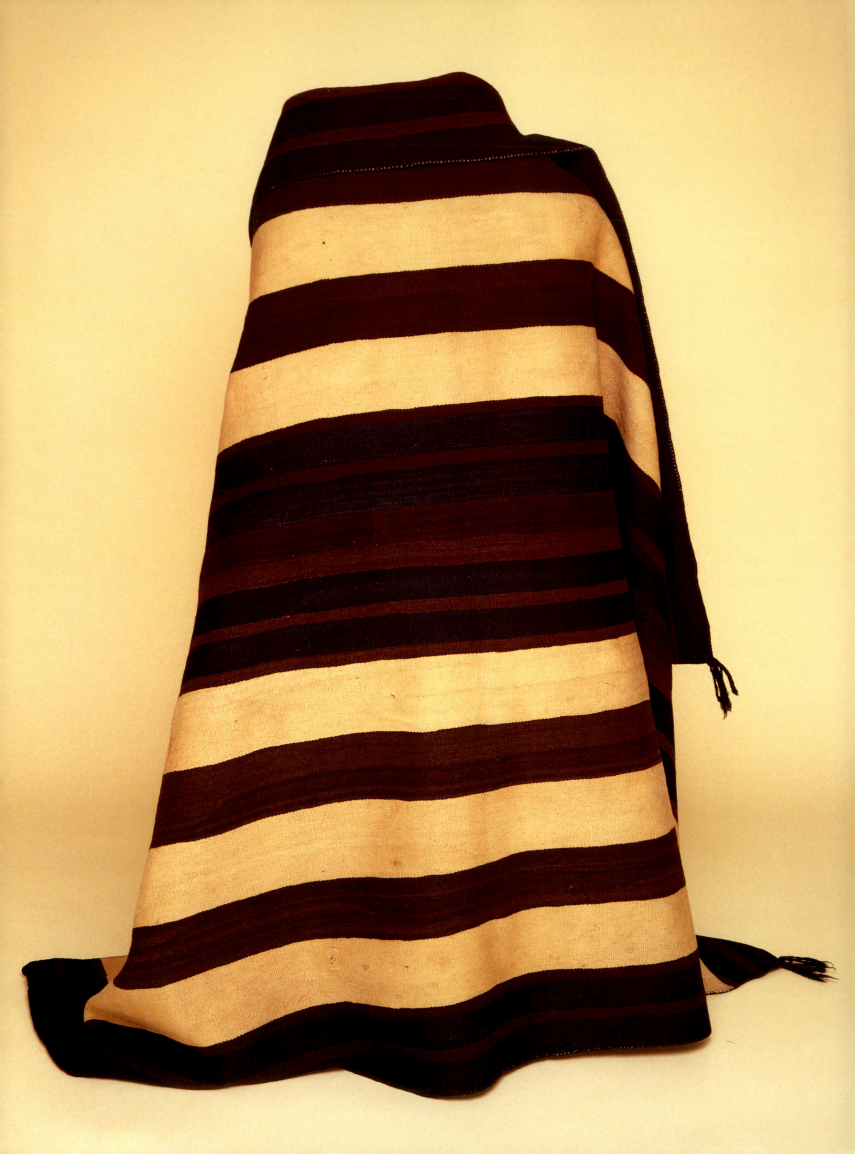

First Phase Chief Blanket

51

These blankets were woven at a time when every aspect of weaving was labor intensive. Shepherds and weavers placed importance on all elements of the weaving process, from sheep herding to hand spinning and hand dyeing the wool.

I find this blanket to be spiritual in its construction and design. This blanket epitomizes the Navajo concept of *hozho*. *Hozho* is the state of being balanced. As a contemporary Diné weaver, I am fascinated with the layout and colors used in this piece because it completely reflects the weaver's thoughts, work ethic, philosophy, and artistic creativity.

MORRIS MUSKETT

PLATE 51.
**First Phase
Chief Blanket**
Navajo
1800–50
Wool; length 151 cm,
width 201 cm
Collected by General
Patrick Henry Ray
Museum purchase, 1915
NA3477

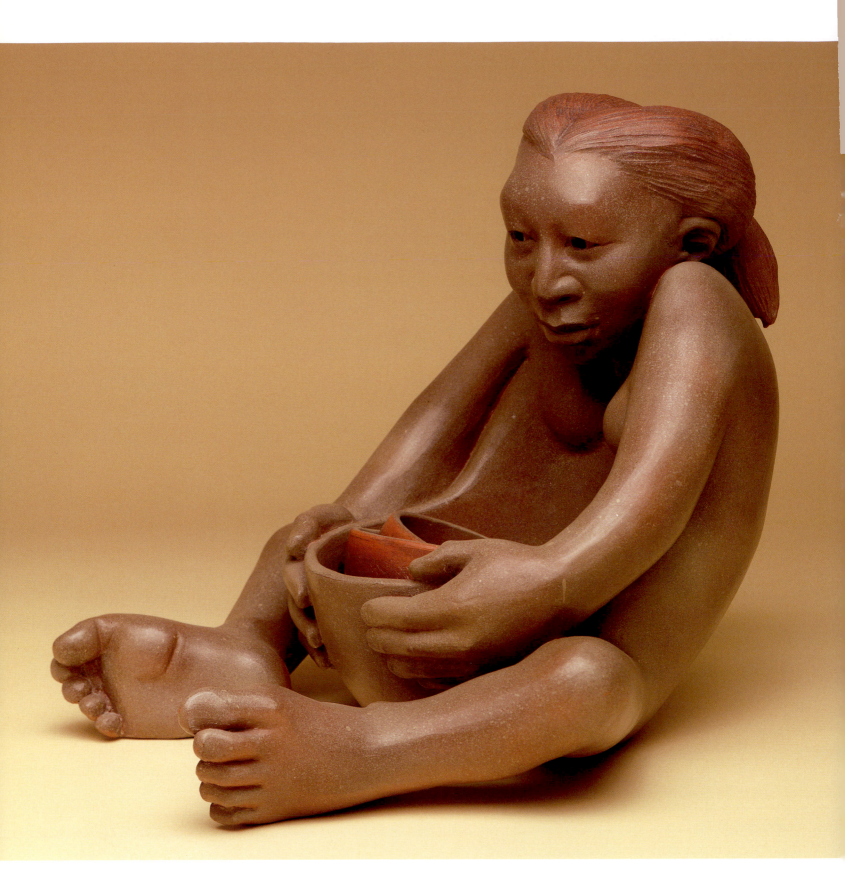

PLATE 52.
"Nestling Worlds"
Artist, Roxanne Swentzell
Santa Clara Pueblo, NM
2000
Clay; height 35.5 cm
Collected by Lucy Fowler
Williams, 2000
2000-19-1

134

Nestling Worlds

This piece came from a cultural perspective but also from what was happening in my life at the time. We were having a lot of forest fires, and I was so saddened by the forests burning up. I wanted to protect them somehow and it made me think about how in the pueblo we see the world as a bowl...a mother bowl. All the "layers" of the world, whether they be geological or plant succession or generations of all life, nestle within each other. It feels good to feel that our "mother bowl" the earth is holding us. So, I made this piece to show the nestling of our world that goes on and on and that it also goes back to our beginning mother bowl.

ROXANNE SWENTZELL

Footsteps

BIOGRAPHY AND LIFE EXPERIENCE

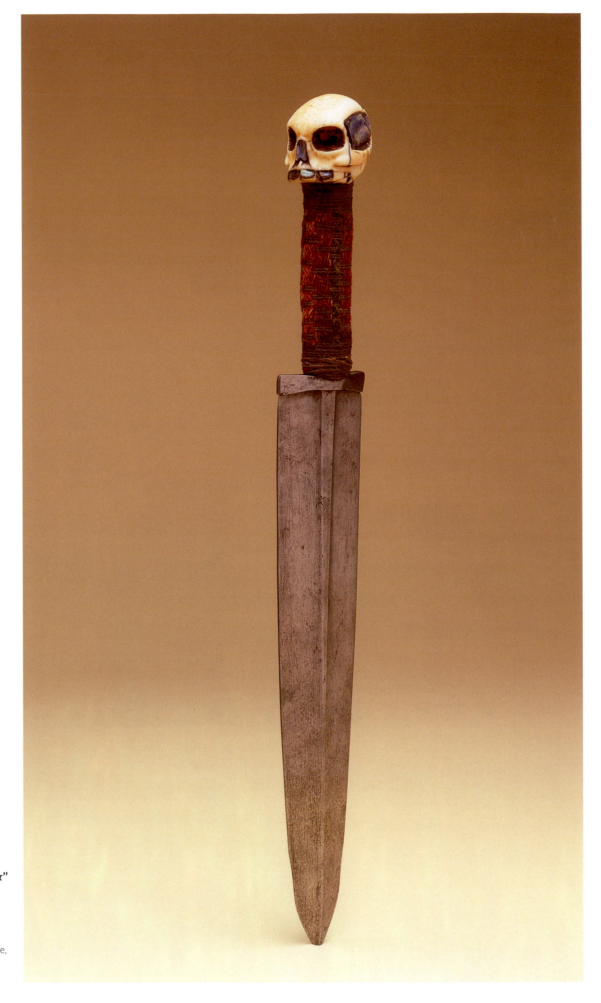

PLATE 53.
**Dagger "Ghost of
Courageous Adventurer"**
Tlingit, Sitka, AK
Early 19th century
Iron, ivory, hide, abalone
shell; length 38.6 cm
Collected by Louis Shotridge,
1918
NA8488

The "Ghost of Courageous Adventurer" Dagger

The "Ghost of Courageous Adventurer" Dagger is an example of the category of Tlingit clan property called *at.óow*, meaning "purchased object" in the Tlingit language. Purchase is usually through the death of a clan ancestor or through some other important experience in the history of the clan that gives members of this clan the right to claim this as their property. *At.óow* are to some extent similar to European crests and heraldry, but the range of what is considered *at.óow* and their social and spiritual roles are considerably more complex. The most common *at.óow* are clan crests, songs, stories, regalia (hats, blankets, tunics, etc.) and clan houses. *At.óow* are made to ensure that our future generations know who they are and where they originate.

With this dagger we are twice fortunate. Not only is the *at.óow* extant in the physical artifact itself, but its collector, Louis Shotridge, also published the story that goes with it in a 1920 article in the University of Pennsylvania *Museum Journal*. The article portrays for the first time in print how we acquire our *at.óow*. Shotridge's main concern was to look at the context of an art object or artifact, arguing that this was where the meaning in Tlingit art is stored. This was in contrast to Boas and Swanton, who focused and insisted on the study of form alone and thus missed much of the point of Tlingit art. I'm very glad that Shotridge left us his legacy of early writings from the Tlingit point of view.

The "Courageous Adventurers" to whom the name of the dagger alludes are the men who walked from Klukwan on the Chilkat to the Copper River and back. The story describes the hardships and heavy loss of life the men experienced as they crossed mountains, glaciers, and rivers. It also mentions the happy moments of the journey such as their meeting and trading with the interior Indians, and their discovery of iron.

The leader of the expedition was a *Shangukeidí* man named Eagle Head. After the return of the expedition, *Kaa.ushtí*, a leader of the Finned House *Kaagwaantaan* (of the Eagle moiety, also the clan and house of Shotridge) made a knife from the materials brought back from the exploration to honor the men who lost their lives. *Kaa.ushtí* hands the knife over to Eagle Head, who, now in his old age, says that all he can do is pass it on to stronger hands.

This is how the dagger, alluding to the exploits of the men's youth and to great moments in clan history, passed into the hands of the *Shangukeidí* to become their *at.óow*. In the words of Louis Shotridge, "Only through sacrifice does man acquire something of value. It was at the cost of brave lives that we now have in our hands those objects that constitute our pride."

NORA MARKS DAUENHAUER

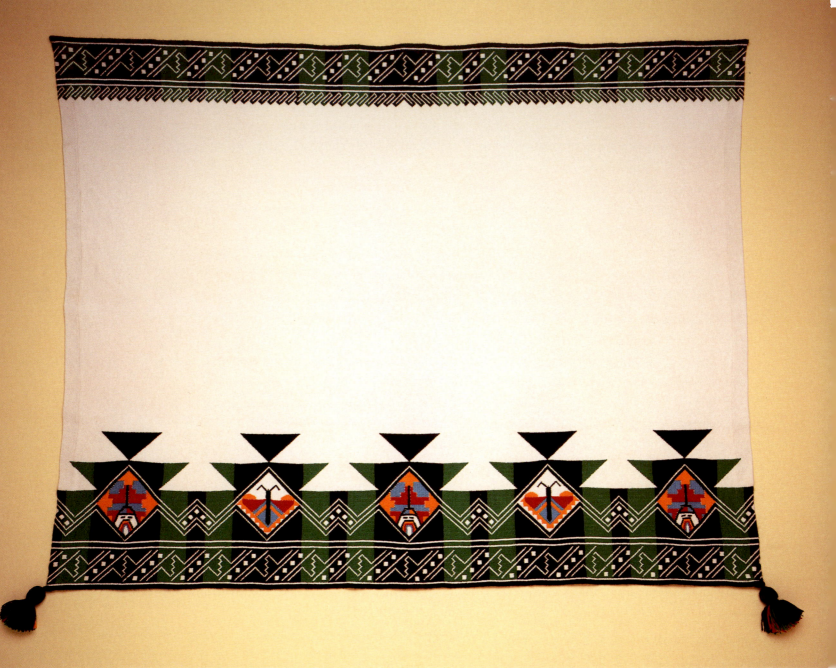

PLATE 54.

Manta

Artist, Ramoncita Sandoval

San Juan Pueblo, NM

2001

Cotton, wool; height

114.2 cm, width 147.3 cm

Collected by Lucy Fowler

Williams, 2001

2001-21-1

140

Embroidery at San Juan

I was born at San Juan Pueblo in 1923. My mother was Crucita Trujillo and my father was Pablo Cruz, both of the Winter Clan. I learned to do embroidery and pottery when I was in fifth grade at the San Juan Pueblo day school. Regina Cata and Lupe Sando of Jemez Pueblo were my teachers. They helped revive both pottery and embroidery at my village. Later, after high school and college, I taught sewing and embroidery at the Institute of American Indian Arts in the 1970s and 1980s. When my first granddaughter was born, I started to make clothing and to do embroidery more regularly. Today there are half a dozen or so women doing this kind of work at my pueblo of San Juan.

This is one of my white mantas. I embroider about two of these a year, and each one takes about three months to complete. I also make traditional shirts, dance kilts, and black mantas. The black mantas are the most time consuming and are particularly hard on the eyes. Men were the original textile artists among Pueblo people. My great-grandfather was a weaver and an embroiderer, and he made similar mantas for his grandfathers in the Pueblo. I sometimes get designs from his work. I make my dance kilts with the traditional patterns of rain, clouds, and lightning designs. I taught myself how to do traditional-style finger weaving, and I like to add a finger-woven band to the bottom of these.

I make dance outfits for all of my grandchildren. I also sell my pieces to other Pueblo people, collectors, and museums. I never accept a job on a deadline—this creates too much pressure and takes the enjoyment out of it for me. I am pleased when I see my kilts worn on special occasions at many of the pueblos. It is important to respect the clothing—it helps you respect the dance, to think about what the dance is for, and to act accordingly.

RAMONCITA C. SANDOVAL

141

PLATE 55.
Hat
Artists, Isabella and
Charles Edenshaw
Haida, BC
Ca. 1900
Spruce root, pigment;
diameter 42 cm
Gift of Anne W. Meirs, 1918
NA8999

142

Recognition

A Haida male or female of the Raven Clan with the Sea Lion as a crest would wear this wide-brimmed hat at important doings, like a potlatch. The wearer would be showing everybody who he or she was—what family they came from, and who they were connected to. Only a person of high standing would wear this hat, especially in public. There would be big trouble if someone who did not have the Sea Lion as a crest tried to wear it. This was a very serious offense and could result in war.

This hat is a collaboration between Isabella and Charles Edenshaw. Isabella was an accomplished weaver who wove spruce-root hats, baskets, baskets with lids, and mats. All of her weavings were finely executed and finished with great care. With her children and her friends, Isabella would go collecting spruce roots on the north end of Haida Gwaii (Queen Charlotte Islands). They would dig and pull up roots, get what they could handle, make a fire outside, bundle the roots, tie them together, and roast them to a certain point; then they would strip the bark off the roots. After they split the roots and bundled them together according to size, they tied them together to be stored at home. Isabella would do much of this work after finishing her daily family duties. During the winter months she would weave. With her finished works, Isabella and her family would travel extensively along the Northwest Coast selling and trading while also working and accepting new commissions and taking new orders.

Isabella's husband, Charles, painted his design of the two Sea Lions onto the sides of the hat with his stylized star (his signature marking) on the top. The design is executed in flowing-form lines, elegant but strong, in the traditional red and black colors of Haida art. Charles was a master of Haida designs. He has been and is highly respected, especially along the Northwest Coast, for his abilities and his standing as a Haida person.

These two Haida people come from longstanding, distinguished lines of the high-ranking, ruling-class Haida. Charles Edenshaw was a hereditary chief or "*Hdansuu*." Westerners could not pronounce this word correctly, so he became known as "Edenshaw." The name was also confirmed when they were baptized by an Anglican minister. Isabella was from Klukwan (Klinkwan) village, Alaska, and was of equal standing. Their marriage was arranged. Together they had three boys and eight girls, of which four girls survived. Charles carved until the end of his life, and died in 1920.

Isabella and Charles Edenshaw lived in a great and sad time of many changes—new trade goods, new diseases, new religions, new ways, new adventures, advantages, and disadvantages. They left a legacy of wonderful, exceptional works, works that they created themselves and others that they collaborated on. They are the reason I am here today, and why I carry on—they are my great-great-grandparents.

JIM HART

PLATE 56.
Baskets
Cherokee, Cherokee, NC
1945–46
Rivercane, pigment
Collected by Frank G. Speck
and John Witthoft
Gift of Frank G. Speck
46–6-49 (left) length 30 cm,
Artist, Lottie Stamper
46-6-47 height 40 cm,
Artist, Helen Bradley

144

Ihya

There is history in these two baskets. There are stories of women, of corn and fish, of change, of children, of walnut and bloodroot, of hands and memory. It's a lot for two little *talutsa* to hold. But Lottie Stamper's double-weave *ihya* (or rivercane) on the left and Helen Bradley's single-weave on the right will hold up to all the history we pour into them and to the memories we take out.

Lottie Stamper was a great teacher who shared her vast knowledge of the uses, forms, and mysteries of baskets with anyone who wanted to learn. Did she make this one from pictures of the old one in the British Museum out of respect for those gone before, as inspiration for those who would learn, as a statement that the old weaving was not dead?

In the 1940s and 1950s, did Lottie and Helen view their baskets as more than a source of supplemental income? Did they remember that, like *Kananeski Amayehi* (Water Spider), women carried fire, caught fish, and stored food in baskets? Surely they knew that their baskets brought *Selu* for ceremonies, the processed and stored corn, and that females themselves were once referred to as "sifters." Did they need scholars or tourists to remind them that the baskets were all about making the world anew?

Were they told the history that put women in the struggle to keep the world alive when the women traded (baskets and vegetables) with the *unega* and their *talutsa* held the tools of diplomacy? When wool and cotton replaced woven mats and metal, ceramics, and wooden casks threatened to replace baskets; when Removal sent memory away, nearly dismantling the power of the women, and when cane stands had to yield to the settlers' roads, cars, and white oak. Were they told that the act of making them is what matters?

Lottie and Helen grew up in the Depression when government and the Cherokees "revived" basket-making to keep people alive, an odd reversal of government policy. People worry today that they won't need to weave them if money and jobs from the new casino no longer require salvation by baskets.

Soldiers, missionaries, Andy Jackson, poverty, Removal, war, roads and carbon monoxide, dead husbands and brothers, hungry children, tourists, scholarly interest and indifference, casino jobs. All these things take the baskets away and make them necessary again. These *talutsa* are not reproductions of old things. Even when new, they are older than the oldest one in the British Museum, as old as memory, as old as *ihya*.

RAYNA GREEN

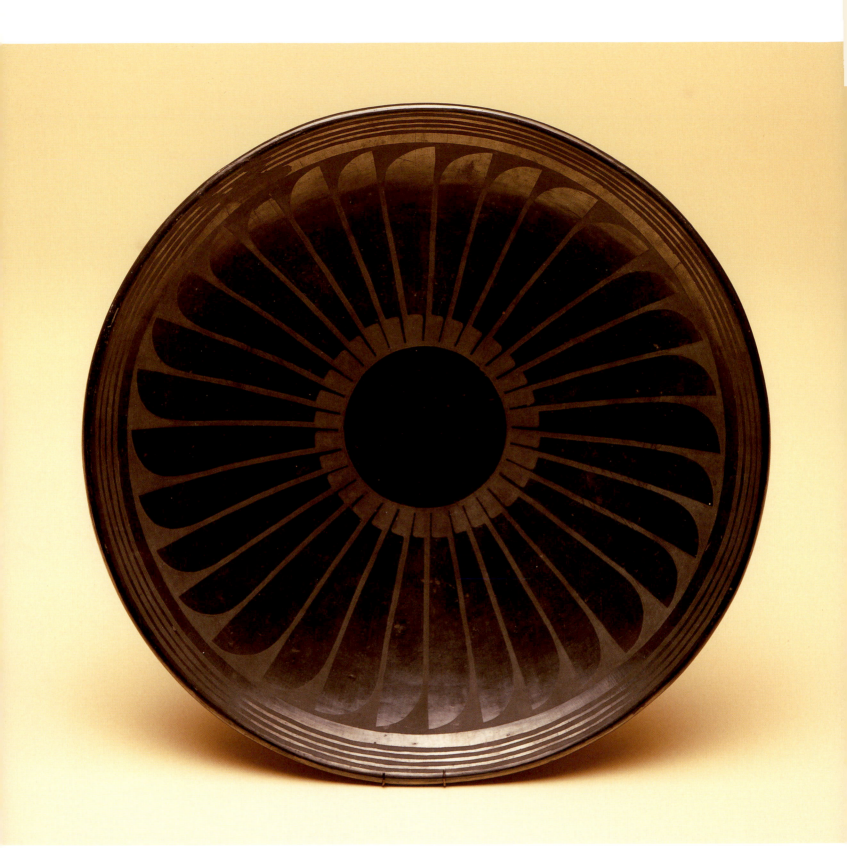

PLATE 57.
Plate
Artists, Maria and
Julian Martinez
San Ildefonso Pueblo, NM
Ca. 1930
Clay; diameter 37.5 cm
Denver Art Museum
exchange, 1959
59-14-10

146

Maria

57

I was fortunate to have known Maria Martinez when I was growing up at San Ildefonso Pueblo. My first memory of her is when I was only 5 years old, in the mid-1950s. We called her in Tewa, "the lady who lives by the corral."

I remember my cousins, friends, and I would play around the village plazas and surrounding fields during the summer months. Sometimes we would visit the women who were making ovenbread, pies, or cookies in the traditional outdoor ovens called "*Pontay,*" and sometimes we would visit Maria and the other women in the village to watch them make pottery. We would stand on Maria's porch for hours, our faces pressed against the screen-door looking in, not saying a word but watching with amazement at the different forms, shapes, and sizes of her pottery.

Sometimes we were fortunate and Maria would stop her pottery making and invite us into her home. She would make us stand in the middle of her kitchen while she went into another room. When she opened a second door, we could see four or five very large (black-on-black or polychrome) *olla*s lined up with lids, where she kept her dried foods. She would reach into the *olla*s, take out dried deer venison or dried fruit, and give it to us, one at a time. We thanked her in the Tewa language and ran out the door as fast as we could to sit under the "Big Tree" on the north plaza and eat our venison or fruit.

We made it a point to visit Maria as often as possible during the summer.

GARY S. ROYBAL

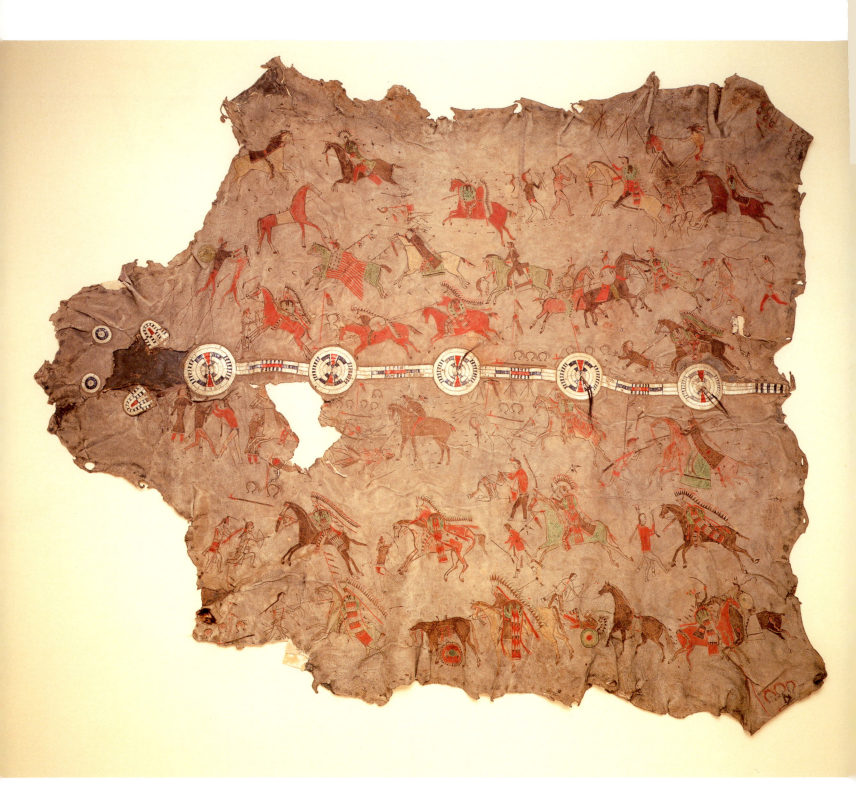

PLATE 58.
Buffalo Robe
Lakota (Sioux)
Ca. 1850
Buffalo hide, porcupine quill,
pigment; length 228.5 cm
Said to have been collected
by General Miles
Museum purchase, 1925
NA10721

Buffalo Robe

This buffalo robe is representative of thousands of similar Plains Indian robes made after 1830 and into 1860. Such robes were worn by eminent leaders who demonstrated their courage before the enemy. One can compare the intent of the pictography to that of the contemporary medals and ribbons of Euro-American military achievements. The entire painting is a biographical or autobiographical account of a warrior's accomplishments, possibly encompassing several episodes in his life, or an epic portrayal of him and his tribal members in a significant encounter with the enemy. As formal attire, this robe was also a declaration of the economic status of the warrior, his family, band, and tribe as illustrated by the prevalence of the eagle feather headdresses, swords, firearms, precious cloth, beads, and ultimately the very media used (the trade pigments).

This robe makes use of several kinds of trade materials. It appears to use wool cloth-trade cloth-both red and blue, with a white selvedge and white with black stripes, often identified as originating from the Hudson Bay Company. The vibrancy of the red, yellow, and green colors suggests that they are trade pigments prevalent among plains tribes as early as 1738. The women portrayed appear to be wearing blue trade-cloth dresses and red trade-cloth leggings. The female figure at the left, near the head part of the bison robe, may be Cheyenne because of the shoulder stripe-typical of the classic Cheyenne convention of decoration if indeed it is not the white selvedge of the blue cloth sewn together at the shoulders. (Cheyenne women or berdache were known to be warriors.) On the right near the edge a rider appears to be riding a horse with a green blanket with a black stripe, also a typical Hudson Bay trade item and what appears to be a long military coat.

The leggings on several riders appear to be decorated with triangular and broad stripes typical of the use of pony beads originally and primarily in colors of blue, white, and black, the original-sized beads traded on the Northern Plains as early as 1800 and were added to with smaller seed beads in a variety of hues after 1840.

The quillwork strip, originally covering the seam of a buffalo hide cut in half for ease in tanning and later rejoined, has metaphysical ramifications. It was also applied to whole tanned hides and eventually to trade blankets and blanket or robe-sized pieces of trade cloth-these became formal attire on public and intimate dress-up occasions worn in a variety of ways, each with its own meaning as a form of communication of the wearer's disposition. The quillwork design on this robe is technically and stylistic circa 1840-50. In time, European glass beads obtained through trade supplanted the work originally done with porcupine quills. Today the older tradition of quillwork is still practiced and treasured above that of beadwork.

ARTHUR AMIOTTE

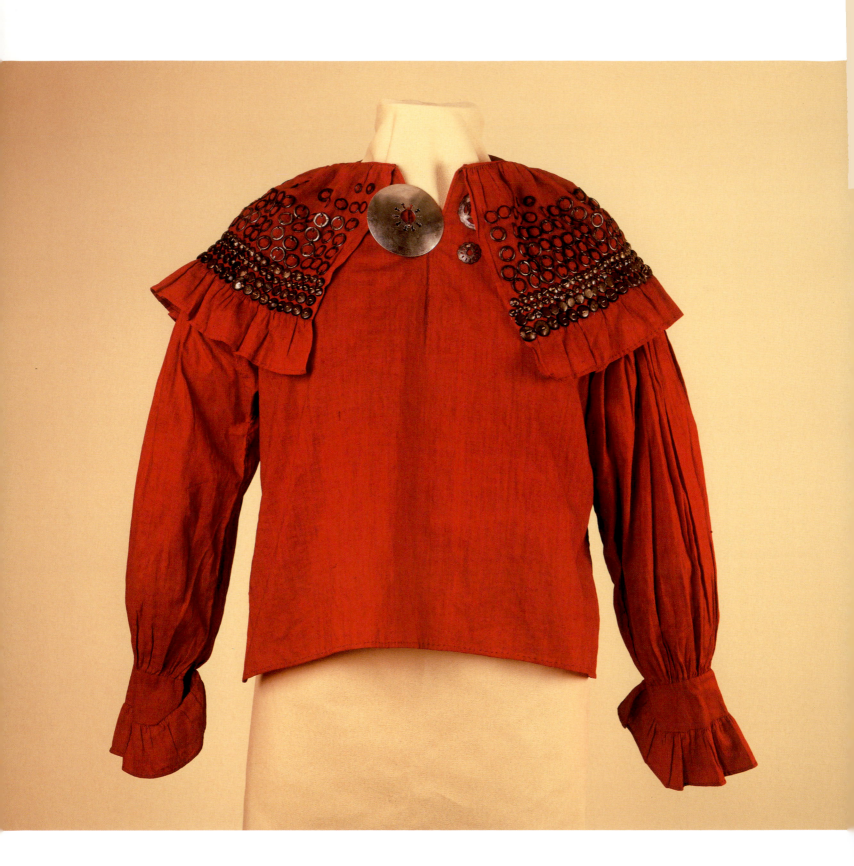

PLATE 59.
Woman's Blouse
Lenape (Delaware), OK
Ca. 1850
Cotton cloth, silver;
length 54 cm
Collected by Frank G. Speck,
1930s
Museum purchase, 1981
81-24-1

Remembering

I see the blouse before me and am stirred by its deep color and intricate beauty.
I touch the fabric, feel its strength, and wonder about the woman
whose breath gave it life and movement.

One hundred fifty years old--it doesn't look its age! The time of my great-grandmother's
birth. Stories abound of this woman's strength, skill and humor, her own mother
beloved and honored for keeping alive traditional ways of healing.

I think of her grandson, my grandfather. From time to time I touch the overalls he wore,
a keepsake, and re-call "helping" him as a child as he planted seeds in the earth,
ever gentle with soil, animals and people alike.

I pull a shawl around me made by his daughter, my mother. It brings love,
wisdom and comfort when I need them most. Carrier of family stories,
Mother's gifts endure for my children and grandchildren.

We see and touch, and so we "re-member"—bring back into being those who came
before. We thank the Creator for their lives in prayers and ceremonies,
honoring them, Lenapes all—past, yet still present and future.

ANN NOE DAPICE

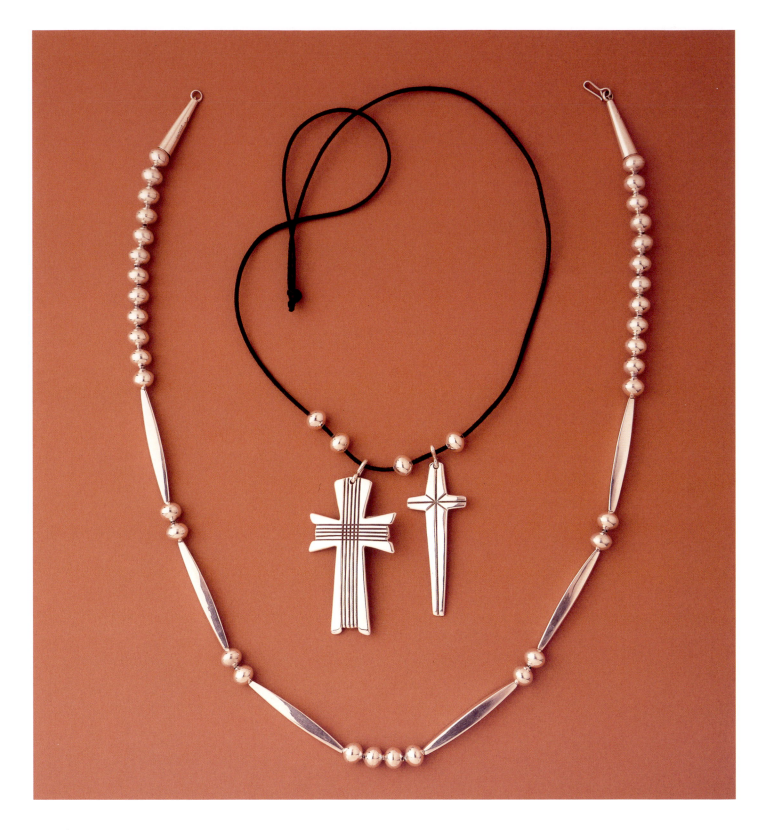

PLATE 60.
Necklaces
Artist, Cippy Crazy Horse
Cochiti Pueblo, NM
2002
Silver; 2003-29-1 (top),
length 75 cm, collected by
Robert W. Preucel, 2003;
2002-17-4 (bottom), length
76 cm
collected by Lucy Fowler
Williams, 2002

152

Wearable Silver

I was exposed to the art of silver jewelry making from an early age. Both my parents, Joe H. Quintana and Terecita Quintana, of Cochiti Pueblo, produced fine silver pieces. However, I did not take up the craft as a child. It took a freak accident in the early 1970s to motivate me to get into silverwork. I am thus a self-taught silversmith, inspired by my parents work, by pictures in art books, and by the beautiful silver work in museums.

The style of my jewelry is primarily influenced by my parents' plain, simple, clean designs. Most of my pieces are deep chiseled or have deep stamp work in hand-wrought silver ingots. I try not to politicize any of my pieces, but rather make them wearable artwork so the people who own the jewelry are proud to wear them. Maybe, someday, they will end up in the museums or books like the pieces I've admired.

My crosses are plain with deeply chiseled line designs emphasizing the form. I usually make them in pairs. My "long bead" necklaces are made in the same style my father used and I am still using the particular bead die he made. Its unique shape distinguishes these beads from the beads produced by other artisans.

CIPPY CRAZY HORSE

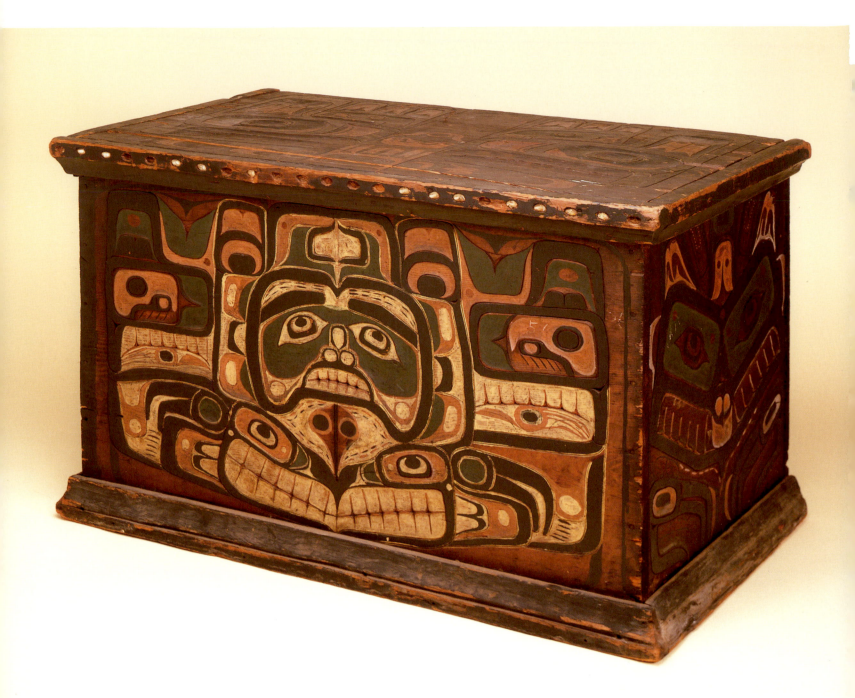

PLATE 61.
Box
Kwakwaka'wakw (Kwakiutl),
Kingcome, BC
Late 19th/early 20th century
Wood, pigment; length
109 cm, height 64 cm
George G. Heye Collection
Museum exchange, before
1917
29-175-335

154

Kwakwaka'wakw Box

Box designs are some of the most complex compositions created in Pacific Northwest Coast design. A box exists as a three-dimensional object, and most often the designs on all four vertical surfaces reference one another in some way. This design is particularly *Kwakwaka'wakw* in its formal characteristics with its free-flowing form lines and expressive painterly application. Since it was collected prior to 1917, I wonder about the conditions it existed within prior to becoming housed in a museum setting. What objects were stored inside it? What activities did this box bear witness to? What information does it contain indecipherable to us nearly a hundred years later?

The design application reminds me of two wooden coppers that are today housed within the old bighouse (*gukwdzi*) in Kingcome Inlet. These two coppers once stood outside a community hall our elders built in the late 1930s. Eventually, when the hall collapsed the coppers were placed in the bighouse. For years they have witnessed events: baptisms, name givings, potlatches, and funerals. Objects have a lifestory, absorbing nicks, scratches, deteriorations, and repairs. At times I wish these objects spoke as we do and could inform us of the great events that have worn away at their surfaces. The central face of this box stares out in a benign way. Within it there exists some tension that never releases, forever suspended. An expression created by the artist Tom Patch Wamiss, who died in the early 1960s, seems to mirror the circumstances of the object—this box that is now contained within another "sort of box" (the museum) survives, for now, suspended in time.

MARIANNE NICHOLSON

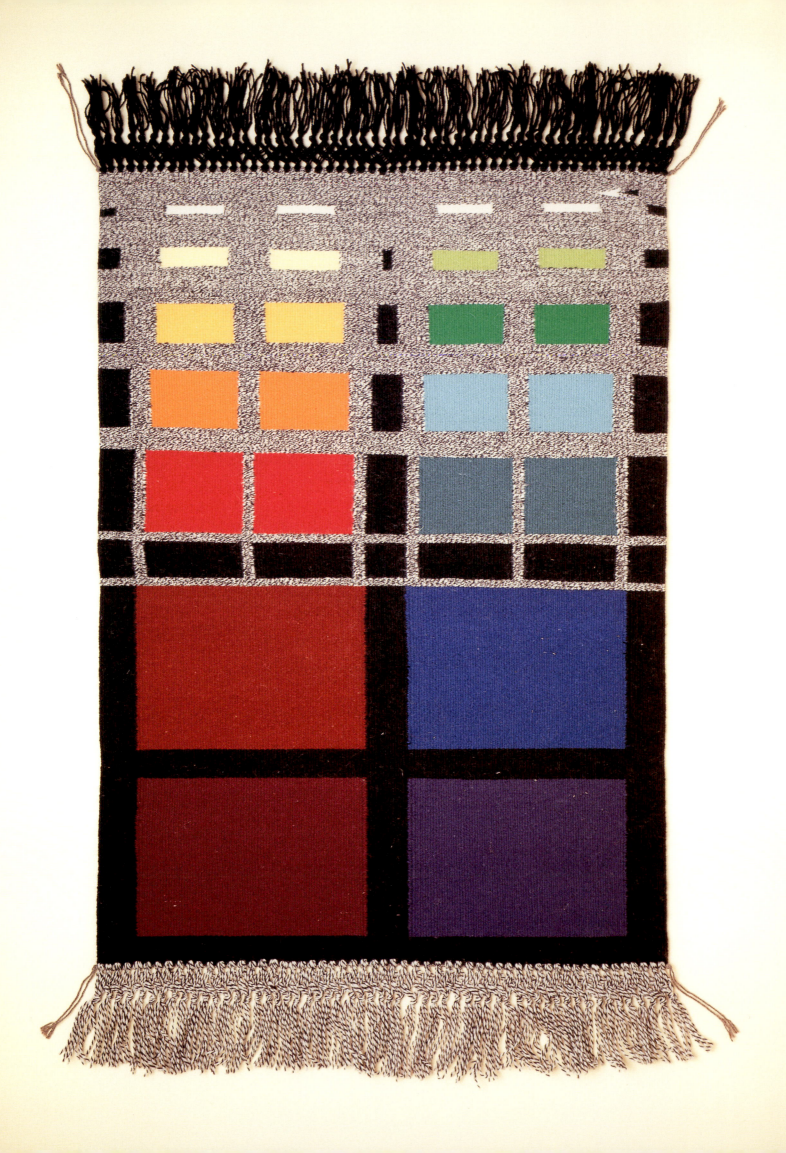

Gravity

I wove this rug back in 1999. This rug represents something that I went through personally. Rather than troubling my family with the problem, I took my time weaving this rug.

I started with the heavy part of the rug, the larger darker blocks, and as I went up things got lighter. I would say that the same thing happened with my problem as I wove. I found out that I just need to put things in proper perspective.

By the time I was done with this rug, I had a full grasp of my problem and it seemed like I didn't need to burden my family. They only had to listen to the solution. But this doesn't mean I take my problems or frustrations out on my rugs. It was a personal problem, and that is all I can say.

MAE CLARK

PLATE 62.
Rug, "Gravity"
Artist, Mae Clark
Navajo, AZ
1999
Wool; length 96 cm,
width 68 cm
Gift of R. B. Burnham and
Co., Trading Post, 2000
2000-15-1

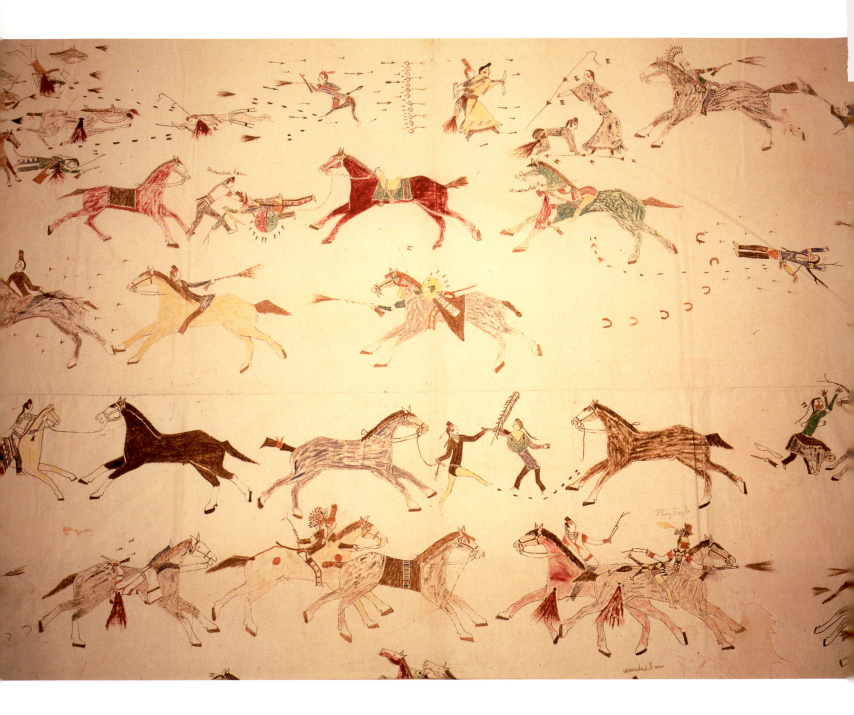

PLATE 63.
Painted Muslin
Mandan
Ca. 1880
Muslin, pigment; length
228 cm, width 231 cm
Collected by Charles H.
Stephens, 1891
Museum purchase, 1945
45-15-1349

The Thunderbird, Spirit, Wind, Crazy Dogs, and Mustangs

63

Separated by 200 years our spirits were reunited, each of us raised to be warriors, defenders of our people and our place. In the moment that we were given to share I knew you were the POW and the MIA. I cannot rest until you are brought home.

Here is the story you told me when I held that ancient pipe which they told me was last smoked 200 years ago but smelled as though it were freshly doused.

They came from the place where dawn and dusk meet and part; the same direction that we lay the heads of those who have begun their journey into the spirit world.

Without an invite, they were trespassers and transgressors traversing into our territory and treading across our sacred sites. Those that followed were the takers.

The *Mashuga waa raa xii* readied four days earlier, knowing this day would come. *Mashugaa waa raa xii* need not speak a word as their regalia proclaimed their role as the protectors of the people.

From their headdress exploding with eagle feathers like the ruffled feathers of the rushing war eagle to their well-worn leather leggin's, painted from the sacred gifts of the grand-mother earth.

The warriors' leggin's, from hip to toe, blended into the earth, protecting him from the force of the prairie winds and the enemy's assault. His eyes keen and bright, as the lightning that shoots from the eyes of the thunderbird, peered into the sunrise from under the shadows of the eagle headdress.

The *Mashuga waa raa xii* sang their warrior songs as their painted war ponies danced into the midst of the intruders, wanting peace but ready for unimagined peril.

You returned triumphant and those for whom you sacrificed ran to greet you, old women rattled their tongues, little children ran behind your mustangs, and the whole village rang out with your victory song.

I could hear the echo of that day's victorious events, and I felt your heart pound in each of your painted scenes. Your winter count told the story of courage, love, and loyalty.

The pipe, the winter count, and the leggin's lie disconnected from body, spirit, time, and place-held in the tomb of the takers. This is the century when you will be brought home-to rest in peace.

L. BUDDY GWIN

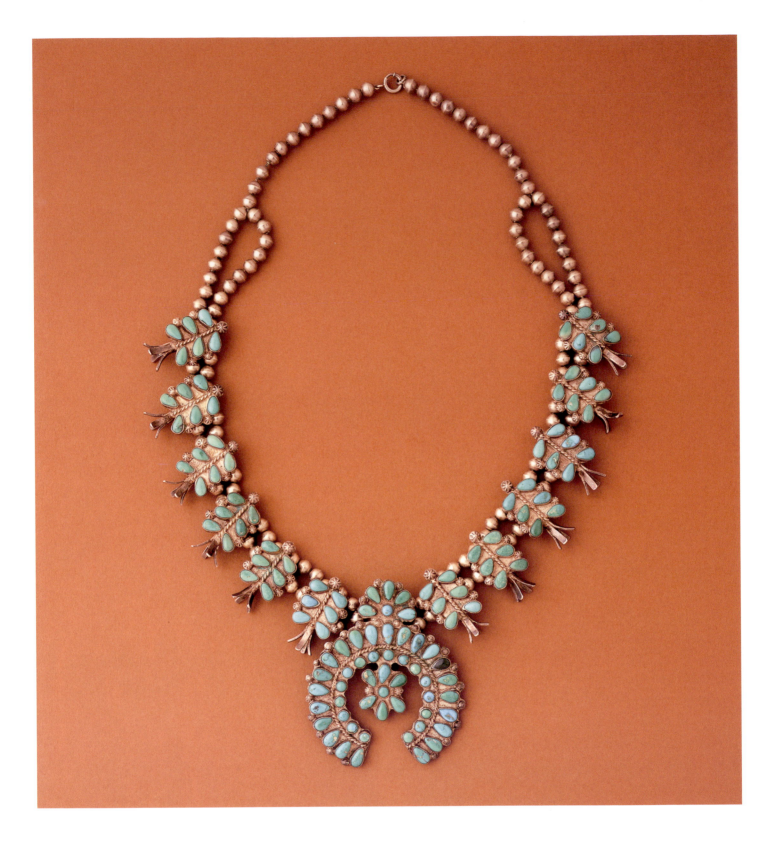

PLATE 64.
**Squash Blossom
Necklace**
Zuni, NM
1900–10
Silver, turquoise;
length 38.2 cm
Gift of Dr. Sylvia Sclar
Friedman, 1991
91-35-1

Mother's Squash Blossom

64

My first glimpse of my Mother's Squash Blossom Necklace may have been at a special family event or a Sunday morning church service. On these occasions she would always want to look her best and she made sure that Dad, my younger brother, and I did as well.

My Mother's Squash Blossom is a single strand, hand made with 12 silver blossoms, with three turquoise stones attached to the *nazhah*, roughly translated as horseshoe-shaped or crescent-shaped pendant. I was told that the creator of her necklace was a Navajo man named Fred Peshlakai, who may have been in his early fifties and owned a silversmith shop on Olivera Street near downtown Los Angeles, California. My Father purchased this necklace in 1956 as a Christmas gift for my Mom, as she was seven months pregnant with me.

Since my initial encounter with my Mother's Squash Blossom, I have come to be the Community Services Coordinator for the National Museum of the American Indian, Smithsonian Institution, at the Cultural Resources Center in Suitland, Maryland, a place far and different from where I grew up in southern California and Shiprock, New Mexico. In one of the programs that I oversee, the Native Arts Program, Native artists collaborate with Community Services staff and schedule appointments with various museums, like the University of Pennsylvania Museum of Archaeology and Anthropology, to research and study museum collections which will then lead to community-based projects, enhancing artistic growth and strengthening career development.

So given the opportunity to respond to the Zuni Squash Blossom Necklace from the University of Pennsylvania Museum collection, I decided to follow similar footsteps of Native artists and explore the collections of the National Museum of the American Indian. I saw a wide variety of jewelry that may be considered Navajo or Zuni. Of course there are always more questions than answers, but one can readily see similar patterns, shapes, designs, and materials shared by neighboring tribes. This Zuni necklace differs from Navajo examples mainly in the use of the image of the dragonfly, a water symbol of the Zuni, the dragonfly being a messenger of water, of survival, in an environment that allows no room for error.

So is there a relationship between this Zuni Squash Blossom and my Mother's Squash Blossom? Maybe the creator of this necklace made it with a very special lady in mind. All I know and believe is my Mother's Squash Blossom is special to her because my Father gave it to her to wear on special occasions.

KEEVIN LEWIS

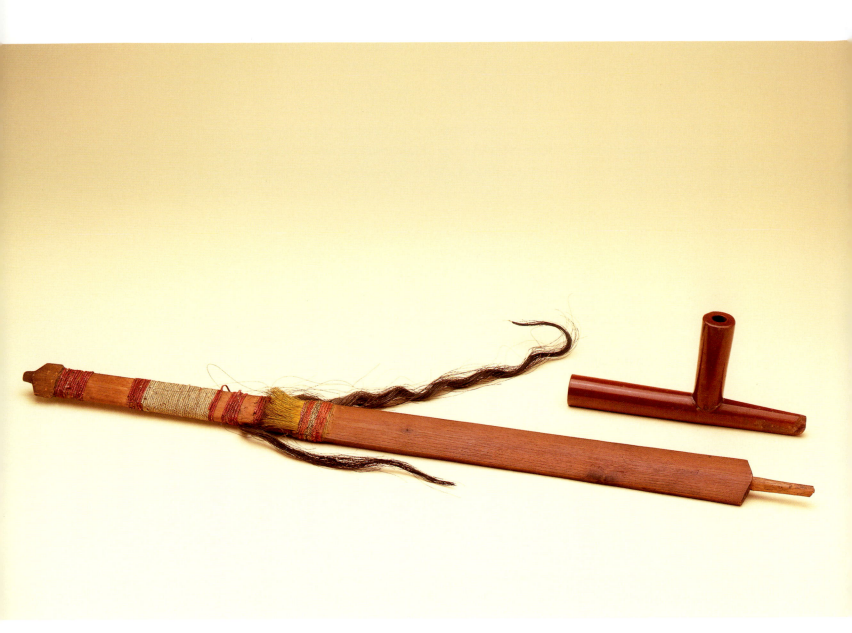

PLATE 65.
Pipe Stem and Bowl
Anishnabe (Ojibwa)
Late 19th century
Wood, porcupine quill,
catlinite; length 83.8 cm
Collected by J. Edward
Whitfield
Gift of Academy of Natural
Sciences, Philadelphia, 1998
L-84-1359 a,b

I Spend More Time With My Pipe

65

As I journey through this life, I spend more time with my pipe.

When I was a young boy, my Father and uncles taught me the traditional *Midewiwin* ways of my ancestors. I learned to offer tobacco in prayer. I learned the healing power of the sweat lodge. I learned the interconnectedness that all living things share. I learned the strength of spirit to be gained living the way my ancestors did. I danced. I sang. I feasted. With teachings of love and mutual respect ingrained in my spirit, I set about exploring the Mother Earth.

Through the years, I have traveled the world and I have made friends with many of its people. I have encountered many different races, languages, cultures, religions, and environments. I no longer see the world through the eyes of a young boy.

I find myself spending more and more time in deep thought, trying to make sense of the world around me. I ask more questions and I ask for more guidance.

I spend more time with my pipe.

Last night, I offered tobacco and prayed for those that have gone to the spirit world before me. These days it seems there are so many. The reasons escape me. As I watched the smoke rise, carrying my prayers to the Creator, I was reminded of the words of the great Chief Tecumseh:

"Live your life that the fear of death can never enter your heart. Trouble no one about their religion: Respect others in their view, and demand that they respect yours, love your life, perfect your life, beautify all things in your life. Seek to make your purpose in the service of your people. Prepare a noble death song for the day when you go over the great divide. Always give a word or a sign of salute when meeting or passing a friend, even a stranger, when in a lonely place. Show respect to all people and grovel to none. When you arise in the morning give thanks for the food and for the joy of living. If you see no reason for giving thanks the fault lies only in yourself."

I live in a different world than my ancestors did. However, in some ways, it is not much different at all. I am grateful for their wisdom and for the teachings that they have passed down. Even in this different world they have served me and guide me as I continue my journey.

I spend more time with my pipe.

STEPHEN J. JOHNSON

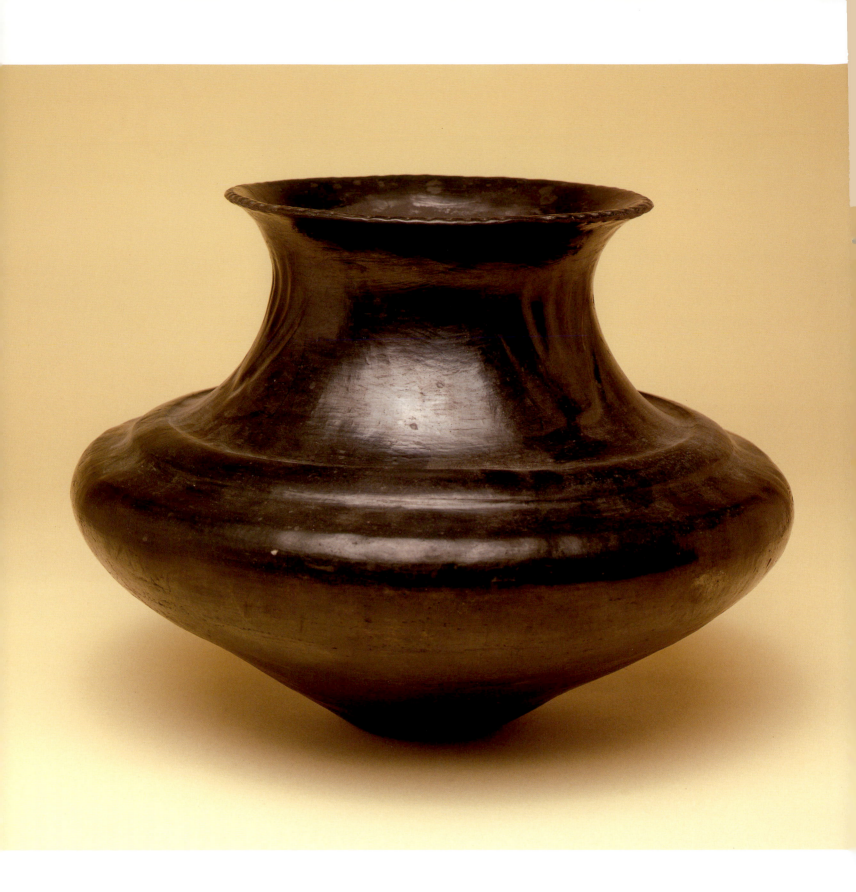

PLATE 66.
Water Jar (*Olla*)
Santa Clara Pueblo, NM
Late 19th/early 20th century
Clay; height 25.3 cm
Denver Art Museum
exchange, 1959
59-14-14

Santa Clara Bear Paw Jar

Long ago, a group of people now known as the Santa Clara Pueblo Tewa were moving south looking for the perfect place to live. They became lost in the mountains and were slowly dying of thirst and starvation. While they considered their options, they noticed a bear lingering at the edge of their campground. At first, they feared that the bear knew of their situation and was waiting for the people to die. As a few days went by, the bear did not attack them, but patiently waited about. Finally, in desperation, the people decided they had no choice but to continue wandering. As the people moved forward, the bear would move in front of them and continue walking. It was becoming clear that the bear wanted the group to follow him. The bear led the band of Tewa to a beautiful valley with a river flowing through it. The Tewa knew they were home. They called their village *Kha'P'o* meaning "Singing Water." Today it is known as Santa Clara Pueblo.

On many of the water jars and food storage jars, you will see the bear paw imprint or the human hand imprint. They are interchangeable since the bear is considered a brother to the Santa Clara People.

This highly polished black Santa Clara water jar was made in the style of Severa Tafoya during the 1890-1920 era. The rim of the water jar is very slightly fluted. The base may be concave to allow for easier carrying on the head. The beautifully shaped jar has a more hand-shaped imprint rather than the stubbier bear paw print.

When I look at the jar, two memories come to mind: the immediate memory of the story I have related and the image of a stately Pueblo Indian woman walking home from the river at dusk balancing the life-sustaining jar of water on her head.

DOLLY NARANJO NEIKRUG

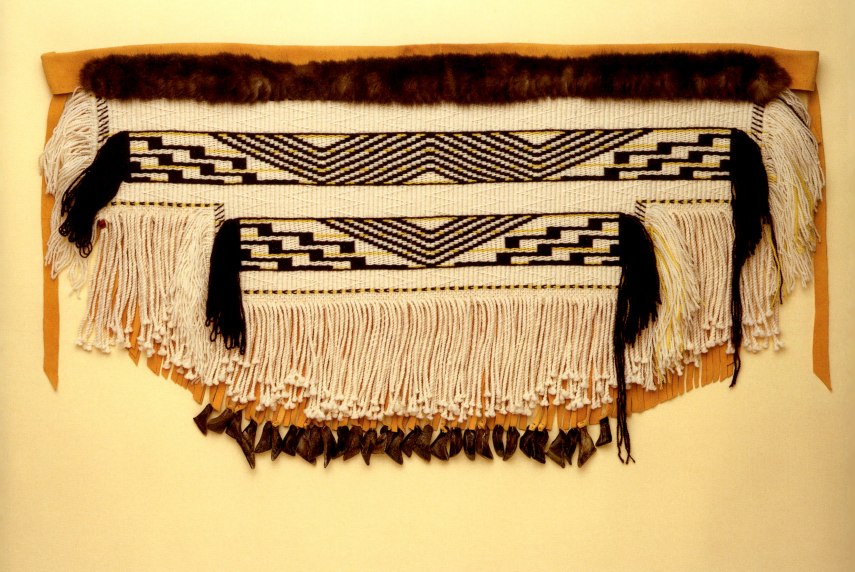

PLATE 67.
Dance Apron
Artist, Teri Rofkar
Tlingit, Sitka, AK
2003
Wool, sea otter fur, deerskin,
deer toes; width 87.6 cm
Museum purchase, 2003
2003-20-1

166

A Tribute to Emily

Over the years there have been cultural exchange programs and exhibits within the Pacific region and the cultural bond has been strengthened by the indigenous people weaving themselves together strand by strand. It has long been a dream of our weavers to put together an exhibition of women's crafts from the Pacific Rim countries.
EMILY SCHUSTER

I met Emily Schuster and Cath Brown in April 1997 in Sitka, Alaska, as they traveled the ocean's rim in pursuit of a dream. Thousands of miles of ocean separate us, but the weaving has no regard for distance.

Taniko weaving on the borders of Maori cloaks closely resembles the border designs used in Tlingit Raven's Tail robes, both in method of weaving and the meaning behind the designs.

Emily died before her dream came to pass. Her enthusiasm, energy, and spirit moved me to weave this *San keit* [waist robe]. A similar garment exists among the Maori called Maro.

If you look at the weaving there are two major design elements:

Sha 'r-dar yar-a'r-ke [Work or embroidery around the head], an old-style Tlingit hat usually worn by Shamans, no longer found on the coast. For the Maori the design is called "Steps to Our Ancestors." This meaning was explained to me by a Maori weaver I worked with several years ago.

Yeil t'oogu [Raven's cradle] is a Tlingit design used at the top edge of large baskets. These baskets were cut up and fashioned into carriers for infants. In the Maori culture I see this same design on the edge of *Kahu kura* [Red feather cloak], as well as on large screens in the Maori *marae*.

The textural pattern that runs throughout the waist robe is a reference to my own linage, "Snail Tracks." I am from the *Ta'k dein taan* clan, a Raven from the *T'aax hi't* [Snail House].

This waist robe is trimmed in sea otter fur and deer toes. It's ready to dance and to speak of the threads that tie.

TERI ROFKAR

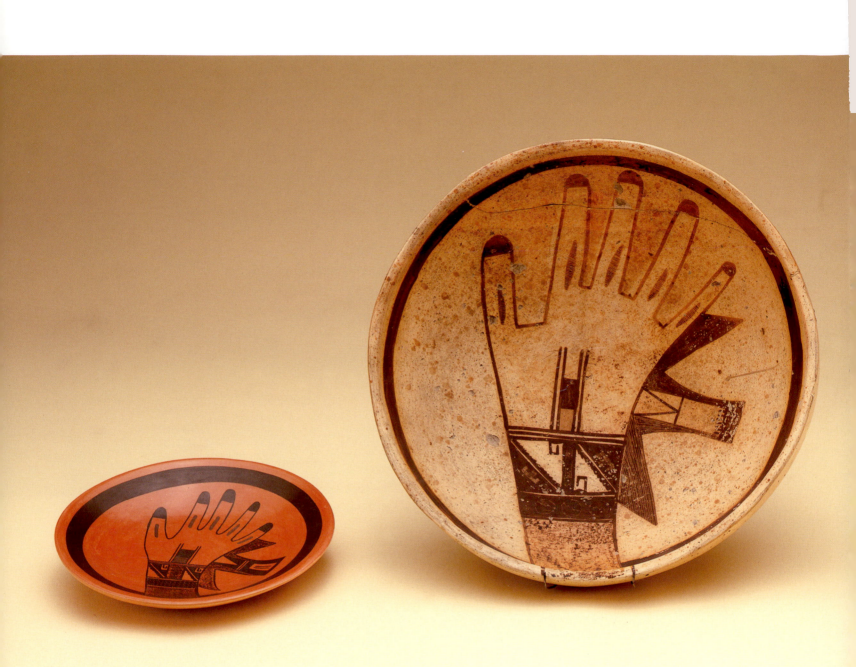

PLATE 68.

Dish (left)

Artist, White Swann

Hopi, AZ

2003

Clay, pigment;

diameter 15.8 cm

Collected by Robert W.

Preucel, 2003

2003-29-2

Bowl (right)

Ancestral Pueblo, Sityatki

A.D. 1400–1500

Clay; diameter 26 cm

Thomas V. Keam Collection

Collected by Stewart

Culin (John Wanamaker

Expedition), 1901

39051

Catching the Rainbird

68

My name is White Swann, and I am a Hopi from Kearns Canyon, Arizona. At age six my grandmother, *Poli-Ini,* and Mother, Fawn, taught me the techniques of pottery making with great patience.

My traditional pottery is hand coiled from native clay dug near home and strained of debris. I'm in my own world through out this whole process, patiently coiling, shaping with gourd tools, and smoothing with sandstone when dried. A river rock is swiftly but gently rubbed against the slightly dampened sides to produce a high shine. Natural pigments of several yellow clays, mustard weed, iron oxide, and soft charcoal-colored stones are applied with homemade yucca brushes to create my own style of intricate designs.

The designs come to me in dreams, from shards gathered from *Awatovi, Kawaika,* and *Sityatki* ruins or from heirlooms from Grandfather Navasie. I especially like to use rainbirds, water symbols, and ancient *kiva* mural designs. I was inspired by this old *Sityatki* pot at the University Museum because of its beauty. To me, the design represents someone catching the Rainbird. I am pleased that the Museum wanted to buy my pot for their collection.

I look forward to each finished piece, giving credit to my Creator, Grandparents, and Mother for ability and guidance. I'm teaching the traditional techniques to my son and three daughters, who have earned awards for their art work.

DOLLY NAVASIE (WHITE SWANN)

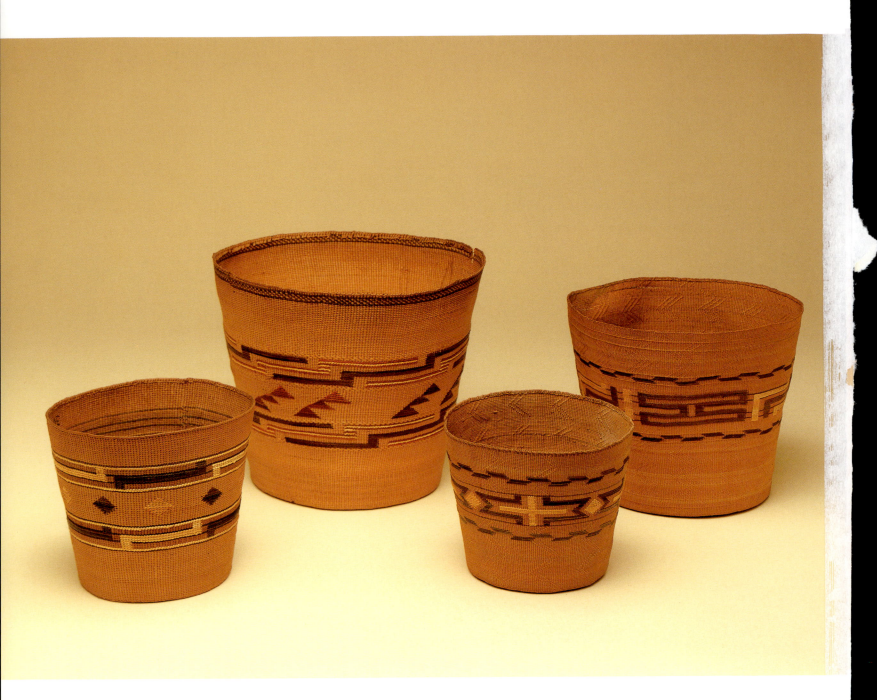

PLATE 69.
Baskets
Tlingit, Sitka, AK
Spruce root, wool
Collected by Louis Shotridge,
1930
From left to right,
30-11-9, height 11.9 cm;
30-11-2, height 17.7 cm;
30-11-8, height 11.2 cm;
30-11-3, height 14.9 cm

Voices from my Past

Is it the beauty that holds your eye? Can you see the weaver as she brings the maidenhair fern and grass to life? *Thluhl k-yar-nee* [Leaves of the Fireweed], *Shar'r-dar yar-a'r-kee* [Work or embroidery around the head], *Klaok shar yar kee'-kee*, [Half head of the Salmonberry] . . . these designs dance around the basket inviting you to follow. The designs on the berry baskets have elements seen on baskets from Hoonah. My Grandmother is from Hoonah. My Clan is from Hoonah, we were weavers. "Grandma? Great Grandma? Is that you?" Perhaps it's the strength of the spruce roots themselves that communicate on another level.

I too enjoy the designs and the individual stories they tell, but then I get closer. Looking at the weave itself, the fine roots on the sides and bottom speak to me of the beaches and trees. The sound of the ocean waves . . . endless hours on hands and knees under the strong young spruce trees harvesting the runner roots . . . not too many . . . remembering the Tree People, we have a relationship, we care for each other. Do you see it? Can you feel it? Energy is still strong within these Tlingit baskets after so many years.

How many years? My Grandmother, Eliza Mork, would say "from time immemorial." As a child I always wondered "how long is time immemorial?"

Between 1997 and 1999 my answer would come. Not one, but several baskets emerged out of the mud here on Baranof Island just south of Sitka, Alaska.

"Are you paying attention?"

"Hello, again."

"Are you listening?" It was as if I had been singled out! I personally found one of the baskets, and it changed my life. Three of the baskets were carbon dated, and all were almost 5,000 years old! The weaving is identical in technique to these here. The roots are split the same way. There is continuity from time immemorial!

These baskets don't speak of the past, but reflect an intimate relationship today, tomorrow, and yesterday. It is up to me to add my voice, a song for the future. Not over the top of the soft voices of the past, but in harmony as a chorus becomes strong with new life. Tlingit basketry becomes strong with new weavers.

TERI ROFKAR

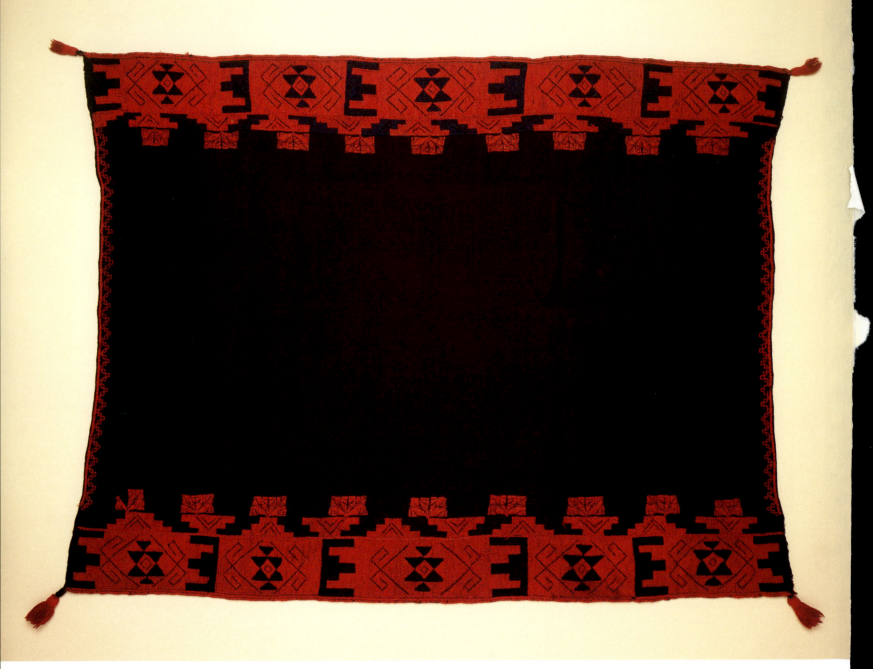

PLATE 70.
Manta
Acoma Pueblo, NM
Ca. 1850
Wool; length 111.7 cm,
width 142.2 cm
Gift of Anne W. Meirs, 1918
NA9104

Black and Red Dimensions

Actually it is not black but blue, a deep blue. A blue so deep and dense and dark it is almost without dimension. It is a blue so deep it is black. I wonder how that depth and solidity is achieved? And how maintained? All this is mysterious to me. And the red that is a border and decoration. Mountains and stars and flowers. Horizons distant and close at the same time. I think of *Aacqumeh* grandmothers and great-grandmothers I never really knew except I know I was born from my Mother who had a Mother and a Grandmother.

Continued by my Mother, Grandmother, and Great-grandmother, I am of that lineage.

Aacqu was noted for its woven fabrics in the old times. *Meeshru hamah.* Long time ago. I've only seen such rare finery in museums. By the time I was a boy in the 1940s, no one at *Aacqu* wove anything like that. I don't know how the deep, dark, dense blue color was achieved. Nor the red. The dimensions had compressed into a flat plane. And even at the time I did not know *Aacqumeh hano* at one time did such fine, fine weaving. And it was not until later that I learned they were indeed very rare anymore.

And I did not know it was the men of the Pueblo of *Aacqu* who wove the fabrics.

My Grandfather was a *chaiyaanih. Chaiyaanih dah.* He knew medicines and ways of healing. He is gone now, therefore you must add a *shaatah* to his name, even to the referential term that designates him. You say *stah-nana-shaatah.* I never asked him about the blue nor about the red. He was beloved and precious. He passed on when I was less than ten years old. I did not know yet how rare the art of fine weaving had become. Perhaps *stah-nana-shaatah* would have told what he knew about the colors of blue and red. Perhaps he would have told me about the dimesions I pondered as a boy and the dimensions I would ponder as a man.

I miss my grandfathers-*shaatah* and my grandmothers-*shaatah*, and the dimensions of our lives.

SIMON J. ORTIZ

Eyes

LOOKING FORWARD FOR FUTURE GENERATIONS

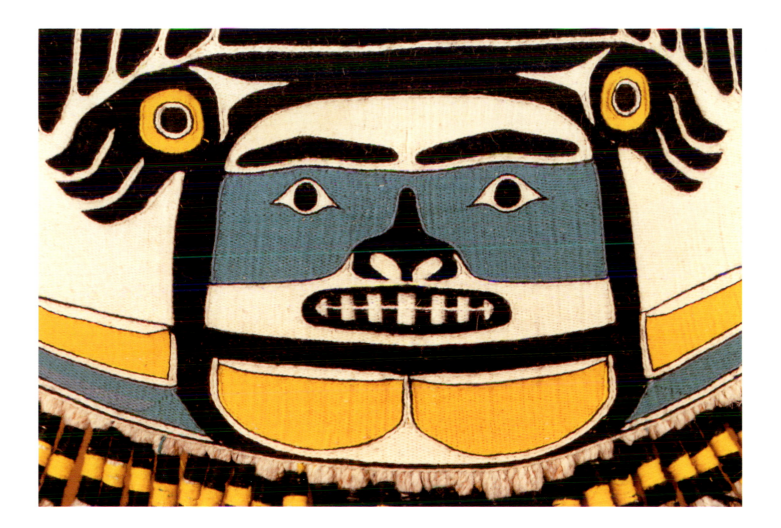

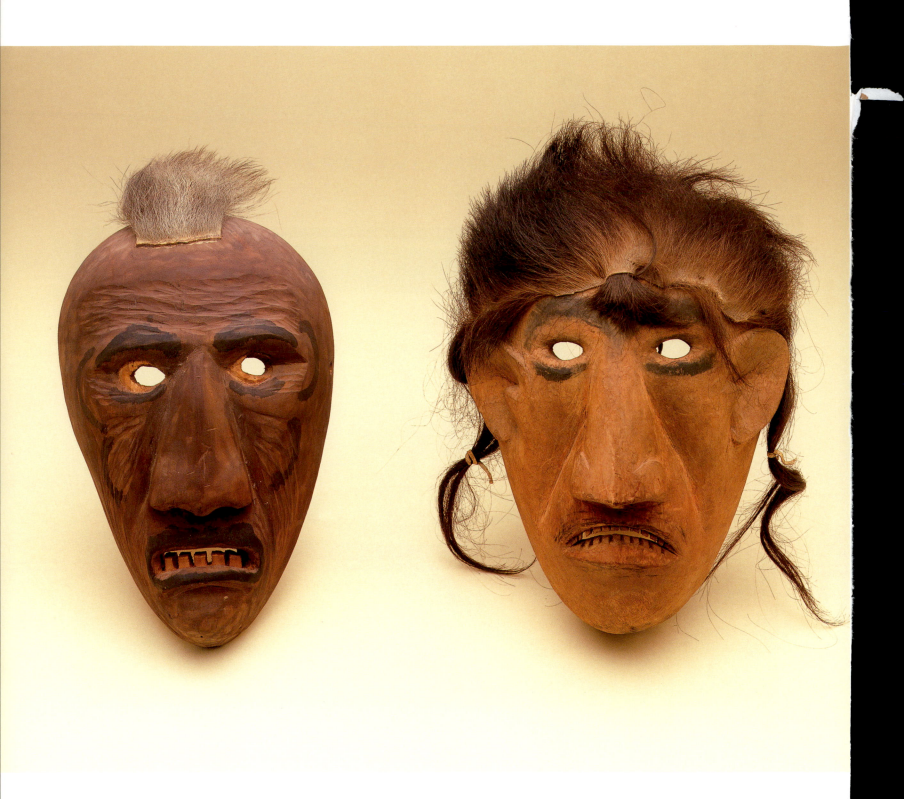

PLATE 71.
Booger Masks
Cherokee, Big Cove, NC
Wood, hair
58-6-1 (left), height 26 cm,
made by Allen Long, ca. 1957,
collected by Paul Kutsche,
1957, Museum purchase,
1958; 70-9-777 (right), height
25 cm, made by Will West
Long, ca. 1940, bequest of
Samuel Pennypacker, 1969

Cherokee Booger Masks

I have a Booger mask in my office at UCLA. It hangs on the wall to the side of my desk, centered above a clock with numerals written in Cherokee. My mask represents the face of an Indian; it is carved from wood, and the top is covered with deerskin with the hair still attached. It is a nice piece of Cherokee craftsmanship. What is more important to me is that it is a symbol of Cherokee history and helps to keep me in touch with our history, facets of which are expressed in Booger dances.

Booger dances are often said to "make fun of the whites," and they certainly do this as well as making fun of other types of people. These dances ridicule the acts of domination. Historic themes commented upon in Booger dances include the Europeans bringing war and disease to the Cherokee and the sexual desires of the Europeans for Cherokee women. But the dances also represent the embodiment of the Cherokee concept of Ga Du Gi (*gadugi*) or simply Ga Du (*gadu*), the coming together to focus on a common goal or mutual aid.

In 2007, Oklahoma celebrates 100 years as a state. The Cherokee Nation of Oklahoma, however, has its own response to the state's centennial by celebrating in 2005 the centennial of a constitutional convention held in Muskogee, Indian Territory. The convention was part of an effort by the Cherokee and other Indians to enter the union as the state of Sequoyah, to be formed solely from the lands of Indian Territory (now roughly the eastern part of Oklahoma) rather than having Indian Territory combined with Oklahoma Territory to the west to form the present state.

The Nation's activities in conjunction with the two centennials will be planned by the Great State of Sequoyah Commission (which I chair). The Commission is part of a current effort of Ga Du Gi to join in mutual respect to further "the welfare and prosperity of Cherokee people and of the sovereign Cherokee Nation," as pledged by participants in a leadership conference at the 2003 inauguration of our principal and deputy chiefs and members of the tribal council. Perhaps we Cherokee should all don Booger masks and participate in a Booger dance for the people of the state of Oklahoma.

RUSSELL THORNTON

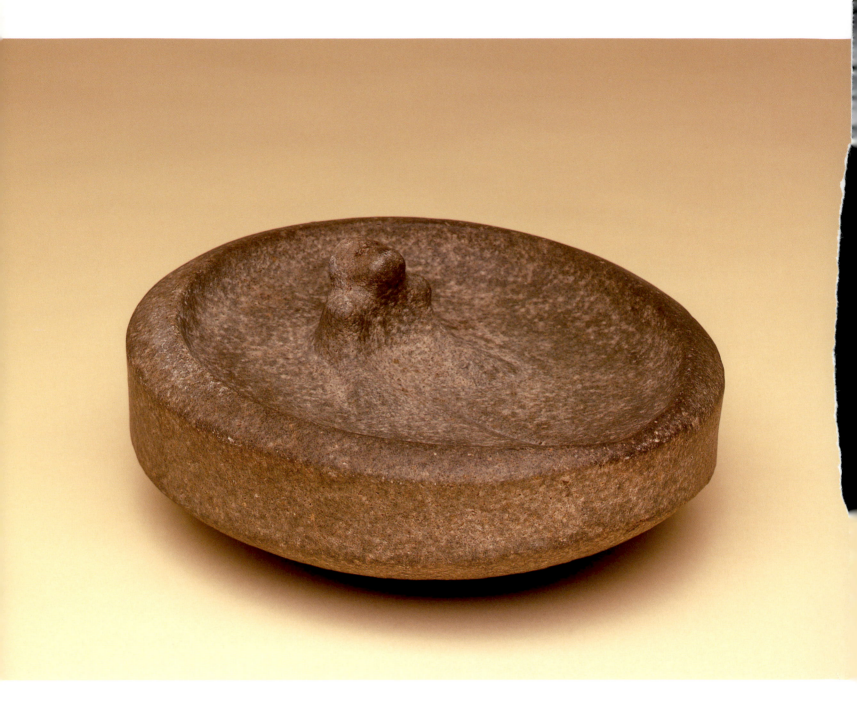

PLATE 72.
Seal Oil Lamp
Prehistoric Inuit (Eskimo),
Kachemak Bay Culture III,
Yukon Island, AK
A.D. 600
Stone: greatest diameter
21 cm
Excavated by Frederica
de Laguna (Museum
Expedition), 1932
32-8-120

Chugach *(Suqpiaq)* Seal Oil Lamp

72

Another year is slowly slipping by us. When you are young, you hope that time moves faster. When you are old, you hope that time will not stop. One of the greatest gifts in life is passing something meaningful to the next generation so that our light will continue to shine for ages of ages. This seal oil lamp is an ancient method of lighting and providing warmth in one's house. In our region, the art of making a fire was a gift from Raven.

In 1933, a famous anthropologist from the University of Pennsylvania, Dr. Frederica de Laguna, joined forces with Dr. Kaj Birket Smith of the National Museum of Denmark and recorded many old stories from my Grandmother's uncle, Makari Makarka Chimivitski, who was born at the village of Nuchek in Prince William Sound, Alaska. The story she documented was called: "How Raven Brought Fire." The story is summarized as follows:

There was a village called *Urumiertuli* in Prince William Sound. At this village the people did not know how to make a fire. Raven told them to get two cedar sticks and a cord and rub them together. Other villages in the region learned this art from the *Urumiertuli* people. They loaded Raven's canoe with all kinds of furs and skins, so he became rich. Then he went away, they did not know where. He did not have his own village, but traveled all around.

Frederica de Laguna and Kaj Birket Smith are more than just names in a history book. They dedicated their lives to understanding and sharing ancient Native knowledge. Their life work has helped to educate the general population, and most importantly their work has had profound effects on preserving our Native culture. Without their great ability to look into the future, many of our histories would have been lost. We need more individuals like them to look into the future and make a positive difference for humanity.

These types of seal oil lamps have a special spiritual connection to a world that is hard to understand, let alone describe. In prehistoric times, the reality of life was different than today. In the old days, the spiritual world was strong, every being and object had a spirit. People were more in tune with this since they lived side by side with nature. This seal oil lamp is a symbol of the spirit of our ancestors. They may have passed on thousands of years ago, but their presence is still with us today.

JOHN F. C. JOHNSON

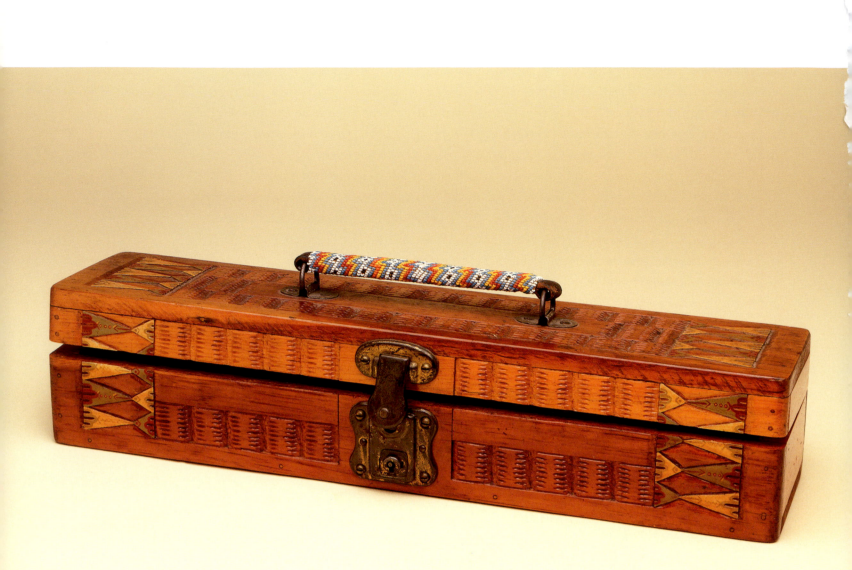

PLATE 73.
Peyote Box
Osage, OK
Ca. 1950
Wood, pigment;
length 49 cm
Denver Art Museum
exchange, 1959
59-14-59

180

Osage Peyote Box

Eloquent objects speak a universal language of truth as well as beauty. The message of this Osage Peyote Box is not just for American Indians or the Native American Church. It addresses broader national struggles for religious freedom and cultural survival. It exposes the tyranny of righteousness masquerading as justice and symbolizes the power of a community united.

"Like the miner's canary," Felix Cohen wrote, "the Indian marks the shifts from fresh air to poison gas in our political atmosphere." He concludes that "our treatment of Indians . . . reflects the rise and fall in our democratic faith." This was never truer than in the "Oregon Peyote Case" of *Employment Division v. Smith* 494 U.S. 872 (1990).

A widely circulated story--perhaps apocryphal--places two law professors hiking with their children in the Blue Ridge Mountains. A Black Snake crosses their path. "Kill It! Kill It!" shouts the professor destined for the Supreme Court. "We're in the Snake's back yard," the other calmly replies. "And he doesn't seem to be harming anyone." The cry of "Kill It" continues. Meanwhile, the Snake passes into the woods. From any objective viewpoint, neither the Snake nor the future Justice Antonin Scalia were endangered.

However, religious freedom was seriously endangered by Scalia's opinion in the Smith case. Therein, Scalia saw constitutional protection for the Sacrament of Wine in the Catholic Church but not the Sacrament of Peyote in the Native American Church. Peyote was treated as if it were a demon drug, a danger at least equal to a Black Snake. Scalia's decision threatened to permanently close this Peyote Box.

More than Cohen's Canary or Scalia's Black Snake the Eagle shaped the ultimate victory of religious freedom. For Native Americans, the Eagle with arrows in his talons symbolizes freedom and sovereignty. Each of the arrows represents a human right and sovereign power. Case law and the U.S. Constitution establishes that these arrows or rights cannot be removed by whim or chance by either Congress or the courts.

After Scalia's decision, the American religious community joined together. They inspired the Congress to pass corrective and protective legislation which in essence said to the snake-killing court, "and what is it that you do not understand about the word NO in the Constitutional protection of religion?" This Osage Box is a reminder that religions are now equally free to worship whether their sacrament is wine or peyote.

RENNARD STRICKLAND

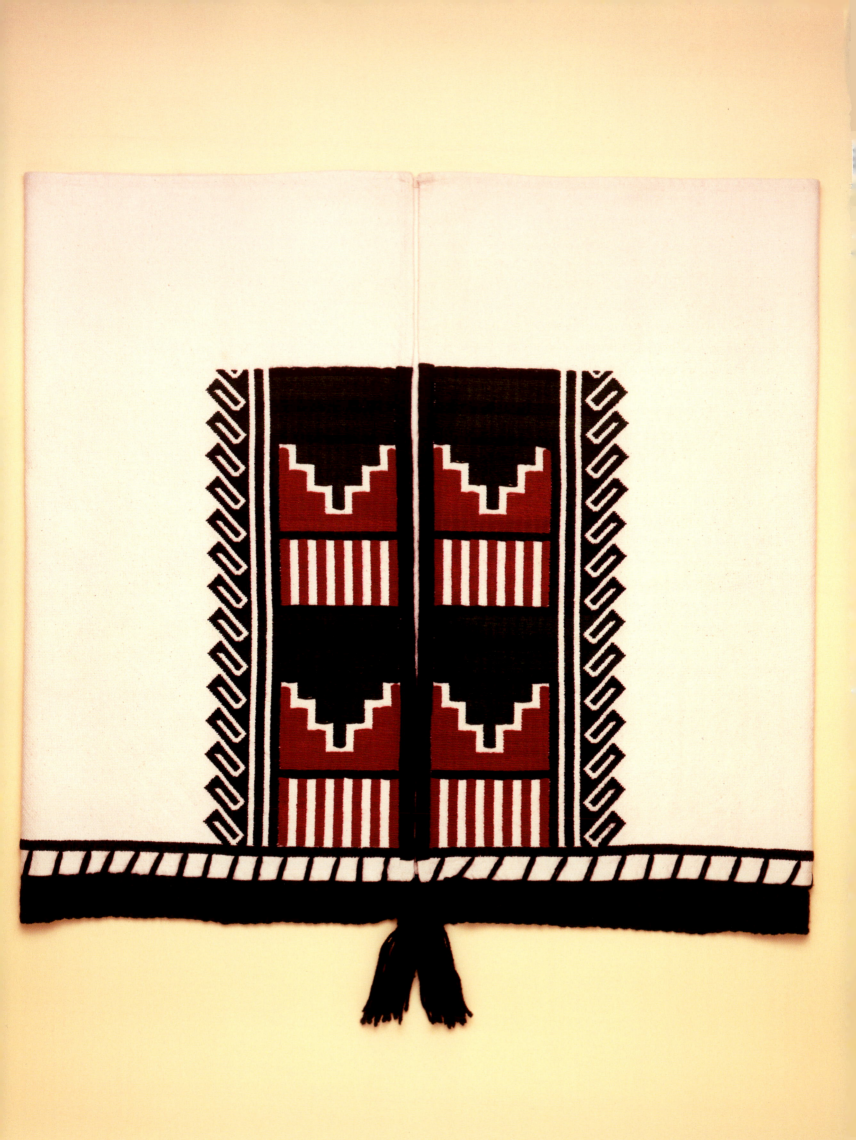

The Face of a Community

I reside in the Tewa village of *Po-who-ge oweenge* (village where the water cuts through), more commonly known by the Spanish name San Ildefonso Pueblo. We are one of the eight villages or pueblos located in the Rio Grande Valley and Jemez Mountain Region of northern New Mexico. We are a community deeply rooted in our culture and religious beliefs, practicing traditional dances and social customs year round.

San Ildefonso has a distinguished reputation as a center for the making of fine pottery. Lorenzo Gonzales, Crucita Blue Corn Calabaza, Popovi Da, and Maria Martinez have all created examples of pottery that have been recognized at both national and international levels. I have always felt, however, that the other art forms made by the people of this village are also remarkable and deserve recognition. Embroidery, basket making, moccasin stitching, beadwork, and traditional paintings of Pueblo culture are among other forms that can be found here.

As a traditional weaver, I feel that my textiles are a way of connecting myself to my culture and my culture to the world. My pieces have a function different from that of people who see them just as art. The pieces I make are worn by my people who practice our culture and religion. The form and function of textiles is a specific "face" of the community which has not changed discernibly for hundreds of years.

I believe that through my embroidery the face of this community can only be strengthened. This can happen by passing on the meanings of a particular design and what its spiritual intent is, or simply saying the design in the native tongue so that it can be learned from a linguistic perspective.

I envision a strong community balanced between the non-Native world and our own, sometimes secretive, world. Our goal must be to rid such a beautiful place of the social ills brought upon us by European contact that still have such a devastating effect on both young and old. I sometimes fear that the children of today do not get enough encouragement so that they might become interested in traditional things. I hope to be a link should a person of this community become lost and seek to know their culture.

Embroidery has unlimited potential as a tool to make a community stronger. The traditions and tribal life ways that have been so important to us as Pueblo People for so long will always be preserved through cloth.

ISABEL C. GONZALES

PLATE 74.
Dance Kilt
Artist, Isabel C. Gonzales
San Ildefonso Pueblo, NM
2002
Cotton; height 71 cm,
width 152 cm
Collected by Lucy Fowler
Williams, 2002
2002-17-8

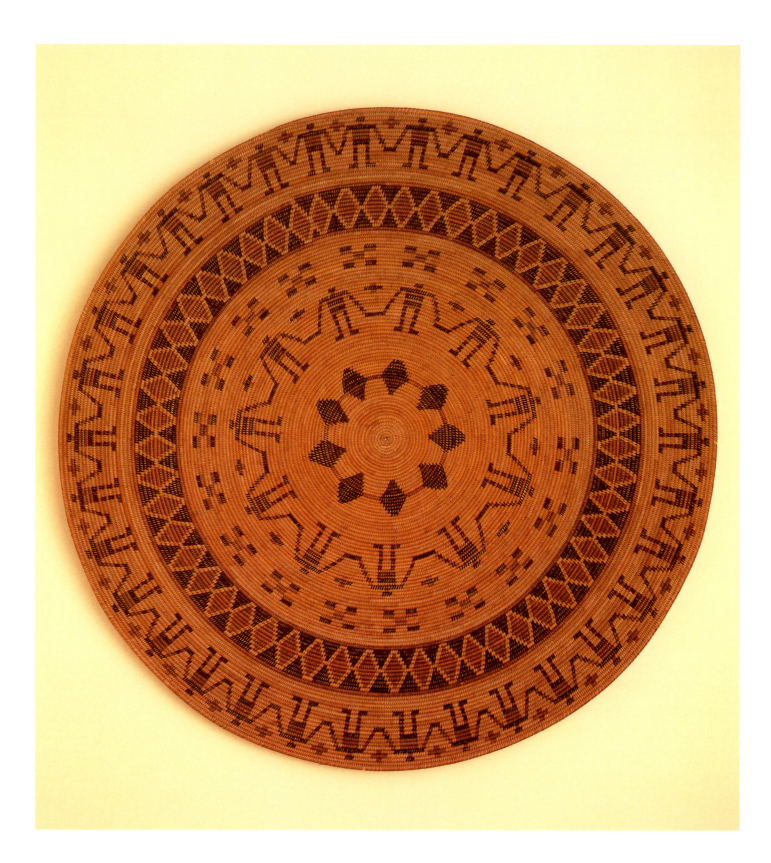

PLATE 75.
Gambling Tray
Yokuts, CA
Late 19th century
Plant fiber; diameter 78.7 cm
Patti Stuart Jewett Collection
Gift of William K. Jewett,
1918
NA8307 a

184

Identity Games

The interpretation of objects, like the people who create them, changes in response to time and circumstances to tell a multitude of stories. For Yokuts women, their dice game was an opportunity to socialize as peers and show off their basket-weaving prowess through their enormous yet delicate and intricately patterned gambling trays. Today, tribes continue to play traditional games, but gaming itself, in the form of casinos and bingo halls, has grown to encompass the much more complicated issue of sovereignty. To look at this gambling tray or other Native objects associated with traditional games in contemporary contexts is to no longer see them only as beautiful works of craftsmanship or mechanisms for social exchange, but as jumping-off points for discussion of Native gaming operations as expressions of tribal sovereignty.

One aspect of sovereignty for many tribes is acquiring the economic strength to remain together as a community. Loss of members to greater financial stability outside the community can lead to a breakdown in community identity. Native peoples must make a conscious decision to stay together as a group. As someone not raised in her west-central Louisiana community, I understand the loss of group relationships and cultural traditions that can accompany this separation. Breakdown of community can lead to the impairment of group identity, but also individual Native identity, through erosion of kinship ties, cultural traditions, and the confidence of knowing where one comes from, of having roots. For many tribes, casinos are the economic answer to maintaining a sovereign community identity.

Hundreds of tribes have set in motion economic development plans, such as the creation of local businesses, natural resource management, and cultural tourism, to improve the quality of life in their communities and keep or bring community members close to home. New gaming forums, such as casinos, are economic strategies that create jobs and revenue for tribal education, housing, social services, and other quality-of-life necessities.

For tribal communities, gaming enterprises are not so much about gambling as they are about physical and cultural survival. Casinos and bingo halls can help establish an economic infrastructure to support a larger population and provide the stability necessary to maintain a strong community. Just as the Yokuts woman's dice game served to bring people together, contemporary tribal gaming operations can forge a sovereign path to the financial freedom to carry on cultural traditions as a cohesive group.

ARWEN NUTTALL

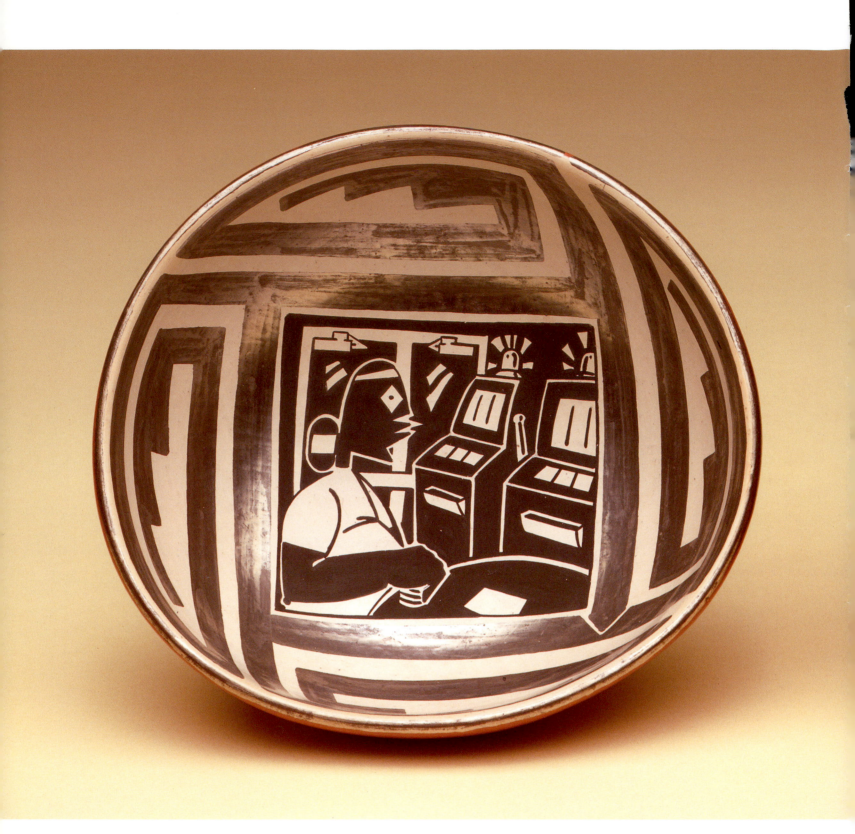

PLATE 76.
Bowl "Slots"
Artist, Diego Romero
Cochiti Pueblo, NM
1997
Clay, pigment; diameter
16.7 cm
Collected by Lucy Fowler
Williams, 1999
99-9-7

Slots

My pot "Slots" is concerned with a personal and political view of gaming and its place within Indian Country. The character Chongo appears as a participant of the casino scene. Carelessly gambling away his stipend, he represents the addictive side of human nature-to which we are all privy. This bowl takes no positive or negative stance but brings this issue into the forefront for debate.

DIEGO ROMERO

76

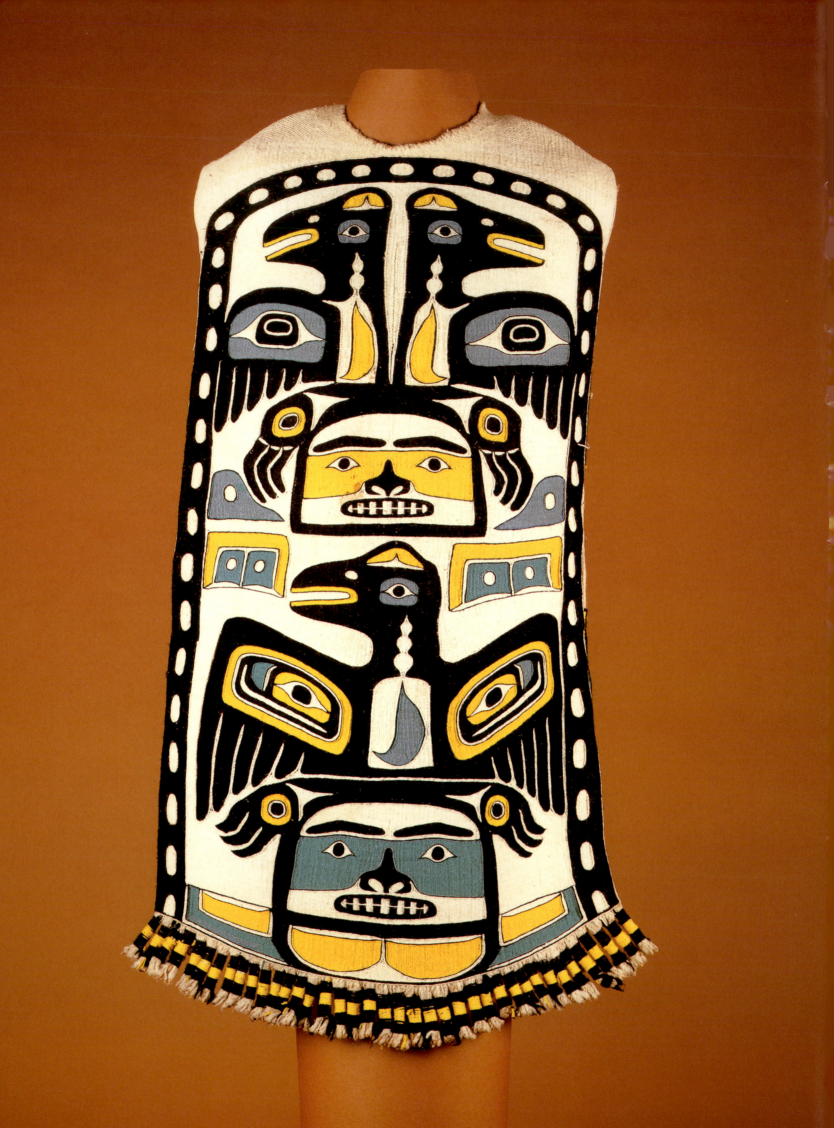

Two Door House Tunic

The Two Door House Tunic is an *at.óow* of the *Lukaax.ádi* clan of the Raven moiety, sometimes referred to in English as the "Sockeye" Clan, after its main crest. *At.óow* are made to ensure that our future generations know who they are and where they originate.

The tunic is associated with the Chilkat *Lukaax.ádi* village of *Kaatx'awultú* (sometimes called Kluctoo or Kalwattu) and popularly called Nineteen Mile, after its location at mile 19 on the present Haines Highway, running along the Chilkat River. The village was destroyed by a rock and mud slide in the late 1890s. Every house there was wiped out, with the exception of Two Door House. After the slide, Two Door House was dismantled and rebuilt at Four Mile, called *Yandeist'akyé* in Tlingit, where it was combined with another house.

The house was used as a clan house for many years until the Haines Highway and airport projects were started. Unfortunately, the Two Door House was in the right of way and was condemned. The clan elders elected once again to dismantle and move it, this time to Haines, where it stands today as a functioning clan house and is known as Raven House. It is the symbolic and physical center of *Lukaax.ádi* ceremonial activities.

After a time, the clan commissioned a tunic with a Two Door House motif commemorating the original house and its being spared from the landslide. This tunic eventually disappeared without clan authorization, and another was made to replace it. Once again the tunic disappeared, and once again it was replaced. Thus, three tunics are known to have been woven to commemorate the Two Door House. These are now located in Philadelphia, Denver, and Oregon. The designs are essentially identical.

Judging from photographs, the Philadelphia tunic has a lighter blue, whereas Denver is more blue-green or turquoise. The Philadelphia tunic has more tassels on the bottom than Denver's—perhaps twice as many. The Raven is facing to the viewer's left on the Philadelphia tunic and to the right on the Denver tunic. Photos of the Oregon tunic are not available for comment at this time.

NORA MARKS DAUENHAUER

PLATE 77.
Tunic
Chilkat Tlingit, AK
Late 19th/early 20th century
Cedar bark, mountain goat
wool; length 123 cm
Collected by Louis Shotridge,
1931
31-29-11

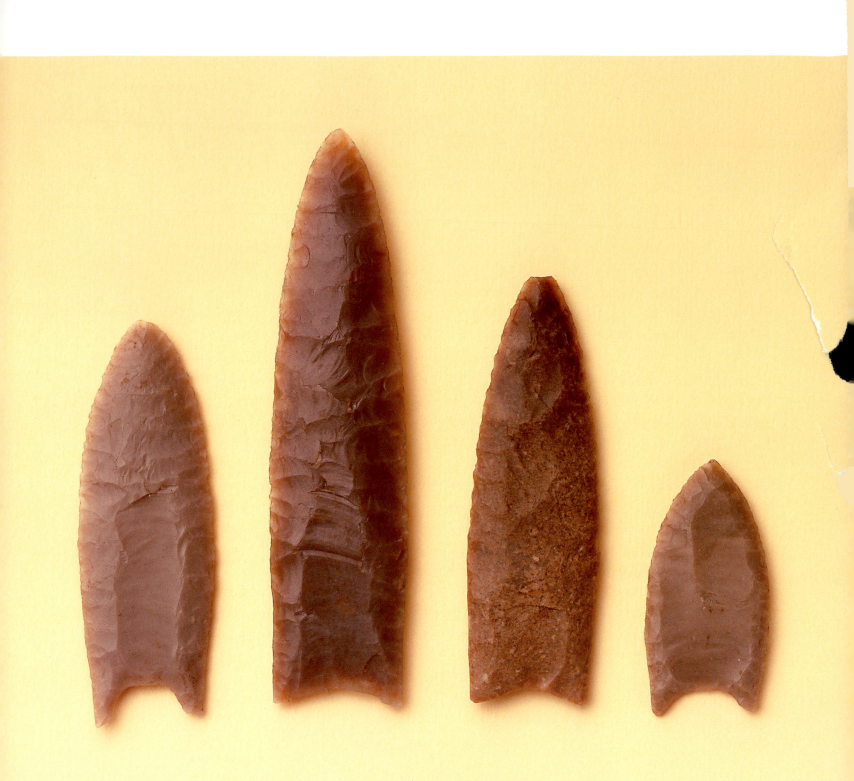

PLATE 78.
**Clovis and
Folsom Points**
Blackwater Draw Site,
Clovis, NM
11,200–9,000 B.P.
Chert; from left, 36-19-16
length 7.8 cm, 36-19-3 10.8
cm, 36-19-2 8.3 cm, 36-19-26
5.1 cm
Excavated by John Cotter
(Museum Expedition), 1936

We are always They and They are always We

78

A palindrome is the perfect title for this essay, since to most traditional American Indians, the beauty of a circle is that it has no beginning and no end. We American Indians are the product of our past and "all our relations" who went before, including those who entered this continent at the dawn of its human occupation. The first generation of those who existed here were not American Indians, but the second generation, those born here, were. That generation carried in their bones, their organs, and their culture the trace minerals ingested by their mothers-microscopic particles of the landscape that tied them to the area as sure as culture tied them to their kin. They were the parents of today's American Indians in a real sense, regardless of the scientific possibilities of multiple migrations or competing originating localities.

The hunting implements of those early people-the Paleoindians-meant life for those who used them, but their beauty extends beyond mere technical utility or basic needs. They are products of intense communion between maker and stone and reflect an artistic ability that astounds most who view them. They are more than mere instruments used 12,000 years ago to provide food for human groups. They are beacons from their makers. They scream: "I was here! I am here! Listen! See!" They mark human movement through the physical landscape of the past, when nothing was known beyond boundaries traversed on seasonal movements. They mark human movement through the temporal landscape as well, marking boundaries from discovery to exploration to familiarity with this continent. Few are the people who touch the past through the lives represented by these objects. Perhaps only those in the future who chart the ripple of humanity across an interplanetary landscape will be able to share the fulfillment of those who study the early inhabitants of this continent.

The past is a landscape: we chart it, divide it, and name it, but it remains unchanged by artificial lines and arbitrary boundaries. Our viewpoints change, and the landscape, though sometimes clear and other times fogged, is always there even though we may not see it. Today that landscape is a battlefield between American Indians and archaeologists-two groups that should be uniting to protect the manifestations of the past rather than haggling over them. If we are not careful, the past will be lost to the highest bidder or the slickest developer, and we will be blaming everyone else but ourselves.

JOE WATKINS

Contributors

Marcus Amerman (Choctaw) is a painter, sculptor, bead-artist, and performance artist. His work provides insightful and ironic commentaries on popular culture. He has participated in numerous exhibitions and performances such as "Who Stole the Tee Pee?" at the National Museum of the American Indian in New York and "Winter Camp: The Legacy of Contemporary Expressions of Oklahoma Tribal Art" at the National Cowboy Hall of Fame in Oklahoma City. He has received many awards and honors including a Dubin fellowship at the School of American Research in Santa Fe.

Arthur Amiotte (Oglala Lakota) is an author, painter, collage artist, and educator. Born on the Pine Ridge Reservation in South Dakota, he is a descendant of the *Minniconjou* chief Standing Bear. He graduated from Northern State University with a B.A. in Art and Art Education and received an M.A. in Interdisciplinary Studies from the University of Montana. As a college student, he was influenced by Lakota modernist Oscar Howe. He has received numerous awards and fellowships including the Arts International Lila Wallace Reader's Digest Artists at Giverny Fellowship. He was appointed to the Presidential Advisory Council for the Performing Arts at the Kennedy Center in Washington, DC, by President Jimmy Carter, 1979-81. The Buffalo Bill Historical Center mounted a major retrospective of his life and work in 2000.

JoAllyn Archambault (Standing Rock Sioux) is Curator of Anthropology and Director of the American Indian Program at the National Museum of Natural History, Smithsonian Institution. She received her Ph.D. from the University of California Berkeley, where she taught Native American Studies. She has organized numerous exhibitions, including "Plains Indian Arts: Change and Continuity," "100 Years of Plains Indian Painting," "Indian Baskets and Their Makers," and "Seminole Interpretations." Her work involves the preservation and promotion of Native American art and culture and political anthropology.

Bryan McKinley Jones Brayboy (Lumbee-Cheraw) is Assistant Professor of Education and Executive Director of the Center for the Study of Race and Diversity in Higher Education at the University of Utah. He is the Principal Investigator of the University of Utah's American Indian Teacher Training Program. He is also a Ford Foundation Postdoctoral Fellow, a recipient of the Kellogg Forum on Higher Education for the Public Good Fellowship, and a former Spencer Foundation Dissertation Fellow.

Mae Clark (Navajo) is a weaver born to the Towering House People and born for the Chiricahua Apache People. Her family was recently removed from her homeland near Big Mountain on the Navajo Reservation as part of the Hopi-Navajo land dispute settlement, and she now lives near Sanders, AZ. She weaves with machine-spun Germantown yarns supplied by Bruce Burnham at R. B. Burnham Trading Post.

Cippy Crazy Horse (Cochiti Pueblo) is a master silversmith. He has exhibited his work at the Santa Fe Indian Market for over 25 years. His work is sold by the Museum of New Mexico and the Institute of American Indian Art in Santa Fe and the Heard Museum in Phoenix.

Ann Dapice (Delaware/Cherokee) is Vice-President of TK Wolf Inc. She holds a Ph.D. in psychology, sociology, and philosophy from the University of Pennsylvania. She has served as professor and administrator at a number of universities and has taught courses in the social sciences and Native American Studies. Her cross-cultural research has been reported in professional journals, books, and academic presentations regionally, nationally, and internationally.

Melissa Darden (Chitimacha) is a basket maker from Charenton, LA, and the granddaughter of renowned basket maker Lydia Darden. Along with other members of her family, she is actively preserving this traditional aspect of Chitimacha culture. Her work has been featured at the Louisiana Folklife Festival, Jazz Fest, Red Earth, the Smithsonian, the Louisiana Native Crafts Festival, the New Orleans Jazz and Heritage Festival, and the Prairie Acadian Culture Center. She has received numerous prizes and honors.

Nora Marks Dauenhauer (Tlingit) is a scholar, author, and playwright who lives in Juneau, AK. She is internationally recognized for her translation and explication of Tlingit oral literature. Her creative writing has been widely published, and her plays have been performed at the Kennedy Center in Washington, DC.

She and her husband Richard have co-authored and co-edited several award-winning books on Tlingit language and myth including *Haa shuká, Our Ancestors: Tlingit Oral Narratives*, *Haa tuwunáagu yís, for Healing our Spirit: Tlingit Oratory*, and *Haa kusteeyí, Our Culture: Tlingit Life Stories*.

Roger C. Echo-Hawk (Pawnee) is a Research Associate at the Denver Art Museum and the University of Colorado, Henderson Museum. As the Pawnee tribal historian, he has worked to gather and preserve recorded oral history and other materials pertaining to Pawnee origins and history. He and his brother, Walter Echo-Hawk, are authors of *Battlefields and Burial Grounds: The Indian Struggle to Protect Ancestral Graves in the United States*.

Diane Glancy (Cherokee/English/German) is Professor of English at Macalester College where she teaches Native American literature and creative writing. Her poetry, scripts, essays, and fiction have received numerous literary prizes, including an American Book Award, the Minnesota Book Award in Poetry, the Native American Prose Award, and a Sundance Screenwriting Fellowship. Among her recent publications are *Primer of the Obsolete*, *The Shadow's Horse*, and *Designs of the Night Sky*.

Isabel Cajero Gonzales (San Ildefonso Pueblo) grew up at Jemez Pueblo and learned the art of embroidery from her mother. After high school, she attended the Haskell Institute in Lawrence, KS. Isabel teaches Pueblo embroidery at the Poeh Center, Pojaque Pueblo. One of her goals is to stimulate more interest in Pueblo embroidery, especially among Pueblo children. She has received numerous awards and honors for her textiles.

Rayna Green (Cherokee/German) is Curator of the American Indian Program, National Museum of American History, Smithsonian Institution. In 1973 she was the first American Indian in the nation to receive a Ph.D. in Folklore, from Indiana University. She has received fellowships from the Ford Foundation and the Smithsonian Institution, along with many civic awards, including the prestigious Jessie Bernard Wise Woman Award. Her writings express the internal and external struggles of Native women resisting patriarchy rooted in white imperialism and adopted by Native men. She has written *Women in American Indian Society* and edited the *British Museum Encyclopedia of Native North America*.

L. Buddy Gwin (Mandan) is an attorney and the tribal spokesperson for the Mashantucket Pequot Tribal Nation. He is the fourth great-grandson of the Mandan chief, Four Bears (*Mató Tópe*).

Sven Haakanson, Jr. (Alutiiq-Sugpiat/Danish/Norwegian) is Director of the Alutiiq Museum and Archaeological Repository in Kodiak, AK, where he lives with his wife and daughter. He holds a Ph.D. in anthropology from Harvard University. His poems are inspired by oral traditions and firsthand experience in managing ethnographic collections that date to the 1800s. He wrote them to remember, celebrate, and understand the deeper significance of each object and what they mean to him.

Jim Hart (Haida) is a master carver from the Queen Charlotte Islands. He began apprenticing over twenty years ago with renowned Haida carvers Bill Reid and Robert Davidson. His commissions include the royal family of Sweden, the Museum of Anthropology at the University of British Columbia, and the Smithsonian Institution. He has had solo exhibitions in Vancouver and Singapore. In 1999, he became the hereditary chief of the Eagle Clan of Haida Gwaii and was given the Edenshaw name.

Richard W. Hill, Sr. (Tuscarora, Beaver Clan) is a writer, artist, and educator. He has taught at the University of Buffalo for many years and served as Assistant Director for Public Programs at the National Museum of the American Indian. He has written extensively on Native art and Native stereotyping and is currently involved in curriculum development and Haudenosaunee language retention.

George P. Horse Capture (A'aninin [Gros Ventre]) is Curator and Special Counselor to the Director of the National Museum of the American Indian. Born on the Fort Belknap Indian Reservation in Montana, he earned a B.A. in Anthropology from the University of California Berkeley and an M.A. in History and an honorary doctorate from Montana State University. He takes an active part in his culture at pow-wows, ceremonies, and other special Indian activities. Among his publications are *Powwow, Beauty, Honor and Tradition: The Legacy of Plains Indian Shirts*, with his son Joseph Horse Capture, and *Robes of Splendor: Native American Painted Buffalo Hides*, edited with Ann Vitart, Michel Waldberg, and Richard West.

Jerry Ingram (Choctaw/Cherokee) is a beadworker and artist. He attended the Institute of American Indian Arts in Santa Fe before earning his B.A. from Oklahoma State Technical Institute. Ingram has received many awards for his art as well as for his efforts to expand the understanding and appreciation of Native American culture. His art is praised for its historical accuracy in form and detail and can be found in the National Gallery of Art, the Heard Museum, and the Philbrook Art Center.

Harold Jacobs (Tlingit) is a carver and song composer. As the cultural specialist for the Central Council of Tlingit and Haida Indian Tribes of Alaska, he has been actively involved in the repatriation of clan *at.óow* under the Native American Graves Protection and Repatriation Act.

John F. C. Johnson (Chugach) is Vice President of Cultural Resources for the Chugach Alaska Corporation. He has worked for the Chugach people for over twenty-five years, particularly in the areas of repatriation of his Chugach ancestors and as director of the Nuchek Spirit Camp. His goals are to insure that his people gain control of their traditional lands as promised under the treaty of the Alaska Native Claims Settlement Act and that his culture continues to grow.

Stephen J. Johnson (Saginaw Chippewa Indian Tribe of Michigan, Bear Clan) is the Director of Asiaworks Global Investment Group in Singapore. A graduate of the University of Pennsylvania's Wharton School, Johnson was Captain of the Varsity Football team, an All-Ivy League player, and member of two Ivy League Championship teams.

Theodore Jojola (Isleta Pueblo) is Regents Professor of Community and Regional Planning at the University of New Mexico. He holds a B.F.A. in Architecture with a double major in math and music from the University of New Mexico, a M.A. in City Planning from MIT, and a Ph.D. in Political Science from the University of Hawaii, Manoa. He is particularly active in the areas of community development, environmental design, indigenous rights, tribal economic development, and microcomputer applications in education and planning. He has published numerous articles, book chapters, and research reports.

Tommy Joseph (Tlingit) is a carver from Ketchikan, AK. He carved his first piece, a halibut hook, when he was eight years old. His works now include items such as bentwood boxes, rattles, masks, spoons, silver engravings, totem poles, and canoes. Joseph demonstrates and interprets Tlingit culture and art to visitors at the Southeast Alaska Indian Cultural Center in Sitka and at the Sitka National Historical Park.

Keevin Lewis (Navajo) is the Community Services Coordinator for the National Museum of the American Indian. He is a graduate of UCLA. He and Elizabeth Weatherford were the Executive Directors of "Living Voices," a fifty-part radio series of short profiles focused on Native people from various nations and backgrounds in the United States, Canada, Mexico, and Panama. He feels honored to be able to provide through his life and career changing opportunities to Native people of the Western hemisphere and Hawaii.

Rebecca Lyon (Alutiiq/Athabascan) is a metal and glass artist, born in Cordova, AK, and raised in Anchorage. Although she studied art at the University of Alaska, Anchorage, she is primarily a self-taught artist. Her work integrates materials in a contemporary interpretation of older traditional objects, honoring the artistry of her ancestors. She has held a fellowship with the National Museum of American Indian and her work is in many major museum collections.

Kevin Noble Maillard (Seminole Nation of Oklahoma) is a practicing attorney. He received a Ford Dissertation Fellowship, the Seminole Nation Education Award, and his B.A. from Duke University, a J.D. from the University of Pennsylvania, and an M.A. and a Ph.D. from the University of Michigan. He has published articles on mixed-blood identity and Federal Indian law in the *American Indian Law Review* and the *Journal of Constitutional Law* and has presented papers at national and international conferences. He has worked at Hughes, Hubbard, and Reed LLP, the Holocaust Litigation Project, and the Lawrenceville School.

Desirée Rene Martinez (Gabrieliño [Tongva]) is a Ph.D. candidate in the Department of Anthropology at Harvard University and a Research Assistant for the Peabody Museum. She received her B.A. in Anthropology from the University of Pennsylvania. Her dissertation seeks to create an archaeology that effectively embraces indigenous points of view. She is co-curator of a photography exhibit at the Peabody Museum on Indian leaders in Washington, DC, during the mid-19th century.

Beatrice Medicine (Standing Rock Sioux) is a distinguished educator. Born on the Standing Rock Indian Reservation in South Dakota, she received her B.S. from South Dakota State University, her M.A. from Michigan State University, and her Ph.D. from the University of Wisconsin-Madison. She has used her research to inform national commissions and to improve the lives of Native Americans in general and women in particular. In 1991 she received the American Anthropological Association's Distinguished Service Award. Medicine has published numerous books, chapters, and more than fifty journal articles.

Morris Muskett (Navajo [Diné]) is a self-taught weaver, dyer, and hand-spinner. He is a member of the Towering House People and born for the Folded Arms People. He is related to the Zia People through his paternal grandfather and the Red-Running-into-The Water People through his maternal grandfather. Muskett weaves both warp-faced and weft-faced textiles using materials such as Navajo Churro wool, alpaca, hemp, merino wool, cotton, linen, mohair, and silk. His work is held in many museums.

Dan Namingha (Hopi-Tewa) is an internationally acclaimed painter and sculptor. His mother is the famous potter Dextra Quotskuyva. He has received the New Mexico Governor's award for Excellence and Achievement in the Arts. His works are represented at Niman Fine Art in Santa Fe, the J. Cacciola Gallery in New York, and the Susan Duval Gallery in Aspen. Thomas Hoving has published a book on his work entitled *The Art of Dan Namingha*.

Dolly Naranjo Neikrug (Santa Clara Pueblo) is an educator and cultural specialist. She holds a B.A. in English Literature and Elementary Education and an M.A. in Education Administration. She has worked for over twenty years as a teacher and principal among the pueblo schools in Northern New Mexico. She has also worked with the Institute of American Indian Arts, the Center for Research and Cultural Exchange, and the School of American Research in Santa Fe.

Dolly Navasie (Hopi, Water Clan) is a ceramic artist. Her first introduction to the art came from watching her maternal grandmother *Poli-Ini* work the clay. Later in her youth, her mother, Eunice "Fawn" Navasie, became both her mentor and inspiration. Navasie, also known as White Swann, works only in traditional styles with traditional materials and has passed on her knowledge to her children. She has won many prizes for her work at the Santa Fe Indian Market and other venues.

Marianne Nicholson (Kwakwaka'wakw, Dzawada'enuxw Tribe) is a painter and photographer. She views her art as contemporary executions of traditional Kwakwaka'wakw concepts. She has a deep interest in the Kwak`wala language and is currently engaged in completing an interdisciplinary Master's degree at the University of Victoria in Linguistics and Anthropology.

Arwen Nuttall (Four Winds Cherokee, Louisiana Cherokee Confederacy) is a staff researcher for the Curatorial Department of the National Museum of the American Indian. She graduated from Newcomb College at Tulane University and

holds an M.A. in Museum Education from the University of the Arts in Philadelphia. She has been an intern in museum education at the University of Pennsylvania Museum and at the Buffalo Bill Historical Center in Cody, WY.

Simon J. Ortiz (Acoma Pueblo) is an internationally known writer and poet as well as a Professor of Literature at the University of Toronto. He is a father and grandfather and uncle and brother. His work emphasizes the enduring connections between land, culture, and community for indigenous peoples. Among his many published books are *Out There Somewhere*, *After and Before the Lightning*, *Woven Stone*, and *Speaking for the Generations*.

Bernard Perley (Maliseet, Tobique First Nation) is a painter and Assistant Professor of Anthropology at the University of Wisconsin-Milwaukee. He holds a Ph.D. in anthropology from Harvard University. He teaches courses in linguistic anthropology and American Indian Studies. His ongoing research is in cultural repatriation, sovereignty, language politics, and the theories and methods of language revitalization. He is working with members of the Tobique First Nation in developing Maliseet language materials.

David Ruben Piqtoukun (Inuit) is a master sculptor. He grew up in the Paulatuk area of the Western Canadian Arctic and lives on the southeast shores of Lake Simcoe, ON. He learned stone carving from his brother, Abraham Anghik, in 1972 and continued his training at the New World Jade Company in Vancouver. Since 1974, his work

has been represented in seven solo exhibitions and nearly 40 group exhibitions across Canada and around the world, including Germany, Italy, and Russia. His main inspirations are water, weather, sunsets, wildlife, and offshore fishing. His work is held in many major international museums.

Dextra Quotskuyva (Hopi-Tewa) is a potter from Keams Canyon, AZ. She is the daughter of Rachel and Emerson Namingha, the granddaughter of Annie and Willie Healing, and the great-granddaughter of Nampeyo. She has been making pottery for nearly four decades. In 1995, she was proclaimed an "Arizona Living Treasure." She has been honored with many exhibitions, and her pottery is found in many museums and private collections. The Wheelwright Museum recently organized an exhibition and catalog entitled *Painted Perfection: The Pottery of Dextra Quotskuyva.*

Teri Rofkar (Tlingit, Snail House of the *T'ak dein taan* [Raven] Clan) is a fiber artist. She makes spruce root baskets and is a specialist in the Raven's Tail weaving technique. Her innovative work is in many museums and public venues. She has held fellowships with the National Museum of the American Indian and the Peabody Essex Museum. She demonstrates her weaving at the Sitka National Historical Park.

A-dae Romero (Cochiti Pueblo/Kiowa) is a law student at Arizona State University. She graduated from the Woodrow Wilson School of Public and International Affairs at Princeton University with a certificate in Political Economy. She is particularly interested in issues of sovereignty and federal Indian law.

Diego Romero (Cochiti Pueblo) is a potter and printmaker. He attended the Institute of American Indian Art in Santa Fe, and the Otis Parsons School of Design in Los Angeles, and he received his M.F.A. from UCLA in 1993. His art combines traditional shapes with modern imagery and often makes political statements about contemporary Indian life. His work is held in many museums including the British Museum, the Spencer Museum of Art, the Museum of Indian Arts and Cultures, and the Bruce Museum.

Mateo Romero (Cochiti Pueblo) is a painter and printmaker. He graduated from Dartmouth College with a B.A. in painting and art history and received an M.F.A. in printmaking from the University of New Mexico. Romero was a painting instructor at the Institute of American Indian Arts and has held a Dubin Fellowship at the School of American Research. His work can be found in many museum collections including the Canadian Museum of Civilization, Museum of Indian Arts and Cultures, the Institute of American Indian Arts, and the Poeh Center.

Gary S. Roybal (San Ildefonso Pueblo) is Curator of Collections at Bandelier National Monument, National Park Service. He graduated from Ft. Lewis College in Durango, CO, where he studied anthropology. He was an adviser for the archaeology and anthropology exhibits at the Bandelier Visitor Center.

Ramona Sakiestewa (Hopi) is an internationally renowned textile artist. She taught herself to weave by evolving and adapting techniques derived from prehistoric Pueblo weaving. She has served as president of the Southwestern Association on

Indian Affairs and was the founding director of ATLATL, a national Native American service organization. She has worked with architects to bring a contemporary Native design sensibility to building projects such as the Chickasaw Cultural Center, the Tempe Performing Arts Center, and the Smithsonian Institution's National Museum of the American Indian. She has had solo exhibitions at the Wheelwright Museum in Santa Fe and the Newark Museum in New Jersey. Her work is held by many major museums.

Ramoncita C. Sandoval (San Juan Pueblo) is a distinguished textile artist. She taught embroidery and sewing at the Institute of American Indian Arts in Santa Fe and now teaches embroidery to others at her pueblo, through the San Juan Cooperative. She has received numerous awards, and her textiles are part of many museum and private collections.

Sherrie Smith-Ferri (Dry Creek Pomo/Bodega Bay Miwok) is Director of the Grace Hudson Museum and Sun House in Ukiah, CA. She received her Ph.D. in Anthropology from the University of Washington. She has curated numerous exhibits and contributed essays to books and catalogs.

Rennard Strickland (Osage/Cherokee) is Phillip H. Knight Professor of Law at the University of Oregon. He founded the Center for the Study of American Indian Law and Policy at the University of Oklahoma and served as Chair and Arbitrator of the Osage Constitutional Commission. He is past president of the Association of American Law Schools and former dean of the University of Oregon School of Law. He has co-curated several major Indian

art exhibitions including "Shared Visions" with Margaret Archuleta for the Heard Museum and "Magic Images" with Edwin L. Wade for the Philbrook Art Center. He was editor-in-chief of the third edition of *The Handbook of Federal Indian Law*.

Roxanne Swentzell (Santa Clara Pueblo/German) is a ceramic artist. She is perhaps most famous for her amazing sculptures of Pueblo men and women which provide insightful commentaries upon the conditions and challenges of contemporary Indian life. She emphasizes human emotions which she regards as a universal language shared by all peoples of the world. Her Pueblo beliefs are to become a Whole Person, someone who walks deliberately with all of one's self and carefully through the world. Her sculptures are her story on that journey. She is the subject of the Museum of New Mexico's *Roxanne Swentzel: Extra-Ordinary People* (2003).

Shawn Tafoya (Santa Clara Pueblo) is a self-taught textile artist. A member of the prominent Tafoya family of potters, he began making art at the age of five. In 1987 he studied traditional pottery and textiles at the Institute of American Indian Arts in Santa Fe. A dedicated teacher, for a number of years he has taught embroidery and traditional pottery at the Poeh Cultural Center in Pojoaque, NM. He received a Dubin Fellowship from the School of American Research, and his work has been acquired by many museums.

Robert Tenorio (Santo Domingo Pueblo) is a distinguished potter. He is a graduate of the Institute of American Indian Arts in Santa Fe where he originally studied

sculpture. He is well known for recreating ancestral puebloan methods of painting and firing. His ceramics are among the largest pieces produced by any pueblo potter, and they regularly win prizes at the Santa Fe Indian Market and other prestigious competitions. His work is held in many major museums.

Russell Thornton (Cherokee Nation of Oklahoma) is Professor of Anthropology at the University of California at Los Angeles. He holds a Ph.D. in Sociology from Florida State University and has taught at several universities including the University of Pennsylvania. He is particularly interested in American Indian historical demography, American Indian revitalization movements, American Indian winter counts, and contemporary American Indian issues. He is the author of several books including *American Indian Holocaust and Survival* and *The Cherokees: A Population History*, along with over a hundred scholarly articles and other publications.

Evelyn Vanderhoop (Haida) is an accomplished textile weaver and painter. She is a member of the Git'ans Git'anee family from Massett, Haida Gwaii, British Columbia. Evelyn weaves using the traditional Raven's Tail and Chilkat weaving techniques which she learned from her mother. The objects she creates range from chief's robes and tunics to smaller objects such as dance aprons, leggings, and other ceremonial regalia. She has participated in numerous exhibitions and has won a number of awards for her work. In 1999 she received an Artist in Residence Fellowship from the National Museum of the American Indian.

Gerald Vizenor (Minnesota Chippewa Tribe, White Earth Reservation) is an internationally acclaimed author and Professor of Native American Studies at the University of California Berkeley. His teaching career has included professorships at several American universities. He has written numerous poems, essays, and novels, all of which comment upon the contemporary condition of Indian America. Among his many publications are *Manifest Manners: Postindian Warriors of Survivance*, *The Heirs of Columbus*, *Fugitive Poses*, and *Shadow Distance: A Gerald Vizenor Reader*.

Joe Watkins (Choctaw) is Professor of Anthropology at the University of New Mexico in Albuquerque. He received his B.A. in Anthropology from the University of Oklahoma and his M.A. and Ph.D. in Anthropology from Southern Methodist University. He worked for many years as the Anadarko Agency Archaeologist for the Department of the Interior's Bureau of Indian Affairs in southwest Oklahoma. He is currently chair of the Committee on Ethics of the American Anthropological Association and has served as past chairman of the Committee on Native American Relations of the Society for American Archaeology. His most recent book is *Indigenous Archaeology*.

Michael V. Wilcox (Yuma /Choctaw) is Assistant Professor of Cultural and Social Anthropology at Stanford University. He received his Ph.D. from Harvard University with a dissertation on the archaeology of the Pueblo Revolt of 1680. His research interests include postcolonial approaches to archaeology, ethnic identity and conflict, and political and historical relationships among Native

Americans, anthropologists, and archaeologists.

Curtis Zunigha (Delaware Tribe of Indians in Oklahoma) is a private consultant and producer of multimedia communications, community development, and government policy throughout Indian Country. As chief of the Delaware Tribe of Indians, he led his tribe to federal recognition in 1996. He serves as Chairman of the Board of Directors of Oklahomans for Indian Opportunity and as Vice-Chairman of the Board for the Oklahoma Institute of Indian Heritage.

Lucy Fowler Williams is the Jeremy A. Sabloff Keeper of American Collections at the University of Pennsylvania Museum of Archaeology and Anthropology. She is a Ph.D. student in cultural anthropology at the University of Pennsylvania, where her dissertation research focuses on historical and contemporary Pueblo textiles. She is the co-author, with Jo Ben Wheat, of *A Burst of Brilliance: Navajo Weaving and Germantown, Pennsylvania* (1994). She has received grants and fellowships from the National Endowment for the Arts, the School of American Research, the University of Pennsylvania Department of Anthropology, and the University Museum. Her most recent publication is *Guide to the North American Ethnographic Collections of the University of Pennsylvania Museum* (2003).

William Wierzbowski is Assistant Keeper of American Collections at the University of Pennsylvania Museum of Archaeology and Anthropology. For nearly thirty years he has worked with Native American art in both a curatorial capacity and as an independent scholar. He has been involved in the exhibitions "Images of a Vanished Life: Plains Indian Drawings" (Pennsylvania Academy of the Fine Arts, 1985) and "Mad for Modernism" (Philadelphia Museum of Art, 1999) as a co-curator and catalogue essayist. His research has focused on the tradition of Plains Indian drawing and painting, especially ledger drawing, and the history of collecting Indian material, primarily in Philadelphia. His most recent publication is "Matches's Sketchbook: Native American P.O.W. Art from Fort Marion," *Expedition* 45 (2003):15–20.

Robert W. Preucel is Associate Professor of Anthropology and the Gregory Annenberg Weingarten Associate Curator of North American Archaeology at the University of Pennsylvania Museum of Archaeology and Anthropology. His research interests include issues surrounding Native American identity, archaeological representation, and material culture. He has received grants from the American Philosophical Society, the University Research Foundation, and the University Museum. His most recent publication is an edited book, *Archaeologies of the Pueblo Revolt: Identity, Meaning and Renewal in the Pueblo World* (2002).

Acknowledgments

We are grateful to the many individuals who have contributed their time and expertise to this project. Gregory Annenberg Weingarten, member of the Board of Overseers of the University Museum and Trustee of the Annenberg Foundation, deserves special thanks. Mr. Weingarten's initial interest in sharing the Native American collections beyond the the Museum inspired the project, and his vision and generosity have made this book possible. We are also especially grateful to the many Native authors with whom we have had the great pleasure of working. Their willingness to lend their voices and overwhelming support to this project has breathed new life into the collections and has helped establish bridges between the University of Pennsylvania and the Native American community. We are delighted to have the opportunity to honor each of them with this book. All royalties will be sent to the American Indian College Fund.

We also extend our deepest gratitude to two directors of the University Museum whose leadership encouraged this endeavor. Jeremy A. Sabloff, the former Williams Director, enthusiastically welcomed and fostered the nascent project. Richard M. Leventhal, the current Williams Director, generously and graciously supported the project to its completion.

Many other individuals played key roles in the book's development and we are grateful to each of them. Karen Mauch and John Chew, both of Philadelphia, illuminated the objects with their outstanding photography. Rich Hendel skillfully tailored the design to the content. Walda Metcalf, Director of Publications at the Museum, ably oversaw all phases of the book's production.

We want to express our thanks to many talented members of the Museum staff. From the American Section we are particularly grateful for the continued support of Robert Sharer, Chief Curator; Clark Erickson, Associate Curator; Stacey Espenlaub, NAGPRA Coordinator; Ginny Ebert, NAGPRA Assistant; as well as the Collections Assistants, Rebekkah Hogan, Julie Thompson, Nicole Virgilio, Cheryl Kilcheski, Maribel Marmol, Jackie Sokoloff, Mark Stetina, Jason Strickler, Susan Thomas, and William Wallis. Suzanne Sheehan Becker, Director of Development, Margaret Spencer, Executive Assistant to the Director, Alessandro Pezzati and Sharon Misdea of the University Museum Archives, Francine Sarin and Jennifer Chiappardi of the Museum's Photographic Studio, Chrisso Boulis, Associate Registrar for Collections, and Jane Epstein of the Traveling Exhibitions Department committed their valuable time and expertise as well.

Finally we would like to acknowledge our families for their support and understanding during the long process of preparing this volume. Lucy is especially grateful to her husband, Erik Williams, for his abiding support and sense of humor. Her sons, Bengt and Erik, also deserve special thanks. Bob thanks his wife, Leslie Atik, for her help and encouragement.

Index

Unega, 145
University of Alaska, 10
University of California, 3
University of Chicago, 3
University of Pennsylvania, 161, 169,
 Department of Anthropology, 4;
 Museum, 4, 9–11, 49; Museum Journal,
 1, 139
Urumiertuli, 179

Vanderhoop, Evelyn, 11, 113, 129, 198
"Vanishing Indian," 3–4, 15

Vigil, Romando *(Tse ye mu)*, 106–107
Vizenor, Gerald, 11, 15, 22, 59, 198

Wakan Yeza, 117
Walters, Harry, 9
Washburn, Dorothy, 9
Watkins, Joe, 21, 191, 198
White Swann. See Dollie Navasie
Wiconi, 131
Wilcox, Michael V., 16, 198
Wilson, John, 103
Wihalai't, 113

Wamiss, Tom Patch, 155
Witthoft, John, 7, 64, 104, 144

X'aanaxgáatwayáa, 18, 127

Yandeist'akyé, 189
Yokuts, 184, 185

Zia Pueblo, 90
Zuni Pueblo, 3, 9, 160–61
Zunigha, Curtis, 103, 111, 199

203

Native American Voices on Identity, Art, and Culture:

Objects of Everlasting Esteem

was designed and typeset in The Serif types

by Richard Hendel and Eric M. Brooks

printed on 115 gsm Daytona Silk by

Butler and Tanner Ltd., Frome, England

and published by

University of Pennsylvania Museum of Archaeology and Anthropology

3260 South Street, Philadelphia, PA 19104

U.S.A.

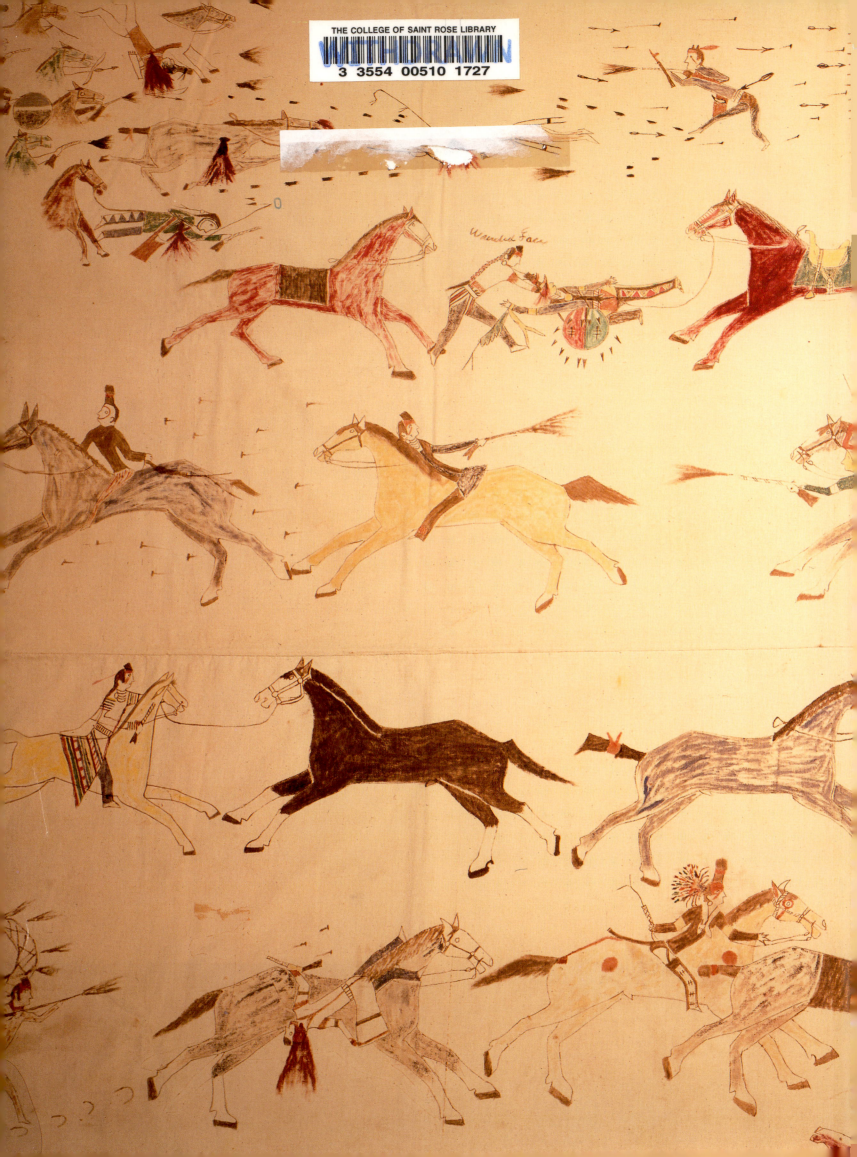

Wounded Face